PHOTOGRAPHY
THE PROFESSIONAL TOUCH

PHOTOGRAPHY
THE PROFESSIONAL TOUCH

ARTISTS HOUSE

Executive Manager Kelly Flynn

Contributing Editor Bob Saxton

Art Editor Colin Robson

Designer Hans Verkroost

Production Peter Phillips

Edited and designed by the
Artists House Division of
Mitchell Beazley International Ltd
Artists House
14–15 Manette Street
London W1V 5LB

ISBN 0 86134 091 4

Typeset by Hourds Typographica Limited, Stafford.
Reproduction by La Cromolito s.n.c., Milan.
Printed in Portugal by Printer Portuguesa, Lisbon.

INTRODUCTION

What is it that makes a photograph great? Technique alone is clearly not enough and imagination by itself is not going to get you the shot you want. The professional touch comes with developing technical skills because they are what you need to exploit the very personal qualities of your imagination and perception, and make the picture happen. Finding out about today's equipment is essential and this book starts with a guide on choosing a camera for your individual needs; on how lenses, films and shutters work; and on the importance of apertures and focal length. In the main part of the book, the portfolios of seven professional photographers are accompanied by comments and advice on composition, lighting, colour and mood. Martyn Adelman, Martin Dohrn, Tessa Musgrave, Clay Perry, Kim Sayer, Jerry Tubby and Tim Woodcock each demonstrate how a highly individual approach to seeing and exploring the technical possibilities of the medium is the essence of a great picture.

CONTENTS

CAMERA EVOLUTION

The camera has a history almost a thousand years older than photography itself. As long ago as the tenth century people were observing solar eclipses by means of *camera obscuras* which projected a view of an outside scene into a darkened room, directing light rays from the scene outside through a small hole in the window shutters to fall as a disc of light on the white wall opposite the hole. But it was not until the early nineteenth century when portable *camera obscuras* were modified to accept a light-sensitive plate, that practical photography was introduced to the world. Since then, designers have found ways to solve the technical limitations of each stage in the camera's evolution with improvements in light-sensitive compounds, exposure times, versatility and quality of lenses – to arrive today at computer control.

Louis Jacques Mandé Daguerre is considered to be the inventor of practical photography, although the world's first photograph was taken by Joseph Niepce in 1826; a dim, extremely fuzzy image of the view from his attic window of a farmyard which took 8 hours to expose! Niepce applied new discoveries about light-sensitive compounds and came up with the missing element – an asphalt solution coated onto a sheet of pewter and placed inside a portable *camera obscura*. But this heliographic process proved

The development of camera design and technology has been one of progressive sophistication in construction on the one hand, and increased simplicity of operation on the other. Size of both camera and film format have been steadily reduced. These illustrations are not to scale: The *Giroux* camera measured 31.1 × 36.7 × 26.7cm when closed and 50.8cm long when extended, and the *Leica* and *Brownie* could fit into the hand.

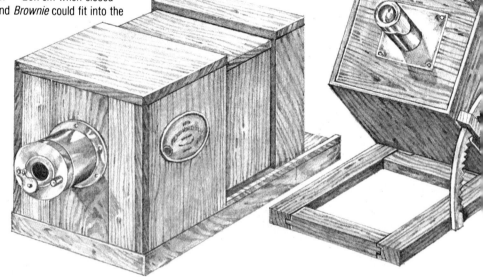

Constructed by Giroux of Paris in 1839, this daguerretype camera took long exposures – about half an hour – yet images were surprisingly sharp. Two boxes slid inside each other to focus the lens on the ground glass screen at the back. The lens had a focal length of 38cm and an effective aperture of f-14. The 'shutter' was simply a brass disc in front of the lens.

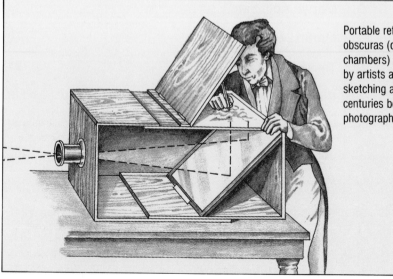

Portable reflex camera obscuras (darkened chambers) were used by artists as a sketching aid many centuries before photography.

In about 1835, Fox Talbot in England produced the calotype process, the first method for easy production of prints from a negative image. By 1840 he had reduced exposure times to less than a minute, using this camera with its simple microscopic lens and adjustable rack. Talbot had realised the key to speed in picture-taking was a small camera with short focal length which could make the most of dim light by concentrating it on a small piece of film.

unsuitable for normal photography, and it was Daguerre who went on to find more sensitive chemicals and invent the first practical photographic process: the Daguerretype which reduced exposure time, and which went on sale in 1839. With this breakthrough improvements became rapid. Josef Petzval invented a lens which admitted nearly sixteen times as much light as Daguerre's and allowed exposures of less than a minute. But it could produce only a positive, and therefore only one picture. It was Fox Talbot in England who invented the first method for producing a number of prints from the original plate. By the 1880s camera development had made enormous advances but the devices were still too unwieldy and costly for all but the most dedicated amateur, until George Eastman launched his *Kodak No 1* – the world's first snapshot camera, small enough to hand hold, cheap to buy, and having 100 exposures on one roll of film. You sent the camera

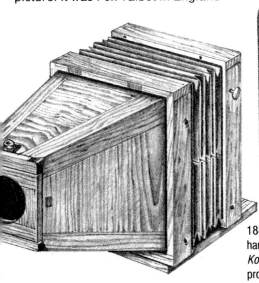

Wet plate cameras rapidly superseded daguerretypes and calotypes with the introduction of the wet collodion process in 1851. Twenty years later the wet plate itself was replaced by the first workable plate using gelatin emulsion which dispensed with the inconvenience of having to coat the plates before or develop them immediately afterwards.

1888 saw the introduction of the first true hand-held camera to use roll-film. Eastman's *Kodak No 1* transformed the laborious processes of photographic technique which only the most dedicated amateur could cope with. Anything beyond 1.2m was in focus, and your camera could be sent back to the factory for the exposed film to be processed and a new film

installed: "You press the button, we do the rest'.

In 1900 photography became child's play, with Eastman's *Brownie*. For one dollar – or five shillings – you could buy a simple-to-operate camera which produced good pictures 6 × 6cm on cartridge roll film. The model above right shows the optional viewfinder.

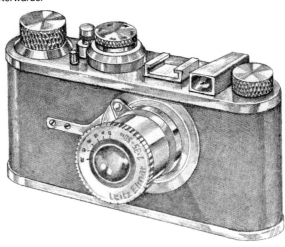

In 1925 the dream of a small and versatile camera for the serious photographer was fulfilled when the first precision miniature 35mm camera went on sale at Leipzig Fair. The *Leica* used 35mm film with 36 exposures, and had a fast focal-plane shutter with coupled film transport, and a high quality f/3.5 lens.

off to have the film developed, and it came back freshly loaded along with 100 prints. The basic simplicity of the box camera has been retained in today's compact and direct-vision camera, while the world's first miniature 35mm camera of 1925 – the *Leica* – spearheaded the revolution in 35mm system photography. The single-lens reflex camera (SLR) was not developed until the 1930s.

COMPACT CAMERAS I

Small, light and simple to operate, the 35mm compact cameras are particularly suited to candid photography when speed and simplicity are of the essence in capturing the moment. All compacts use a simple direct vision system: a viewfinder separate from the camera 'taking' lens. Most 35mm compacts are now totally automatic – auto focusing coupled with automatic exposure. Manufacturers of compacts concentrate on such refinements to make picture taking as simple as possible over a wide range of conditions. This may not be what you are looking for in a camera because creative possibilities are restricted, particularly in models with no manual focusing override. The fixed lens on most compacts makes versatility restricted too, but for quick, snap shots, the 35mm format gives for excellent results.

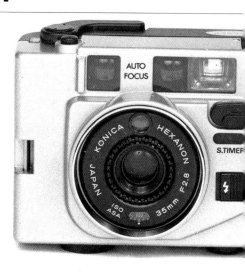

Olympus XA series includes rangefinder focusing (XA) manual aperture setting (XA) auto programme aperture and shutter (XA4) and aperture priority auto exposure (XA). Slide-apart dust barrier. Choice of 3 screw-on flash units which function integrally. 35mm lens, except XA4 model which has extra wide 28mm lens.

Pentax Sport. Automatic loading, winding, and semi-automatic motorized rewinding. Automatic focusing with infra-red measuring system which works even in the dark. Shutter speed and lens aperture automatically set. Built-in pop-up flash. 35mm lens.

Unlike single lens reflex cameras (SLRs), compacts do not have interchangeable lenses. This restricts their versatility, but allows for simplicity of construction and a lightweight compactness compared to the more bulky SLR. Most of the 35mm compacts have fixed standard lenses, though it is possible to buy a model with a 28mm fixed lens.

The best compacts produce pictures that are good enough for very large prints – used with care, results can be obtained that are as good as those from an SLR.

The degree of control over aperture and shutter speed settings varies from model to model, so if the option of manual operation is important to

Konica AF-3. Built-in automatic focusing with infra-red light to focus instantly including in the dark. Built-in electronic flash is coupled with the auto-exposure mechanism.

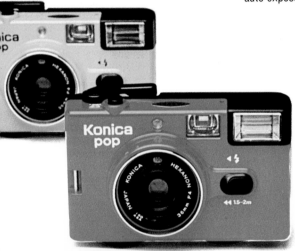

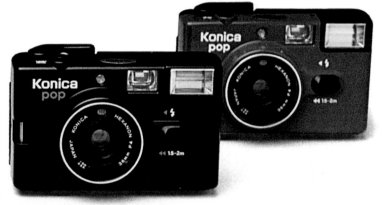

Konica Pop. Focus preset for a range from 1.5m to infinity. Built-in flash, a 35mm F/4 high resolution coated lens.

Compact cameras use a direct-view sighting device. Unlike the SLR, the image seen through the viewfinder is slightly different as that 'seen' by the lens – this is known as the 'parallax effect', (see over).

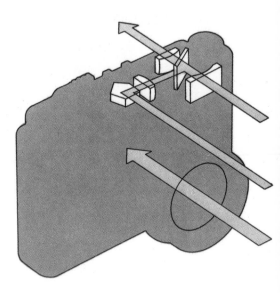

COMPACT CAMERAS 2

you, check before you buy.
All compacts use a direct-vision device – the viewfinder becomes a direct extension of your eye, so that you do not see the same area that the lens sees, which, of course, is the one recorded on the film. The difference between the eye viewpoint and the lens viewpoint is called parallax effect. The subject appears to be precisely framed in the viewfinder, but in fact there is a slight displacement, and the top part of the scene may be cut off. This becomes more critical in close-up work. Most compact cameras take the problem into account and mark the viewfinder to indicate the area that will be included in a close up. On some

models, focusing is achieved by a rangefinder system that produces a double or split image in the viewfinder until you adjust the lens focus control to correct setting.
Some compacts – the Konica range, for example, have an infra-red auto focusing system, and a 'focus lock' which permits selective focusing of subjects not in the direct centre of the viewfinder.

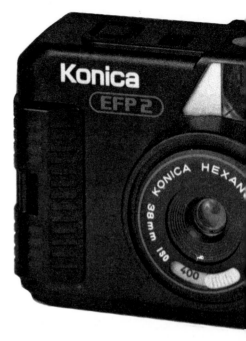

Konica EFP-2. Full-frame 35mm camera with built-in electronic flash. Bright frame, direct optical viewfinder 3-step aperture.

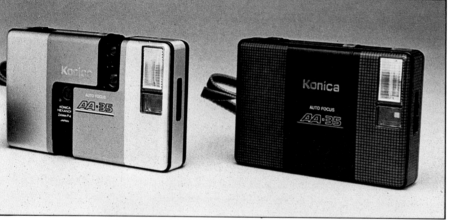

Konica AA-35. Half-frame 35mm camera – takes 72 shots from a 36-exposure film. 24mm lens and infra-red auto-focus. Automatic winding and rewinding and auto-flash coupled with auto exposure. Film winds on vertically (left).

Olympus Trip AF. 35mm camera. Auto exposure and infra-red auto focus.

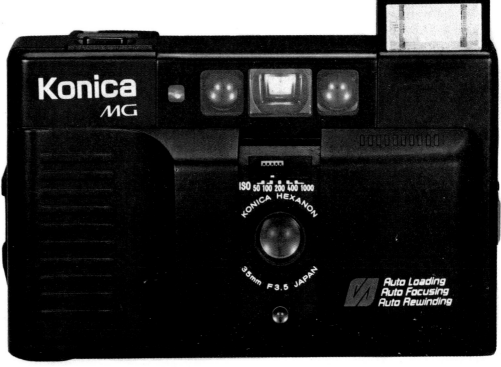

Konica MG, 35 mm camera, infra-red auto focus, auto exposure. Built-in flash and auto wind.

The workings of a simple camera demonstrate the principle of photography. Light passing through a lens, strikes light-sensitive film. The film responds to the amount of light reaching it and records the image. The amount of light passing through the lens needs to be precisely controlled to expose the film correctly.

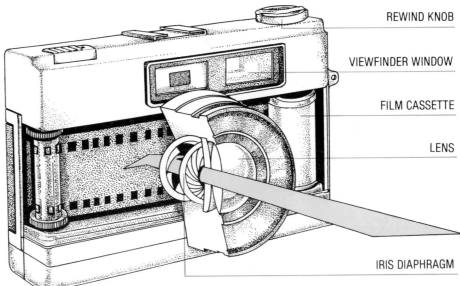

REWIND KNOB

VIEWFINDER WINDOW

FILM CASSETTE

LENS

IRIS DIAPHRAGM

SLR CAMERAS I

The 35mm single-lens reflex (SLR) is by far the most versatile of camera designs, offering the most extensive and comprehensive range of lenses and accessories and the advantage of a through-the-lens (TTL) viewing system which enables you to see exactly what the lens sees, thereby eliminating the 'parallax error' of the direct-vision viewfinder cameras. TTL metering allows for accurate control of both shutter and aperture while you concentrate on composing and framing the shot. 35mm SLRs are small and lightweight compared to other types of professional cameras, giving images of very high quality.

The 35mm SLR is complex in construction. All models show you the image exactly as it is formed by the lens, by means of a 45° mirror between the lens and the film. At this angle it reflects the light upwards to a ground glass focusing screen at the top of the camera which measures 24mm × 36mm – the size of the picture frame as it appears on the film. When you look into the eyepiece you view the image on this screen through a pentaprism – a solid block of optical-quality glass which presents the image the right way up and laterally corrected. It is absolutely fundamental to this reflex viewing system that the distance light has to travel from the lens to focusing screen (via the mirror) is exactly equal to the distance from the lens to the film. Because of this precise viewing system it is possible to make accurate visual checks of the whole image at any aperture setting, to try out different lenses to see their effects on the change of view, and also to try out filters and various other special effects accessories.

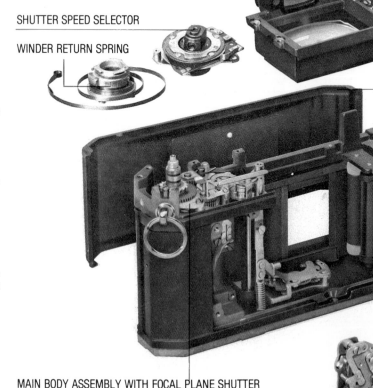

SHUTTER SPEED SELECTOR

WINDER RETURN SPRING

MAIN BODY ASSEMBLY WITH FOCAL PLANE SHUTTER MECHANISM

On an SLR camera light passes through the lens to be reflected by the mirror and pentaprism to the eyepiece. To expose the film, the mirror swings up immediately before the shutter opens to allow light to pass through to the film.

SELF-TIMER MECHANISM

MIRROR HOUSING WITH INSTANT RETURN MECHANISM

REAR LENS COMPONENT

FRONT LENS COMPONENT

REWIND CRANK

TOP HOUSING

SHUTTER RELEASE

FILM ADVANCE LEVER

PENTAPRISM

FOCUSING SCREEN
HOUSING AND EYE-PIECE LENS

CAMERA BACK

LENS MOUNTING PLATE

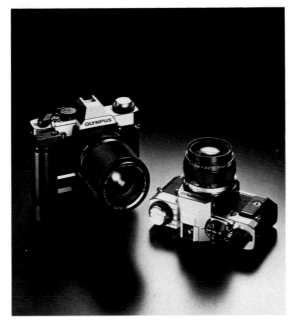

Olympus OM-20. 35mm Auto/Manual SLR.
Through-The-Lens (TTL) Direct 'off-the-film' light
measuring system on real time – reads the light
precisely the instant the light hits the film.

LENS CASING WITH
APERTURE AND FOCUSING SCALES

LENS NAME PLATE

FILTER MOUNT

The range of models available in the 35mm SLR format is large – the most important variation being their metering systems. The more automatic your camera is, the less you have to do, and most SLRs now have some kind of automatic exposure, usually one of two types: shutter speed priority or aperture priority. With a shutter priority camera, the photographer sets the shutter speed, the camera takes the light reading and sets the aperture to give the correct exposure. So if shutter speed is your priority – photographing action and sport, for example, you will probably prefer to give up manual control over aperture in favour of control over shutter speed. On aperture priority, you set the aperture and the camera selects shutter speed. Aperture setting will be critical on portrait work when depth of field (see pp 26-27) is a priority.

'Programmed' cameras give you a choice of exposure modes – auto shutter, auto aperture or totally automatic control at all over shutter speeds and aperture settings. Automatic cameras with manual override are often preferred by creative photographers who want the option of total control over the operations of the lens.

SLR CAMERAS 2

The greatest advantage of an SLR is being able to change lenses. The mount system on an SLR is often a twist-on, twist-off bayonet, but few manufacturers share the same mount, so it is vital to use lenses with the correct mount for your make of camera.

The choice of SLRs available is now wider than ever, with major manufacturers bringing out new models incorporating revolutionary design features all the time. In-built microcomputers, shutter speeds at 1/4000 sec, interchangeable focusing screens, advanced motor-drive attachments, automatic multi-spot or -pattern metering are among the new technology features of the latest professional SLR cameras. The design of the SLR may seem complex, but it is entirely functional and enables you to exercise greater control over the image.

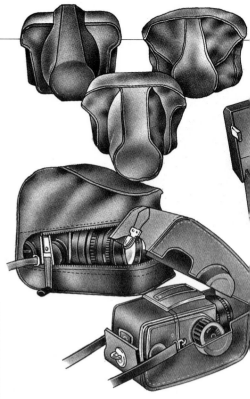

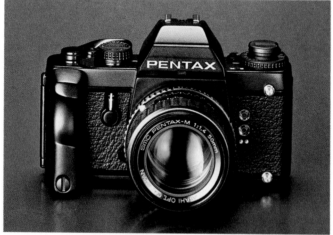

Pentax LX. 35mm Auto/Manual SLR camera. Integrated Direct Metering measures light directly off the film plane. Eight interchangeable viewfinders. Built-in self-timer.

Konica FC-1. 35mm auto (shutter-priority) SLR camera. Centre-weighted light metering system.

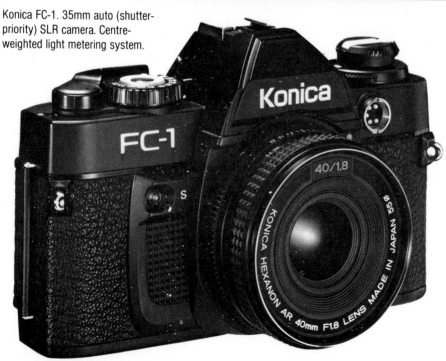

CAMERA CARE

Some cameras come in their own cases, though these are not usually very protective and will be of limited use if you are using more than one

A soft blower brush is essential for cleaning lenses and inside and outside the camera.

Anything sticky on the lenses should be removed with distilled water on artist's brush or cotton bud.

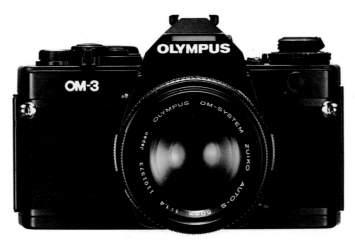

Olympus OM-3. 35mm SLR with mechanically controlled shutter. Centre-weighted average light measurement switchable to different spot methods. Interchangeable focusing screens.

lens or need to carry accessories about. More useful is a photographic soft shoulder bag, or a traditional 'box' case. Strongest and most protective of all is the rigid metal case.

Nikon FM2. 35mm SLR with mechanical shutter release. TTL centre-weighted measuring system, Top shutter speed 1/4000 sec. Multiple exposure facility. Interchangeable focusing screens. 150 range 12–6400.

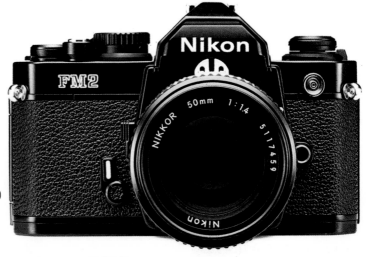

Traces of grit can be removed with a soft brush. Use soft tissue to remove any dust on lenses.

Nikon FA. 35mm electronically controlled. TTL Automatic Multi-Pattern Metering. Shutter-priority and aperture-priority modes. Manual exposure mode also provided.

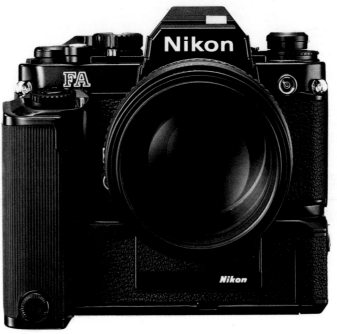

A clean cloth torn in half to give a ragged edge can be used to clean optical glass.

SLR CAMERAS 3

Nikon FG-20. 35mm Auto/Manual SLR camera. Aperture-priority automatic exposure: you select aperture, the camera sets the matching metered shutter speed. Model features manual override.

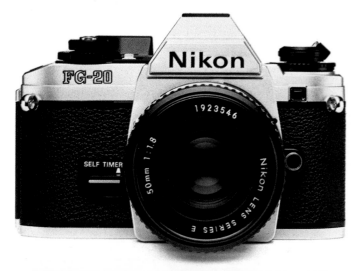

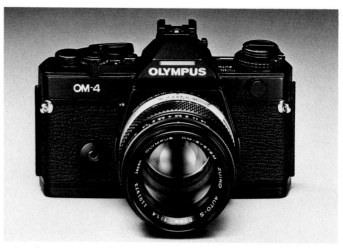

Olympus OM-4. 35mm Auto/Manual SLR. Multi-spot metering system. TTL Off-the-Film light measuring works in real time — after the mirror is raised, during the actual exposure. Manual override.

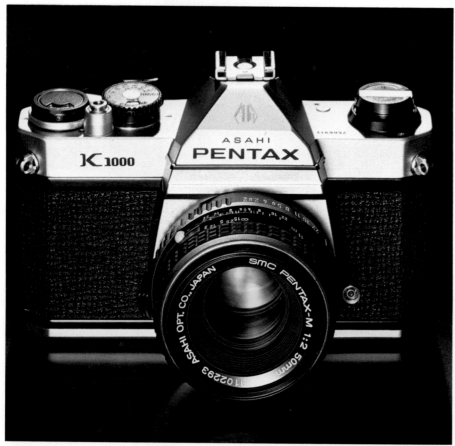

Pentax K 1000. 35mm Manual SLR. CdS meter measures average brightness of the ground glass at full aperture. Cross-microprism or split-image focusing screen.

A sophisticated SLR system incorporates an unparalled range of facilities, from five-frames-per-second motor drives to macro flash units and automatic data recording.

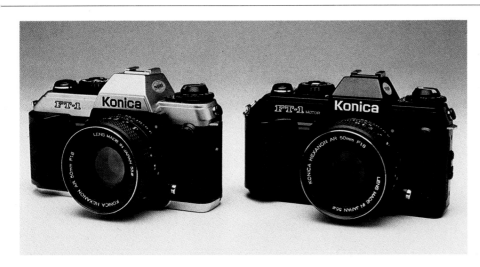

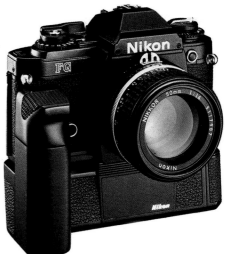

Konica FT-1. 35mm Auto/Manual SLR. Built-in autowinding with direct-drive micromotor which functions as the film take-up spool and powers the autoload, autowind mechanism. Continuous mode shoots two frames per second. Shutter-speed priority auto exposure – you choose the shutter speed, the camera sets the aperture.

Nikon FG 35mm Programmed/Auto/Manual SLR. In addition to auto and manual mode, fully automatic programmed exposure mode – shutter speed and aperture electronically set.

If you need to focus a lens closer than its minimum focusing distance a bellows unit or extension tubes have to be fitted. A bellows unit is the more versatile because it can be adjusted within the limits of its minimum and maximum extension. Tubes can only be extended by a fixed amount, but can be used separately or together. Macro lenses can be focused closer than normal lenses. Close-up supplementary lenses give some loss of definition.

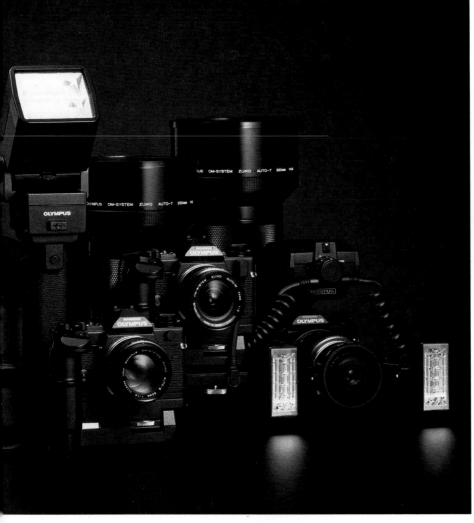

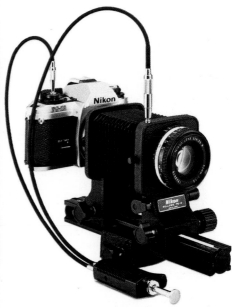

The best quality close-up work is obtained with a bellows unit. This Nikon PB-6 attachment allows for variable extension and high degree of control.

SLR CAMERAS 4

THE SYSTEM CAMERA

The range of equipment items which can be added to the basic body of a system camera means that every photographer can build a completely personalised outfit to accommodate both general work and specialized areas of photography. The type of system required for a photographer who shoots mainly sport and action will be very different from one geared to landscape and architecture, and different again from the equipment a still-life photographer needs. The picture-taking capabilities of the type of system you need to build is the first consideration.

Every system camera has its own range of interchangeable lenses. Some lenses can be used on different-make camera bodies. Independent lens manufacturers produce each lens in a range of fittings to suit most cameras.

Many SLR cameras have interchangeable focusing screens. Ground glass screens normally have a focusing aid in the centre – a disc of microprisms, a split-image rangefinder, or one which incorporates both. Screens with rectangular grids are available: allows for accurate lining-up of horizontals and verticals. To hold and focus cameras in different positions, attachments for waist-level or eye-level viewing, magnifiers, and eye-correction pieces can be used.

Camera backs enable conversion of the size and type of film used, others record data on each frame of film for you, while bulk film holders can be fitted – 250 exposures without having to change film.

Power winders allow for two-frames-per-second shots without having to wind on film manually, while the more expensive motor drives can shoot five or more frames per second.

Attachments for microscopic photography, underwater housing, bellows units are expensive items for highly specialized work.

1 camera body
2 standard pentaprism
3 waist-level finder
4 meter prism
5 focusing screen: ground glass
6 focusing screen: ground glass with clear centre spot
7 focusing screen: ground glass with microprism surrounding clear centre spot
8 focusing screen: ground glass with centre cross hairs
9 focusing screen: ground glass with microprism surrounding split-image rangefinder
10 focusing screen: ground glass with clear centre spot and grid
11–14 eyepiece correction lenses
15 right-angle finder
16 magnifier
17 rubber eyecup
18 spot meter
19 auto flash
20 power pack
21 heavy-duty flash
22 flash bracket
23 bulk-film back
24 power winder
25 motor drive
26 motor drive unit
27 pistol grip unit
28 data back
29 converter lens
30 200mm lens
31 400mm lens
32 catadioptric (mirror) lens
33 fish-eye lens
34 28mm lens
35 50mm lens
36 85mm lens
37 75mm–150mm zoom lens
38–40 lens hoods
41–43 extension rings
44 bellows
45 bellows rail
46 reversing ring
47–55 filters
56 tripod
57 cable release
58–60 filter holders
61–63 lens caps
64 everready case
65 holdall
66 spare lens
67–68 bulk film magazines
69 lens pouch
70–72 lens cases
73 underwater housing

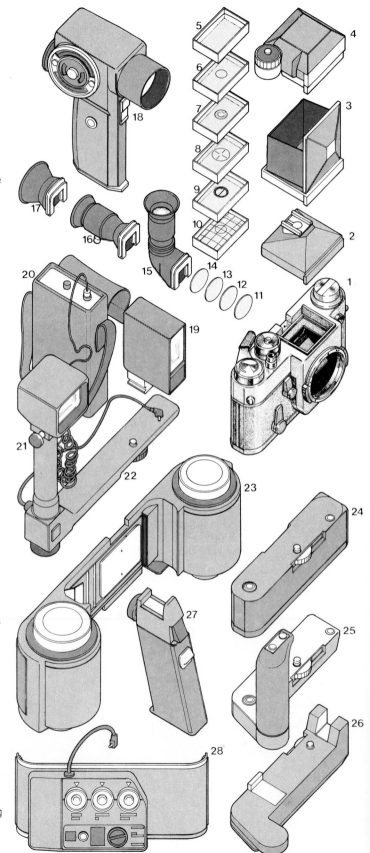

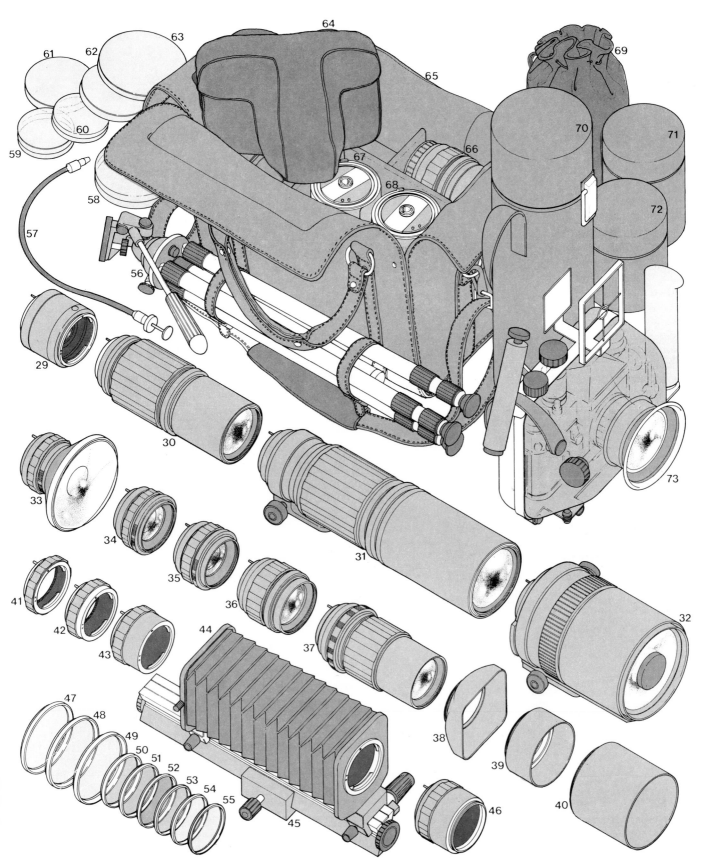

CAMERAS

Roll film cameras take a larger film format than the 35mm SLR and are therefore bulkier to handle. The limited number of exposures per roll (usually twelve) can be an advantage against having to shoot off 20 or 36 exposures before the film can be processed. Also, the larger film size offers improved image detail and quality. Roll film cameras represent a compromise between the portable, versatile 35mm SLR and the image quality of the large format cameras (see pp. 22/23). There are two main types – the SLR and the Twin-Lens Reflex (TLR). Some cameras take interchangeable magazines and backs for instant picture film or varying film formats, and interchangeable lenses.

Some roll film cameras are designed for waist-level use. You look down a focusing hood to see the image – reversed left to right – on the focusing screen. Both SLRs and TLRs accept interchangeable lenses (on TLRs both lenses have to be changed, which makes it costly). Nearly all SLR models also take film 'backs' to allow for changing films over part way through a film, and some can be fitted with instant film backs to test out

lighting and equipment. These are not available for TLRs which are mechanically simpler, having two lenses mounted one on top of the other. The top lens forms a viewing

Below: Pentax 6 × 7 SLR. Looks like a big 35mm SLR, but is in fact a medium-format roll film camera. Through-the-lens (TTL) metering pentaprism for use with all the interchangeable lenses available for this model – a selection of these is pictured below right.

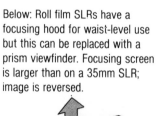

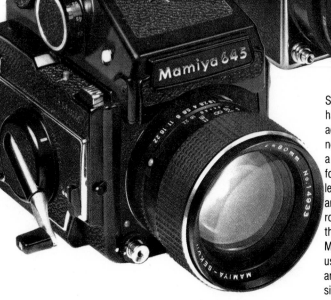

Below: Roll film SLRs have a focusing hood for waist-level use but this can be replaced with a prism viewfinder. Focusing screen is larger than on a 35mm SLR; image is reversed.

Small enough to hand-hold, with the advantage of a large negative size, and a range of options for interchangeable lenses, film backs and viewfinders, roll film SLRs like the Hasselblad and Mamiya (left) can be used in almost any photographic situation.

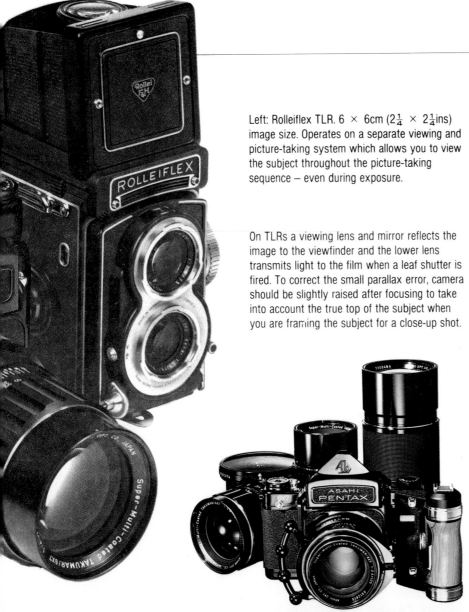

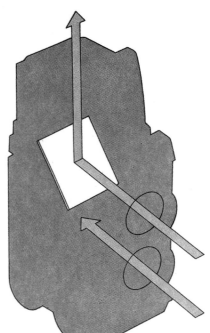

Left: Rolleiflex TLR. 6 × 6cm ($2\frac{1}{4}$ × $2\frac{1}{4}$ins) image size. Operates on a separate viewing and picture-taking system which allows you to view the subject throughout the picture-taking sequence – even during exposure.

On TLRs a viewing lens and mirror reflects the image to the viewfinder and the lower lens transmits light to the film when a leaf shutter is fired. To correct the small parallax error, camera should be slightly raised after focusing to take into account the true top of the subject when you are framing the subject for a close-up shot.

and focusing image, the lower is the taking lens.
Some roll film cameras are referred to as 'six by six' or 'two-and-a-quarter square' which is simply size of the negatives: 6cms (or $2\frac{1}{4}$ins) square. Some models take a picture 6 × 7cm, and a few take ones measuring 6 × 4.5cm which must be turned through 90° for a vertical shot, and therefore have to be used with a prism viewfinder.

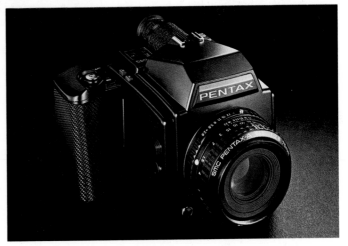

Pentax 645 SLR. Pentaprism for eye-level photography. 6 × 4.5cm image size; built-in motor drive; 7 exposure modes (micro-processor control system shown left). Interchangeable lenses.

LARGE FORMAT CAMERAS

'Large format' applies to those cameras which produce an image size of 5 × 4ins and above. The most outstanding feature of large-format cameras is the ultimate quality achieved by this large film size, while their construction makes for great accuracy in viewing and composing. The viewfinder is directly behind the lens so that the focusing screen shows an inverted and reversed-left-to-right image the same size as the film. Either a focusing hood or a light-proof cloth to surround the screen and cover the head (below), can be used as a viewing aid and to help prevent reflection on the glass. The camera consists of a front standard and a rear standard, connected by bellows – there is no camera 'body'. The front supports the lens and shutter; the rear, the focusing screen and film holder. Different image sizes are obtained by varying the distance between the two. On the most popular and versatile type, the monorail (main picture), these standards can be moved

BASEBOARD CAMERAS
Also called field or view cameras because they are designed as studio cameras which can be folded up and carried about for use in landscape photography. These large-format cameras have a baseboard which opens like a drawbridge, to support the lens panel and bellows.

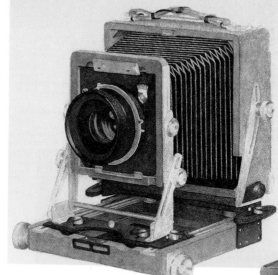

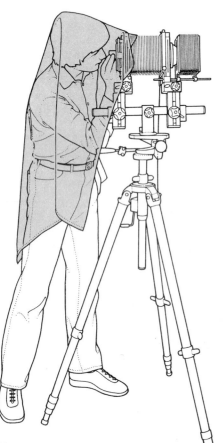

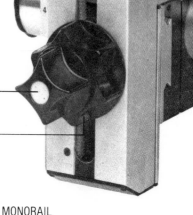

BACK SWING AND TILT KNOB

The Monorail camera (right) has adjustable screen and lens panels that can be made to rise and fall, or swing and tilt, to allow maximum control over the image. These camera movements are particularly useful in correcting distortions in perspective.

FOCUSING KNOB

BACK RAISING AND LOWERING KNOB

MONORAIL

TRIPOD MOUNT

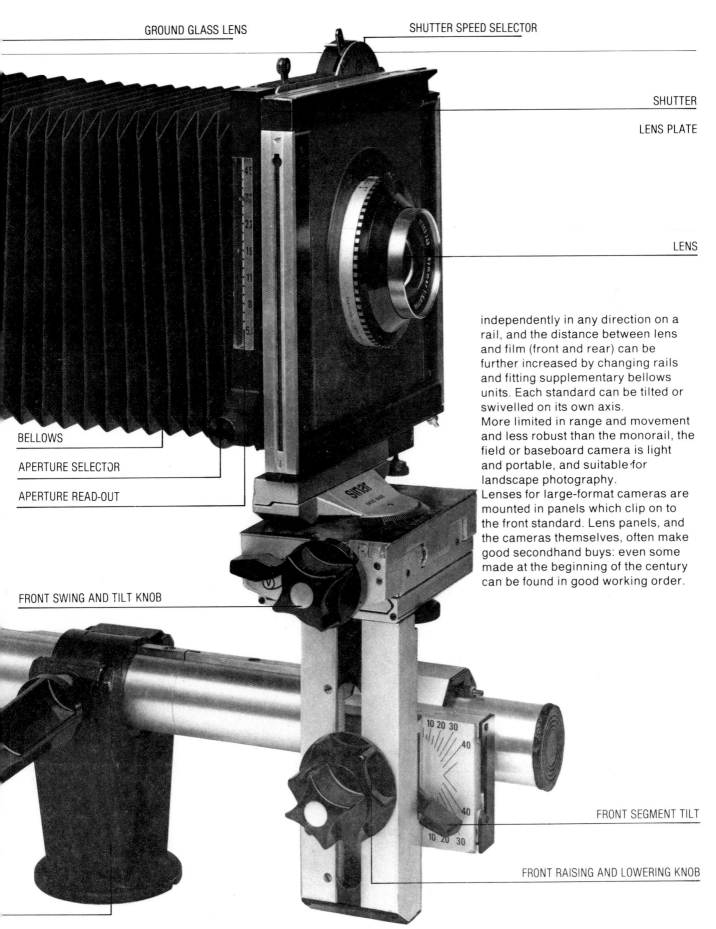

GROUND GLASS LENS

SHUTTER SPEED SELECTOR

SHUTTER

LENS PLATE

LENS

BELLOWS

APERTURE SELECTOR

APERTURE READ-OUT

FRONT SWING AND TILT KNOB

FRONT SEGMENT TILT

FRONT RAISING AND LOWERING KNOB

independently in any direction on a rail, and the distance between lens and film (front and rear) can be further increased by changing rails and fitting supplementary bellows units. Each standard can be tilted or swivelled on its own axis.

More limited in range and movement and less robust than the monorail, the field or baseboard camera is light and portable, and suitable for landscape photography.

Lenses for large-format cameras are mounted in panels which clip on to the front standard. Lens panels, and the cameras themselves, often make good secondhand buys: even some made at the beginning of the century can be found in good working order.

LENSES AND FILTERS I

The lens has to carry out the fundamental job of collecting light rays from the subject in front of the camera and projecting them as an image on to light-sensitive film at the back. The sharpness and accuracy of this image is determined by the *quality* of the lens you use, and the best lenses are made from several different kinds of special optical glasses cemented in layers to form a highly complex piece of optical machinery. The *type* of lens you choose will depend on the kind of job you want it to do. There are four basic types – standard (normal), long focus, wide angle and zoom. The difference in price between two lenses of the same type and produced to do the same job, will usually mean a difference in the 'speed' or maximum aperture of the lenses – the faster the lens the wider the range of lighting conditions it can cover.

Zoom, ultra telephoto and mirror (catadioptric) lenses can all be used to bring distance objects into close-up. A zoom has variable focal lengths (usually a range of 80mm to 200mm). Mirror lenses are more compact than conventional telephoto lenses.

Changes of focal length, distance between lens and subject, and lens aperture all affect the way in which the image is formed. To control the relative size of the subject you can either move the camera or stay where you are and change the lens, which means transferring to a different *focal length*. It is the focal length of any particular type of lens which determines the magnification of the image. The standard (normal) lens for any format camera has a focal length roughly equal to the diagonal of the film being used and will produce an image paralleling most closely normal human vision – 50mm is the standard lens for the 35mm SLR. A wide-angle lens has a shorter focal length than a standard lens, and a long-focus lens a longer focal length. As well as affecting the relative size of the image, the focal length of the lens determines the angle of view – the area it 'sees'.

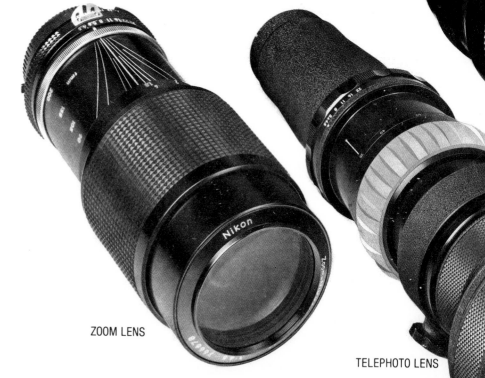

ZOOM LENS

TELEPHOTO LENS

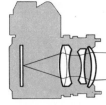

The focal length of a lens is inscribed on the film mount e.g. 50mm. This measurement is arrived at when the lens is focused on a distant object at infinity, and with maximum aperture, and the image is sharp on the film plane (below). To photograph a nearer subject and obtain a completely sharp image, the lens has to be further away from the film plane (left).

A standard lens for a 35mm camera has a focal length of about 50mm (2ins). With an angle of view at just over 45° (left), this lens can take in more of the subject than a long-focus lens, and the image is smaller because it is closer to the lens. Compare with diagram far right.

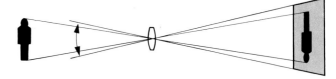

A long-focus lens for a 35mm camera has a focal length of 70mm or more, and therefore a limited angle of view. On a 100mm lens, for example, this would be 24° (above). Magnification is proportional to focal length, so an image from a 100mm lens will be twice proportionate as that from a 50mm (standard) lens.

CATADIOPTRIC
(MIRROR) LENS

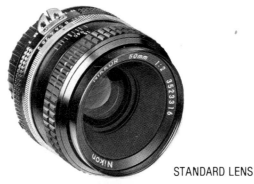

STANDARD LENS

The longer the focal length of a lens the narrower the angle of view. A 250mm lens (right) has a dramatically magnifying effect on the image, showing the subject five times larger than with a 50mm lens.

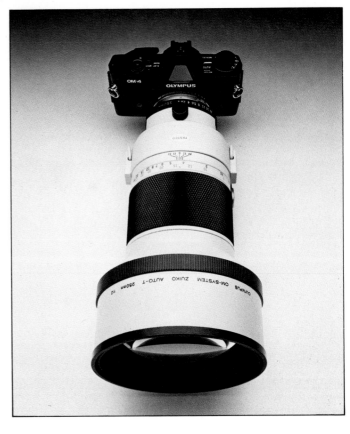

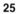

LENSES AND FILTERS 2

The focal length of a lens influences not only the size of the image and angle of view, but also affects other interrelated mechanisms – depth of field, for example, and perspective. On all cameras which are not fully automatic the aperture of the lens is governed by a control ring on the lens barrel, marked with f stops to indicate the progressive phases of the iris diaphragm. The aperture determines the amount of light transmitted from lens to film, the shutter determines the *duration* of light. On the average standard 35mm SLR lens the stops range from f/8 (maximum aperture) to f/16 or f/22 (the smallest aperture). So the lower the f stop number the larger the aperture. If you close the aperture by one stop, the amount of light is halved – you achieve the same effect if you measure the shutter speed – say, from 1/125 to 1/250th second. Conversely, a wider aperture or a slower shutter speed allows more light to pass through. The same f-stop requires a larger aperture in a long lens than in a short one because a long lens spreads its image over a larger area – it has to collect more light rays to keep the image as bright as the image that can be obtained on a shorter lens set to the same f-stop.

A 100mm lens needs an aperture double the diameter of one for a 50mm lens to cover four times the area. But the larger opening affects depth of field – the related sharpness of things in the foreground and background of the object you are focusing on. If you focus your standard lens on a nearby object, with the aperture wide open, the front of the object will be sharper than the background. As you close the aperture the overall sharpness increases. This zone of sharpness is the 'depth of field.' Wide angle lenses have a large depth of field, but the shorter the focal length, the greater the distortion at the outer limits of the image.

Long-focus lenses have shallower depth of field and a compression of perspective effect which becomes more pronounced and dramatic on the longest lenses. Fish-eye lenses have a much wider angle of view than the human eye, having a pronounced distorting effect. Zoom lenses have variable focal lengths.

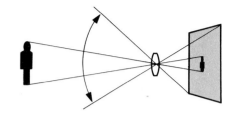

A wide-angle lens for the 35mm camera has a shorter focal length than that of a standard lens. One of the most popular is the 28mm lens which has an angle of view of 75° (above). The image of the subject is about half the size of that from a standard lens.

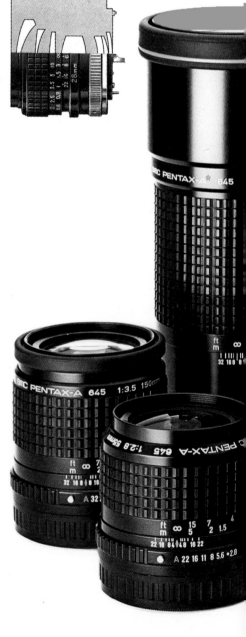

Camera shake can be a problem when using long-focus lenses – they are longer and heavier than standard or wide-angle lenses. If you don't have a tripod with you, stand up against a wall if possible, and support both the lens and the camera body with your elbow, as illustrated right.

Choice of lenses for the 35mm format is extensive – from ultra-wide to ultra-telephoto.

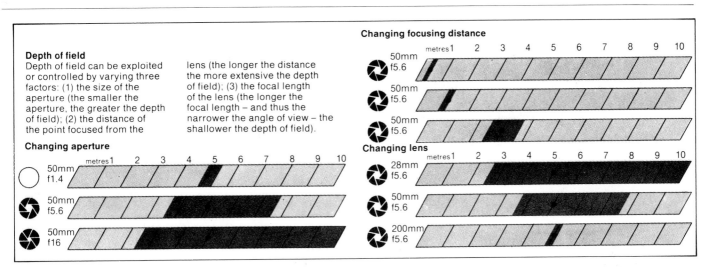

Depth of field

Depth of field can be exploited or controlled by varying three factors: (1) the size of the aperture (the smaller the aperture, the greater the depth of field); (2) the distance of the point focused from the lens (the longer the distance the more extensive the depth of field); (3) the focal length of the lens (the longer the focal length – and thus the narrower the angle of view – the shallower the depth of field).

Changing aperture

50mm f1.4
50mm f5.6
50mm f16

Changing focusing distance

50mm f5.6
50mm f5.6
50mm f5.6

Changing lens

28mm f5.6
50mm f5.6
200mm f5.6

Focal lengths and angles of view of four different lenses compared: 1. Wide-angle, 28mm. 2. Standard, 50mm. 3. Long-focus, 135mm. 4. Zoom lens: focal length can be changed to alter the scale of image.

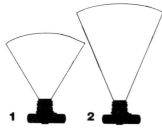

A perspective control (shift) lens is particularly useful when photographing buildings – it can be moved off its normal axis to solve the problem of converging lines.

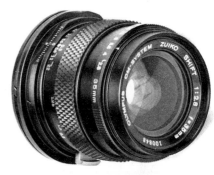

A macro lens is used for extreme close-up photography. By increasing the distance between the lens and the film with extension tubes or bellows, a shot can be taken with the front of the lens as close as possible to the subject.

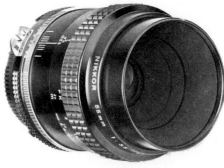

Fish-eye lenses can have angles of view as wide as 180°. They give distorted circular images, turning straight lines into concentric curves. The extreme image distortion limits their use.

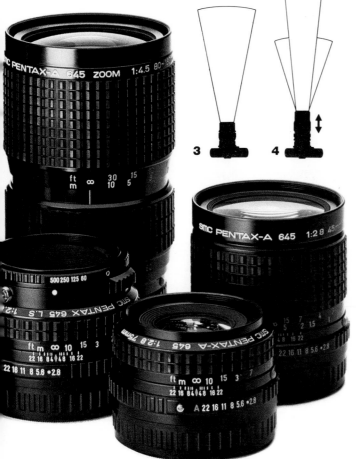

LENSES AND FILTERS 3

ANGLE OF VIEW

Choosing the right lens for the right shot . . .
The shorter the focal length of a lens, the wider
its angle of view. Focal length also affects the
relative size of the subject. Depth of field is
much greater on wide-angle lenses than on
long-focus lenses. Pictured here, the same
subject shot on a range of *Nikon* lenses from
8mm to 1200mm.

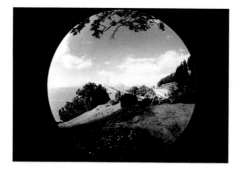

Fish-eye
8mm 180°

Ultra wide-angle
15mm 110°

Wide-angle
35mm 62°

Standard or Normal
50mm 46°

Medium telephoto
85mm 28°30′

Telephoto
135mm 18°

Telephoto
180mm 13°40′

Telephoto
200mm 12°20′

Super telephoto
600mm 4°10′

Super telephoto
800m 3°

Super telephoto
1200mm 2°

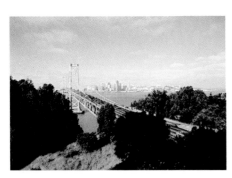

Wide-angle
24mm 84°

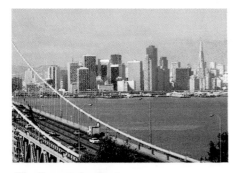

Medium telephoto
105mm 23°20′

Super telephoto
400mm 6°10′

The diagram shows how the greater the focal length of a lens, the narrower its angle of view. For a 50mm (standard) lens the minimum focusing distance may be as short as 0.45m. For a 250mm telephoto lens the minimum focusing distance may need to be as much as 6m.

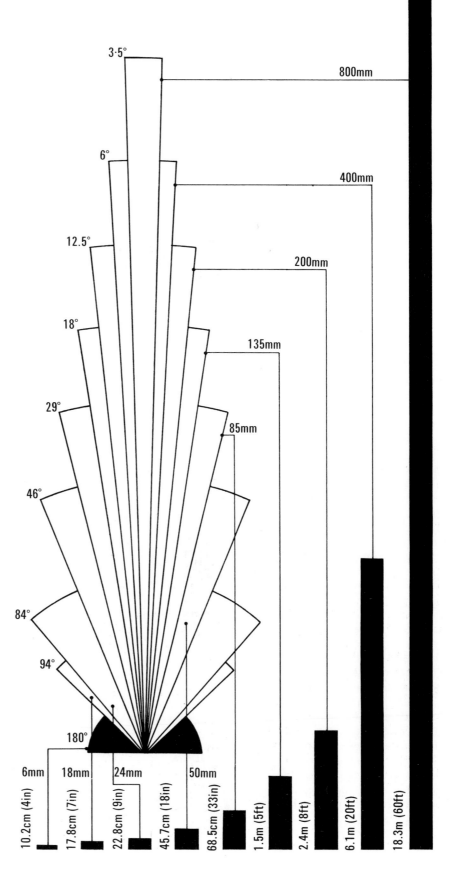

LENSES AND FILTERS 4

FILTERS FOR BLACK AND WHITE FILM

Filter	Result lighter	Result darker	Suggested uses
Yellow	Yellow; green slightly	Blue slightly	Landscapes, sports. Slightly darkens sky, grass appears lighter.
Yellow-green	Yellow and green	Blue	As above, but contrast greater; effect on grass more pronounced.
Green	Green	Red and blue	Subjects with concentrated green, which normally appear too dark.
Orange	Yellow and orange; red slightly	Blue; green slightly	Gives dark sky, accentuates clouds; brings out texture.
Red	Red	Blue and green	Produces dramatic sky, gives lighter brickwork on houses.
Blue	Blue	Red; green slightly	Emphasizes mist.
Ultraviolet	Ultraviolet eliminated		Penetrates haze. Gives clear distances.
Polarizing			Reduces reflections from non-metallic surfaces.

There are basically three main types of filters: black and white filtration; colour compensation filtration; and special effects. Filters for use in black and white photography lighten their own colour and darken the opposite colour, so that a yellow filter, for example, will enhance the contrast between a blue sky and clouds, while an orange filter will darken the sky further. A dramatic effect can be obtained with a deep red filter which reduces haze and darkens sky to almost black.

Colour compensating filters, for use only with colour reversal film, are designed to cope with variations in the colour temperature of light falling on the subject. They increase their own colour by filtering out the opposite or complementary colours. They can be used to compensate for unwanted biases in the light source, in daylight or in artificial lighting. They warm up or cool down slightly the colours present in the image, and are made in the three primary colours and three secondary colours in various strengths. In daylight certain filters can be used to reduce a bluish cast in strong sunlight or correct strong shade or to cool down pronounced reddish tones and to warm up skin tones.

Polarizing filters are extremely important: they control reflective surfaces such as glass and water; penetrate reflections on transparent materials, and darken the sky while whitening the clouds.

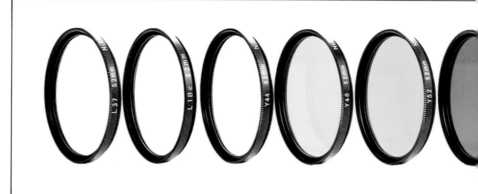

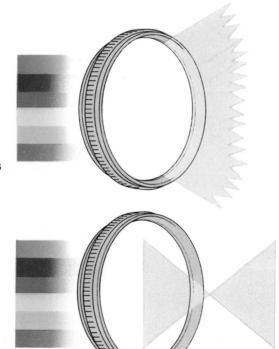

Left:
Light rays passing through a diffusion filter scatter, softening the image, making colours paler.

Right:
Coloured filters absorb and transmit light selectively to affect the tonal or colour balance of the whole image.

Left:
Refraction filters produce multiple images to blend colours.

Right
Diffraction filters produce streaks of colour by breaking up points of white light.

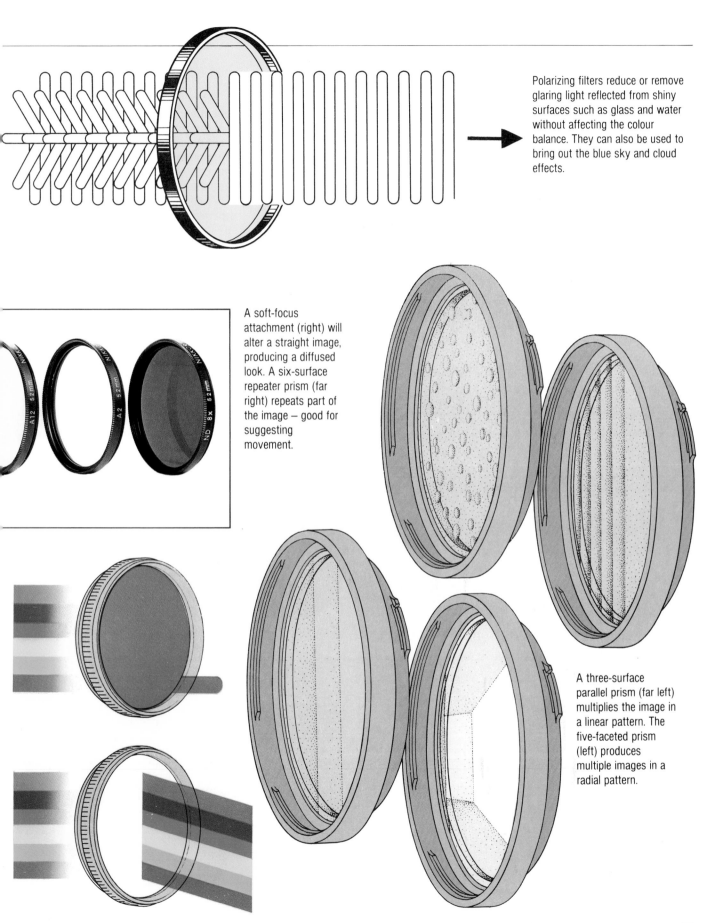

Polarizing filters reduce or remove glaring light reflected from shiny surfaces such as glass and water without affecting the colour balance. They can also be used to bring out the blue sky and cloud effects.

A soft-focus attachment (right) will alter a straight image, producing a diffused look. A six-surface repeater prism (far right) repeats part of the image – good for suggesting movement.

A three-surface parallel prism (far left) multiplies the image in a linear pattern. The five-faceted prism (left) produces multiple images in a radial pattern.

LIGHTING I

There are four major types of light source used in photography: 'available light' is the term to describe natural sources such as sunlight and artificial light sources like street lamps and domestic bulbs; while the other two types are specifically designed for photographic purposes – studio spotlights and flash lighting. The earliest photographers were only able to use available light, and that in a very restricted way, but today's fast lenses and sensitive films enable photographers to capture the natural atmosphere of available light, while artificial lighting allows for greater freedom to work in poor or unfavourable conditions to obtain pictures that would otherwise be impossible, and make the subject appear as if it had been lit naturally, or to create special effects.

and some take flashcubes which consist of a set of four flashbulbs. Electronic flash is the most economic because it can be recharged to give an almost unlimited number of flashes. Battery-operated electronic flashguns can either be mounted on the camera or on a bracket which is attached to the camera.

Flash and shutter speed must be correctly synchronized so that the flash is triggered when the shutter is fully open; because length of exposure depends on the duration of

With modern fast lenses and sensitive films you can take pictures in poor light without having to use an artifical light source, but this involves slow shutter speeds and wide apertures which will restrict freedom of control over the image. Additional lighting, either in the form of tungsten lamp or flash, can be used when available light is weak.

The most popular kind of lighting equipment is flash – either flash bulbs or electronic flash units. Many simple cameras have built-in electronic flash

Nikon Speedlight SB-15. When used with Nikon FA, FA-2 or FG, camera automatically controls flash output to set correct exposure by measuring light through the lens (TTL).

Nikonos Speedlight SB-102. Advanced underwater electronic flash for Nikonos-V amphibious camera. Auto TTL flash control sets correct exposure. Synchronizes at 1/90 sec. or slower.

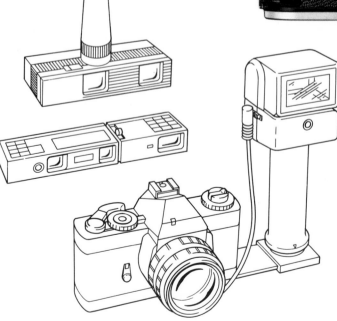

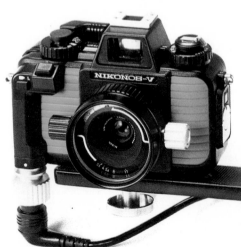

Some simple cameras have built-in electronic flash; others, flashcubes mounted on a short arm. Battery-operated electronic flash guns can be mounted on a camera or on a bracket, as left.

the flash and not on the shutter speed. Synchronization is made through a special contact on the camera, either a socket in which the flash lead is plugged, or part of the shoe which holds the flashgun. Camera dedicated flash units are available for attachment to 35mm SLRs, using through-the-lens (TTL)

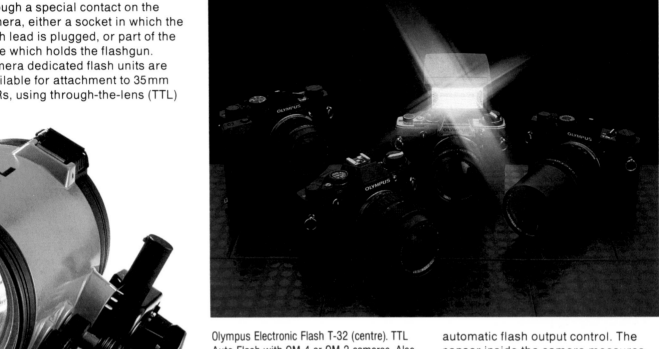

Olympus Electronic Flash T-32 (centre). TTL Auto Flash with OM-4 or OM-2 cameras. Also has 3 normal Auto and 2 Manual settings.

automatic flash output control. The sensor inside the camera measures the flash unit's light through the lens and the camera automatically controls flash output for the correct exposure, whatever the angle of the flash and whatever aperture the lens is set at.

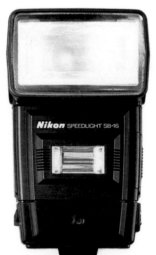

Nikon Speedlight SB-16. Compatible with all SLR Nikons. Automatic TTL flash control for correct exposure. Tilting/Rotating head to bounce flash or to match the picture angle of the lens in use.

Capacitor flashgun builds up a charge of electricity to fire a flash bulb.

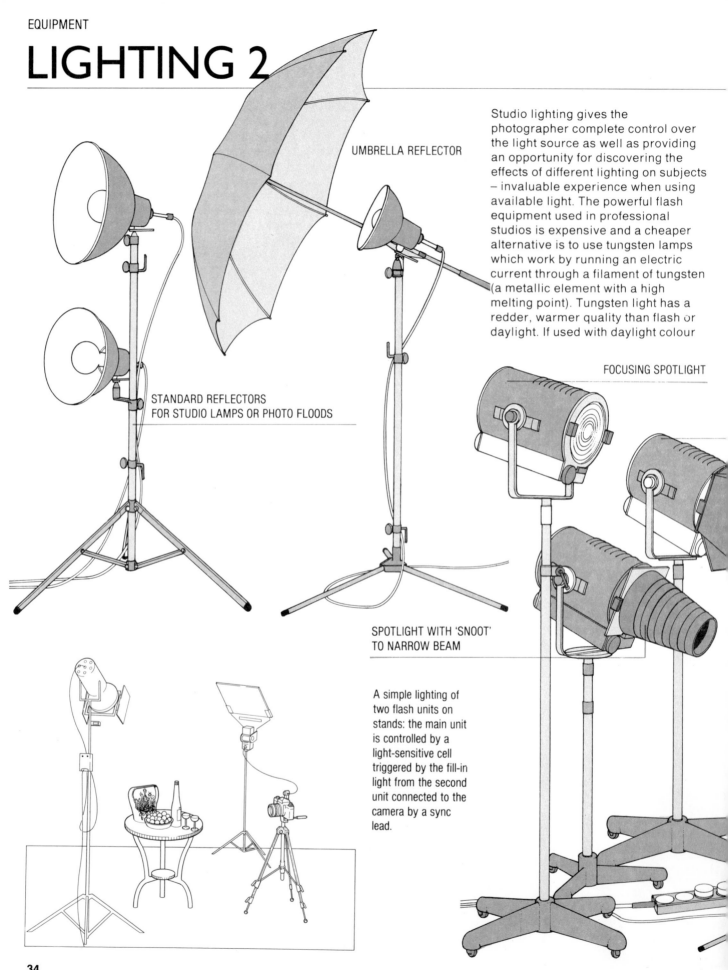

LIGHTING 2

UMBRELLA REFLECTOR

Studio lighting gives the photographer complete control over the light source as well as providing an opportunity for discovering the effects of different lighting on subjects – invaluable experience when using available light. The powerful flash equipment used in professional studios is expensive and a cheaper alternative is to use tungsten lamps which work by running an electric current through a filament of tungsten (a metallic element with a high melting point). Tungsten light has a redder, warmer quality than flash or daylight. If used with daylight colour

STANDARD REFLECTORS
FOR STUDIO LAMPS OR PHOTO FLOODS

FOCUSING SPOTLIGHT

SPOTLIGHT WITH 'SNOOT'
TO NARROW BEAM

A simple lighting of two flash units on stands: the main unit is controlled by a light-sensitive cell triggered by the fill-in light from the second unit connected to the camera by a sync lead.

film, the colour temperatures must be balanced with correction filters. Photofloods produce an intense light for two or ten hours depending on the type. Studio lamps have a longer life than photofloods and can last for about 100 hours, but they are much more expensive. The tungsten-halogen lamp provides a continuous, high-intensity light for about 50 hours and is ideal for colour photography.

The light from photofloods and studio lamps can only be controlled by reflectors. The larger and the more shallow the reflector, the greater will be the area covered by the lamp, and the more diffuse the light. The deeper the reflector the narrower the angle of reflection and the more intense the light. The distance between the lamp and subject will also affect the intensity of the light and area it covers. Floodlights give a general light over a large area, while spotlights produce narrow, sharp, intense beams of light.

A professional studio will invariably use a lighting set-up based on electronic flash. Window or bank lights give a broader coverage than single lights, but because they are

CLAMP-ON
FLOODLIGHT

diffused give a softer shadow; though diffusers, made of heat-resistant glass or plastic, can also be placed in front of single lights to soften them. For all-purpose work, a reflector shaped like a bowl, is ideal.

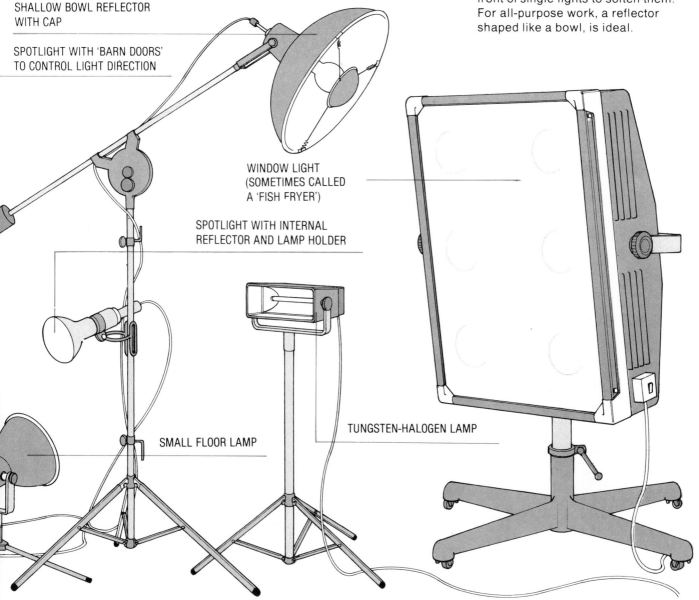

SHALLOW BOWL REFLECTOR
WITH CAP

SPOTLIGHT WITH 'BARN DOORS'
TO CONTROL LIGHT DIRECTION

WINDOW LIGHT
(SOMETIMES CALLED
A 'FISH FRYER')

SPOTLIGHT WITH INTERNAL
REFLECTOR AND LAMP HOLDER

SMALL FLOOR LAMP

TUNGSTEN-HALOGEN LAMP

FILM

There are two types of film available: negative film from which an unlimited number of prints can be made for direct viewing; and reversal or transparency film for viewing when projected onto a screen. When buying film, it is worth checking if the price includes processing.

Most cameras are designed to take film of a specific format – 35mm, for example – which mainly determines the camera's size and shape. The *type* of film you choose will depend on whether you want to shoot in black and white, or in colour for slides or prints. Colour negative film makes prints, while colour reversal film gives colour transparencies or slides. Colour slide films are balanced for exposure in average daylight, or with flash, but there is also film (Type B) specifically for use with artificial (tungsten) light.

Your choice of film's *speed* (degree of sensitivity to light) is governed by the subject and the potential light source.

Slow speed colour films give rich colour, evenness of tone, and fine detail; fast films enable you to take pictures in weak light, but detail is coarser (grainier), colour saturation reduced and contrast between tone is more evident. Medium speed films are a compromise between the two extremes. Speed is rated by numbers – the higher the number the faster the film. The different speed ratings of films are measured in ASA or DIN, which are gradually being replaced by ISO, a universally accepted set of film speed standards. So that a film rated at ASA 200/24 DIN becomes ISO 200/24°. A film rated at ISO 200 is twice as fast as ISO 100 and therefore requires half as much exposure in the same lighting conditions. The DIN rating doubles the speed by adding a numerical factor of 3, so that DIN 24 is twice as fast as DIN 21.

Choose a medium-speed film for average conditions (ISO 64 to ISO 100) such as landscape or nature shots in bright sunshine or in shade, or flash. Slow-speed films (ISO 25) are suitable for portraits and still life in average lighting conditions; fast films (ISO 200) are suitable for a wide range of subjects and conditions, but particularly for close up and action shots when you may need fast shutter speeds – 1/500 sec. Ultra fast (ISO 400 to ISO 1000) might be used for action and reportage photography in poor lighting conditions.

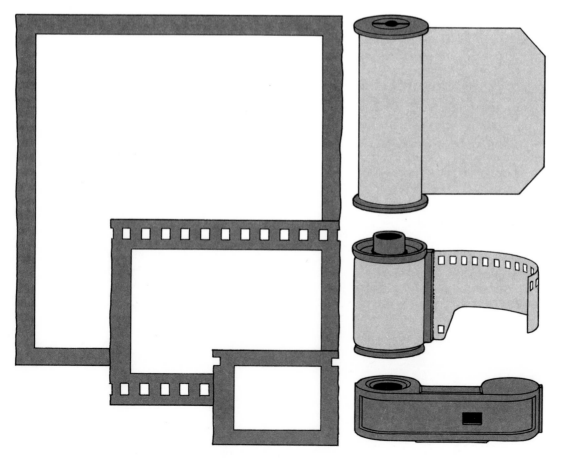

Standard film sizes are packaged in different ways: 120 and 220 in rollfilm; 35mm in cassettes; and 110 in cartridges. A 120 roll gives 12 exposures; a 220 roll gives 24, both producing image sizes of 6 × 6cm ($2\frac{1}{4}$ × $2\frac{1}{4}$ ins). A 120 roll for a 6 × 4.5 cm format gives 15 exposures 35mm cassette film produces a picture 24 × 36mm and is available in 20, 24, and 36 exposures. These have to be rewound before opening the camera. Drop-in cartridges of 110 film, in 12 or 20 exposures, producing pictures 13 × 17mm, are easiest for loading and unloading.

DAYLIGHT EXPOSURE GUIDE

Film speed (ASA)	Sunny	Partly cloudy/ Hazy sun	Hazy/bright (indistinct shadows)	Dull (no shadows)
		(+1)	(+2)	(+1)
25	1/30, f 16 1/60, f 11 1/125, f 8	1/30, f 11 1/60, f 8 1/125, f 5.6	1/30, f 5.6 1/60, f 4 1/125. f 2.8	1/30, f 4 1/60, f 2.8 1/125, f 2
50-64	1/60, f 16 1/125, f 11 1/250, f 8	1/60, f 11 1/125, f 8 1/250, f 5.6	1/60, f 5.6 1/125, f 4 1/250, f 2.8	1/60, f 4 1/125, f 2.8 1/250, f 2
100-125	1/125, f 16 1/250, f 11 1/500, f 8	1/125, f 11 1/250, f 8 1/500, f 5.6	1/125, f 5.6 1/250, f 4 1/500, f 2.8	1/125, f 4 1/250, f 2.8 1/500, f 2
160	1/125, f 16-f 22 1/250, f 11-f 16 1/500, f 8-f 11	1/125, f 11-f 16 1/250, f 8-f 11 1/500, f 5.6-f 8	1/125, f 5.6-f 8 1/250, f 4-f 5.6 1/500, f 2.8-f 4	1/125, f 4-f 5.6 1/250, f 2.8-f 4 1/500, f 2-f 2.8
200	1/125, f 16 1/250, f 11 1/500, f 8	1/250, f 11 1/500, f 8 1/1000, f 5.6	1/250, f 5.6 1/500, f 4 1/1000, f 2.8	1/250, f 4 1/500, f 2.8 1/1000, f 2
400	1/250, f 22 1/500, f 16 1/1000, f 11	1/250, f 16 1/500, f 11 1/1000, f 8	1/250, f 8 1/500, f 5.6 1/1000, f 4	1/250, f 5.6 1/500, f 4 1/1000, f 2.8
1000	1/1000, f 16-f 22	1/250, f 11-f 16 1/500, f 16-f 22 1/1000, f 11-f 16	1/250, f 8-f 11 1/500, f 8-f 11 1/1000, f 5.6-f 8	1/250, f 8-f 11 1/500, f 5.6-f 8 1/1000, f 4-f 5.6

If using negative films the general rule is to err on the side of overexposure rather than underexposure because detail can be 'burnt-in' during the printing stage. On transparency film, exposure will be more critical, because with this type of film a positive image is produced on the film itself during processing, and there is virtually no way of correcting any error.

As a guide to automatic exposure reckoning, in bright sun, it is generally best to shoot at f-16 at the shutter speed which is the reciprocal of the film speed: with the ISO 100 film, for example, use f-16 at 1/125; with ISO 400 film, use f-16 at 1/500. Each full f-stop represents a doubling of the size of the aperture – and therefore double the amount of light falling on the film; but if you double the shutter speed, from 1/125 to 1/250 for example you halve the length of time that volume of light is allowed to pass through the aperture. In terms of the amount of light reaching the film, then, f-11 at 1/125 is equivalent to f-8 at 1/250. This is what is referred to as an 'equivalent exposure'.

With automatic metering, readings may be falsified by conditions of extreme brightness – on a beach or on snow – so the subject should be given the equivalent of one f-stop more exposure (the next slower shutter speed or the next larger f-stop) because the meter will indicate reduced exposure to cope with the extra light. The equivalent of one or two f-stops more exposure should be given when photographing a dark subject in poor lighting.

NIGHT EXPOSURE GUIDE (at ISO 100)

Subject	f 4	f 5.6	f 8	f 11
Bonfire/fireworks	1/15	1/8	1/4	1/2
Well-lit shop windows	1/30	1/15	1/8	1/4
Well-lit streets	1/4	1/2	1	2
Flood-lit monuments	1	2	4	8
Full-moon landscape	1 min	2 min	4 min	8 min
Well-lit store interiors	1/15	1/8	1/4	1/2
Well-lit stage	1/30	1/15	1/8	1/4
Average home lighting (close to subject)	1/4	1/2	1	2

Modern fast lenses and fast film speeds enable the photographer to achieve good results when shooting in conditions that would normally require artificial lighting equipment, and allow for creating the kind of natural atmosphere which the use of flash would kill. If shooting at night, it is best to make the most of dusk when available light will be able to provide for some fill-in detail: the exposure times listed above may then be halved. Longer exposures are necessary as the light level decreases, which means the use of a tripod or some kind of camera support with a cable release to cope with the problem of camera shake and blurred images being recorded on the film. You can sometimes reduce exposure time so that a tripod and cable release are not required, by using a faster film and a wider aperture. To make sure you get the picture you want in this situation, it is usually necessary to take a second picture, giving it half the recommended exposure, then a third picture giving it twice the exposure – a process called bracketing. In very long exposures in dim light (or extremely short exposures under bright light) films may appear underexposed and colour balance altered. This is known as reciprocity failure – the reciprocal relationship between light intensity and exposure does not apply. With exposures longer than about 1 sec the reciprocity factor is important: closing the lens aperture by one stop does not necessarily require twice the exposure time, but usually a bit more. To be on the safe side, take one picture with a few extra seconds exposure time, then bracket exposure around this assumed exposure time if you can.

Black and white films and colour reversal films allow for uprating or pushing the film.

ISO 400 film for example, can be exposed as if it were ISO 800. During printing, adjustments can be made to compensate for this one-stop underexposure but grainy effects will result.

STORAGE AND MOUNTING

A mounting and storage system for negatives, prints and slides is essential for minimizing the risk of deterioration from heat, damp or fumes – and for being able to lay your hands on a particular picture at a moment's notice. Various types of boxes, files and drawers are available for storage of negatives and transparencies and choice will depend on size, function and cost. Whatever the system, a strict method of classification is vital as films start to accumulate.

Negatives are extremely susceptible to dust and scratches must be stored carefully. They are best cut into strips and protected by sleeves or special envelopes made of transparent or translucent material and then secured in vinyl binders. Complete rolls of film or negatives of the same subject can be put on one page

GREASEPROOF PAPER ENVELOPES

ACETATE SLEEVES

BINDER SLEEVES

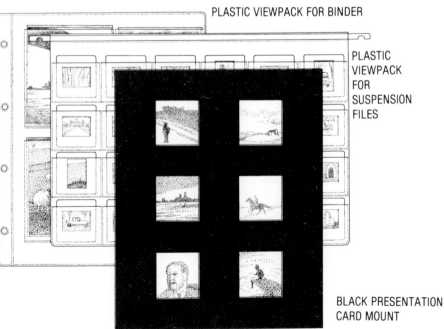

PLASTIC VIEWPACK FOR BINDER

PLASTIC VIEWPACK FOR SUSPENSION FILES

BLACK PRESENTATION CARD MOUNT

in special ring binders and a contact sheet made and filed with it: record exposure date and any technical data and give it a reference number.

Transparencies are highly susceptible to moisture and must be kept dry and cool. They are adequately protected by being cut into strips and put into acetate sleeves, or into card or plastic mounts. Alternatively, ready-mounted transparencies can be kept in the plastic containers processors return them in. If you wish to keep the slides in correct order, draw a diagonal line across the top of the mounts, so that you see immediately if you have returned one out of order. Slides may also be put into numbered slots in special boxes or cases – an index card in the lid provides space for recording data. Binders are available with plastic sleeves for storage of mounted slides, similar to those used for storing negatives. If you are planning to store negatives or transparencies in a damp garage or attic it is advisable to buy special sealed containers available from photographic suppliers.

For presentation purposes an artist's portfolio case is an excellent, though expensive, choice. Prints and transparencies can be viewed together in binder sleeves. Plastic viewpacks allow for viewing several slides at a time and can be kept in a filing cabinet. Matt black presentation card mounts give a particularly professional look to a display of transparencies.

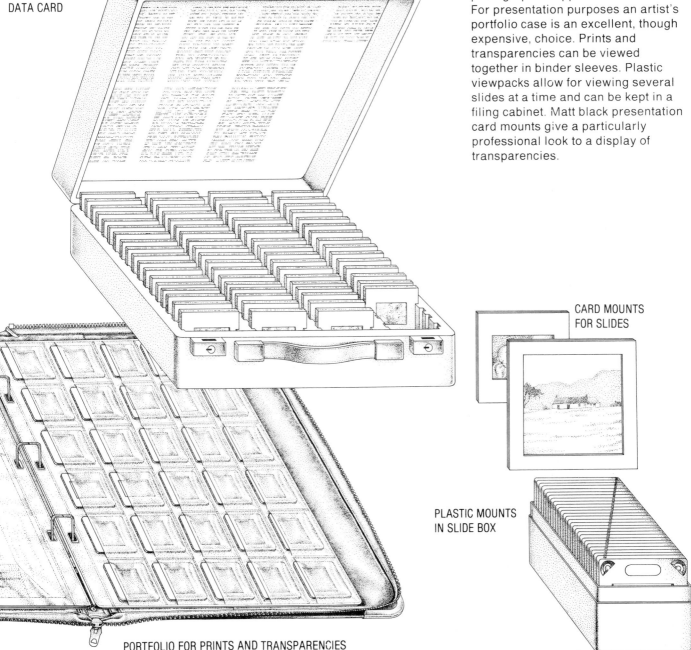

FILING CASE WITH DATA CARD

CARD MOUNTS FOR SLIDES

PLASTIC MOUNTS IN SLIDE BOX

PORTFOLIO FOR PRINTS AND TRANSPARENCIES

PROJECTORS

Equipment for viewing and presenting colour slides ranges from a simple hand viewer which holds individual slides against a luminous background behind a magnifying glass to a sophisticated audio-visual set-up of several carousel projectors with slide and sound synchronization. However simple or complex the system, it is your judgement when it comes to editing transparencies that really determines how good or bad your slide shows will be.

First rule when planning any slide show is: be ruthless when selecting transparencies for presentation. Apart from saving your audience from the boredom of looking at a monotonous barrage of almost identical pictures, the editing process teaches the photographer valuable lessons in picture-taking. Forced to choose one from several slides taken from the same or similar viewpoint, you learn a lot about your own and your camera's picture-taking capabilities. Plan the sequence of

slides carefully: balance distance views with close-ups and mid-distance shots so that the effect of a well-directed and sharply-edited movie film is achieved. A light-box on which several slides can be viewed side by side, is invaluable for editing, and when the best have been

selected they can be tried out in various sequences in the projector. A projection screen will give the best surface on which to project the slides, and before the show starts make sure that projector and screen are set up at the right distance, the magazine loaded carefully (with slides the right way up!), and a spare projector lamp and fuse are handy. It really does pay off to have a trial run-through.

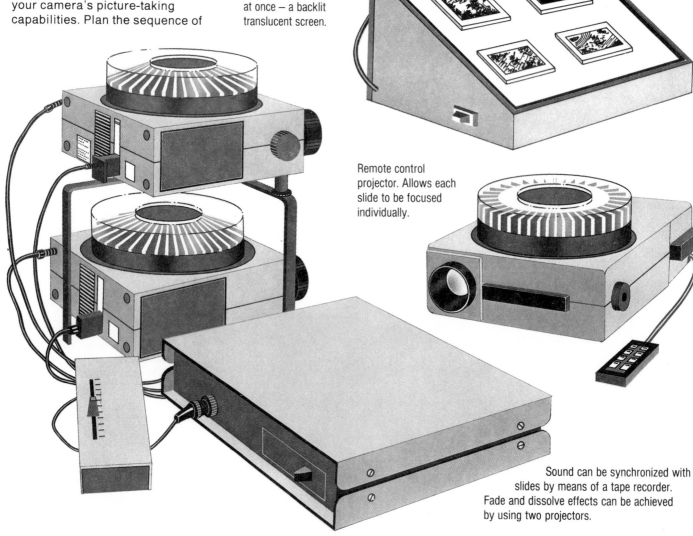

Light box. To view and edit several slides at once – a backlit translucent screen.

Remote control projector. Allows each slide to be focused individually.

Sound can be synchronized with slides by means of a tape recorder. Fade and dissolve effects can be achieved by using two projectors.

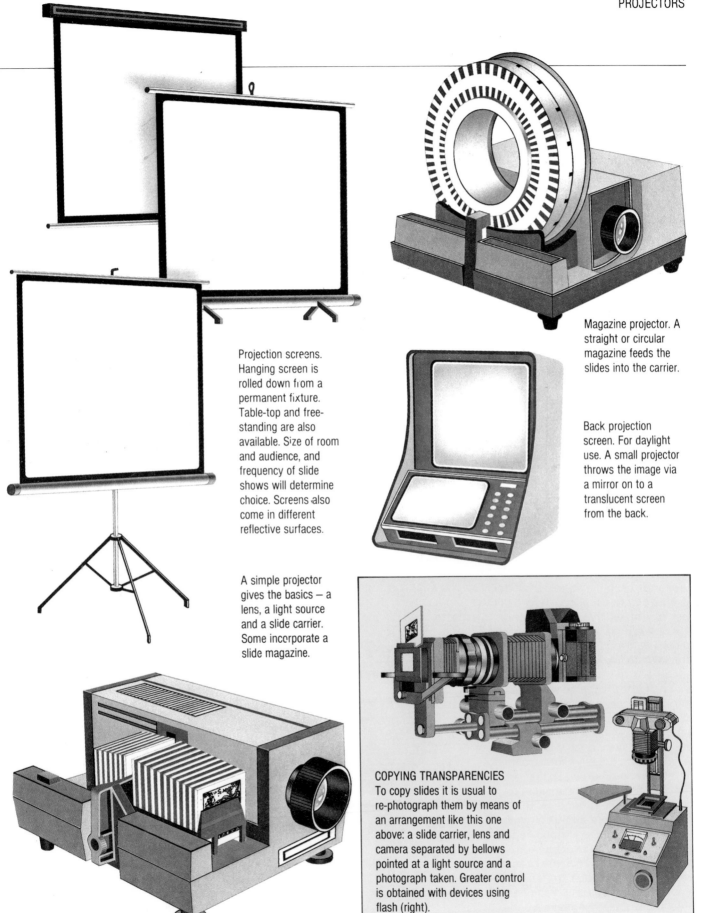

Projection screens. Hanging screen is rolled down from a permanent fixture. Table-top and free-standing are also available. Size of room and audience, and frequency of slide shows will determine choice. Screens also come in different reflective surfaces.

A simple projector gives the basics — a lens, a light source and a slide carrier. Some incorporate a slide magazine.

Magazine projector. A straight or circular magazine feeds the slides into the carrier.

Back projection screen. For daylight use. A small projector throws the image via a mirror on to a translucent screen from the back.

COPYING TRANSPARENCIES
To copy slides it is usual to re-photograph them by means of an arrangement like this one above: a slide carrier, lens and camera separated by bellows pointed at a light source and a photograph taken. Greater control is obtained with devices using flash (right).

ACCESSORIES I

The range of accessories for cameras is vast, so a well-planned, versatile camera kit geared to your own individual needs for the kind of photography which interests you needs careful thought. Too many extras will simply lead to missed shot opportunities, and with cost a major consideration, it makes sense to decide on essentials first like a protective case and a camera support.

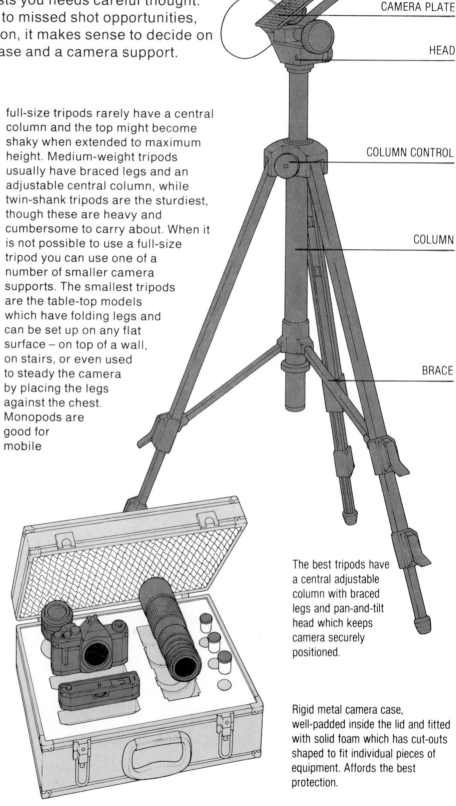

CAMERA PLATE

HEAD

COLUMN CONTROL

COLUMN

BRACE

Bags and cases. Expensive precision instruments need to be carefully protected – a good camera case or bag is essential. Metal cases provide the best protection for carrying equipment in all weathers and can be fitted either with partitions or solid foam cut into the various shapes required for each piece of equipment. Soft bags are much more expensive than ordinary hiker's carry-alls but with their strong base and waterproof canvas, they do a much better job of protecting equipment. Good for outdoor and on-the-move work, they are available in various sizes. Make sure there is a grab handle as well as shoulder strap – which must be non-slip.

Traditional leather 'box' type case is usually fitted with in-built partitions which can be rearranged to suit individual requirements.

Tripods. Some form of camera support is essential for slow shutter speeds or when the focal length of the lens increases. Even in situations where it is possible to hand hold a camera, a tripod will give extra precision in composition and will enable you to set up a shot while waiting for the right moment to shoot. A tripod will be indispensable if you plan to use long-focus lenses. Make sure you test before you buy. The best ones have a central column which can be adjusted for height and which can be reversed so that you can attach the camera upside down very close to the ground. Heads should have a pan-and-tilt movement. It is essential to use a tripod head that gives good control over camera position. Mount the heaviest camera and longest lens you can – check the stability of the legs and of the head. If anything wobbles or shakes, don't waste your money. The lightest

full-size tripods rarely have a central column and the top might become shaky when extended to maximum height. Medium-weight tripods usually have braced legs and an adjustable central column, while twin-shank tripods are the sturdiest, though these are heavy and cumbersome to carry about. When it is not possible to use a full-size tripod you can use one of a number of smaller camera supports. The smallest tripods are the table-top models which have folding legs and can be set up on any flat surface – on top of a wall, on stairs, or even used to steady the camera by placing the legs against the chest. Monopods are good for mobile

The best tripods have a central adjustable column with braced legs and pan-and-tilt head which keeps camera securely positioned.

Rigid metal camera case, well-padded inside the lid and fitted with solid foam which has cut-outs shaped to fit individual pieces of equipment. Affords the best protection.

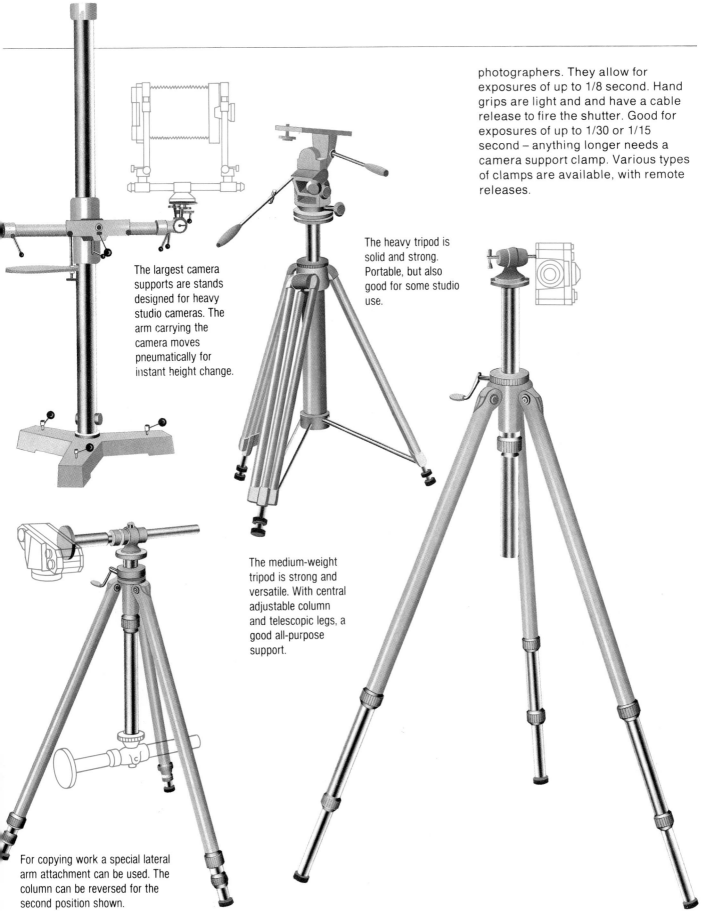

The largest camera supports are stands designed for heavy studio cameras. The arm carrying the camera moves pneumatically for instant height change.

The heavy tripod is solid and strong. Portable, but also good for some studio use.

photographers. They allow for exposures of up to 1/8 second. Hand grips are light and and have a cable release to fire the shutter. Good for exposures of up to 1/30 or 1/15 second – anything longer needs a camera support clamp. Various types of clamps are available, with remote releases.

The medium-weight tripod is strong and versatile. With central adjustable column and telescopic legs, a good all-purpose support.

For copying work a special lateral arm attachment can be used. The column can be reversed for the second position shown.

ACCESSORIES 2

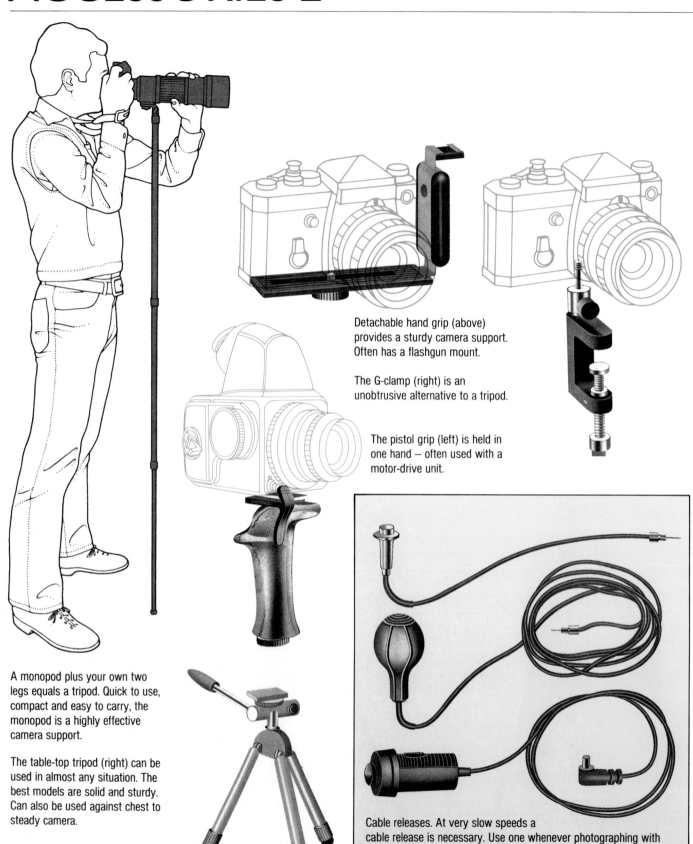

Detachable hand grip (above) provides a sturdy camera support. Often has a flashgun mount.

The G-clamp (right) is an unobtrusive alternative to a tripod.

The pistol grip (left) is held in one hand — often used with a motor-drive unit.

A monopod plus your own two legs equals a tripod. Quick to use, compact and easy to carry, the monopod is a highly effective camera support.

The table-top tripod (right) can be used in almost any situation. The best models are solid and sturdy. Can also be used against chest to steady camera.

Cable releases. At very slow speeds a cable release is necessary. Use one whenever photographing with a tripod to eliminate camera shake.

HAND HOLDING THE CAMERA

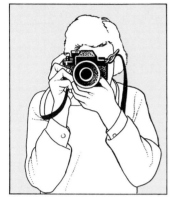

Normal hand-hold position: the left hand supports the weight from beneath while being in position to adjust focus and aperture controls.

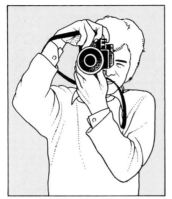

To minimize the risk of camera shake when pressing the shutter release for a vertical shot, support camera with left hand as pictured.

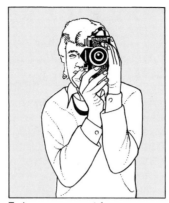

To increase support from underneath a long-focus lens, elbows can be held close to the body, in this position.

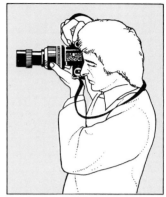

Using a long-focus lens without tripod, greater care to support weight from beneath is needed and fast shutter speed selected.

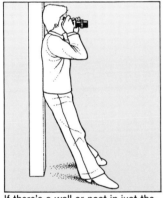

If there's a wall or post in just the right position to support you — use it. Keep back straight, feet firmly planted, and you become the camera's tripod.

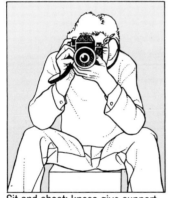

Sit and shoot: knees give support to both elbows in this position for low-angle shots. A rigid metal case is perfect for this purpose.

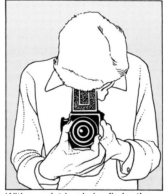

With a waist-level viewfinder the camera can be pressed against chest or stomach. The weight is supported by the left hand and pressed against chest or stomach.

For extra stability on a waist-level viewfinder pull the strap taut and hold camera firmly against stomach and keep steady.

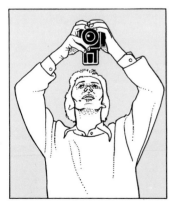

To focus over the heads of crowds, adopt this position and keep hands as steady as possible. High-angle viewpoints can be dramatic.

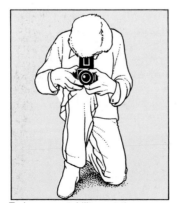

To improve stability rest the camera on your knee. Good for low-angle shots and particularly effective photographing children.

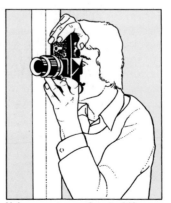

Using exposures of up to 1/4 or 1/2 second becomes a possibility with a hand-held camera if you press firmly against a doorway or post to steady the camera.

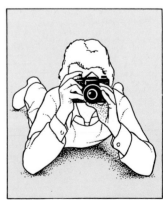

To shoot from a very low viewpoint lay on the ground, using elbows as support for the camera and the normal hand positions. It's effective — and comfortable.

MARTYN ADELMAN

Born in London in 1947, Martyn Adelman was surrounded by images from an early age, as most of his family were involved in the art world. His most vivid schoolday recollections are of avoiding academic subjects so that he could take extra lessons in art and technical drawing. He went on to study graphics and typographical design at the Watford College of Technology and later at the London College of Printing. In London he eventually joined a rock band, and spent two years touring as a drummer.

He returned to graphics after becoming disillusioned with the music business, but several design jobs later began to look for a medium that would give more immediate results. Photography seemed to answer this requirement. So Adelman left London to work for his uncle, a commercial photographer in New York: "it was an enlightening experience to work with tough New Yorkers and it taught me a great deal about coping with clients." Six months after returning to London he began a spell as photographic assistant to Don Silverstein, travelling all over Europe, with a four-month assignment in Africa. In the mid-1970s he set up a studio of his own and began working for magazines, doing mostly still life work. He now specializes in landscape and portraiture.

One of Adelman's key talents is his ability to find ways of transfiguring the ordinary — often by including some incongruous element or by photographing in evening sunlight, when raking shadows crisply define details of landscapes and urban views. Many of his pictures are still, serene tableaux, with a touch of the surreal. Typically, compositions are full of tension, drama or a sense of precarious balance. Lenses range from 18mm and 24mm for striking manipulations of scale and perspective, to his favourite 105mm telephoto. In his black-and-white studio portraits, settings and compositions are kept simple, but often with unconventional poses that challenge the viewer's preconceptions.

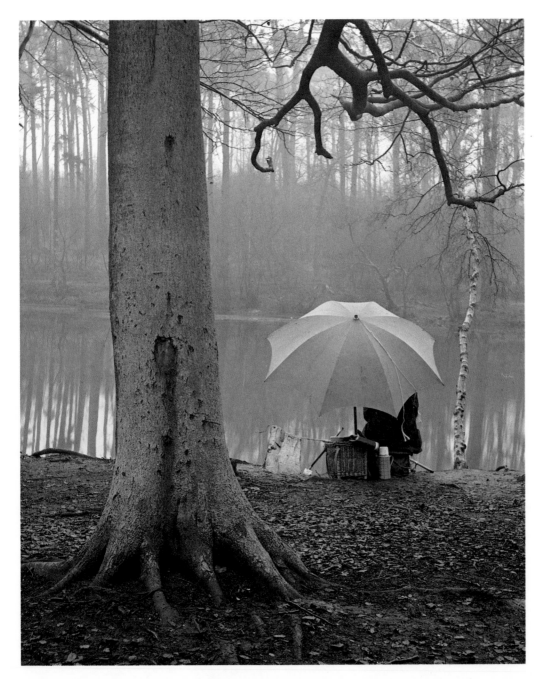

A sensitive approach to colour can make a photograph elusively evocative, like a phrase of music. In this lakeside scene by Adelman, a veil of morning mist softens an already limited palette of colours to yield an image steeped in tranquillity. The blue thermos flask serves as a compositional focus, discreet enough not to disturb the picture's balance — imagine how different the effect would be if the flask were yellow! Notice the intensity of detail in the picture, inviting the eye to scan back and forth, relishing the subtleties of texture and detail. Adelman achieved this richness by using slow 5 × 4 inch slide film (Ektachrome 64). The camera was something of an antique — a modified Pony Premo No. 6, made c. 1912. Adelman enjoys handling vintage cameras and finds that their technical limitations impose a disciplined approach that often has creative rewards.

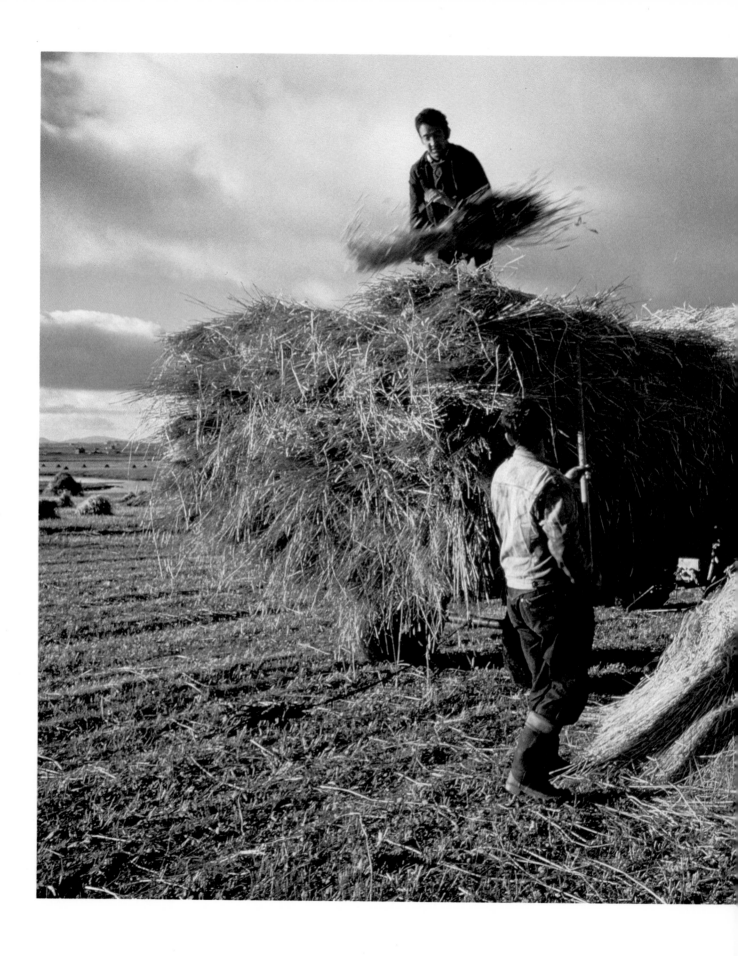

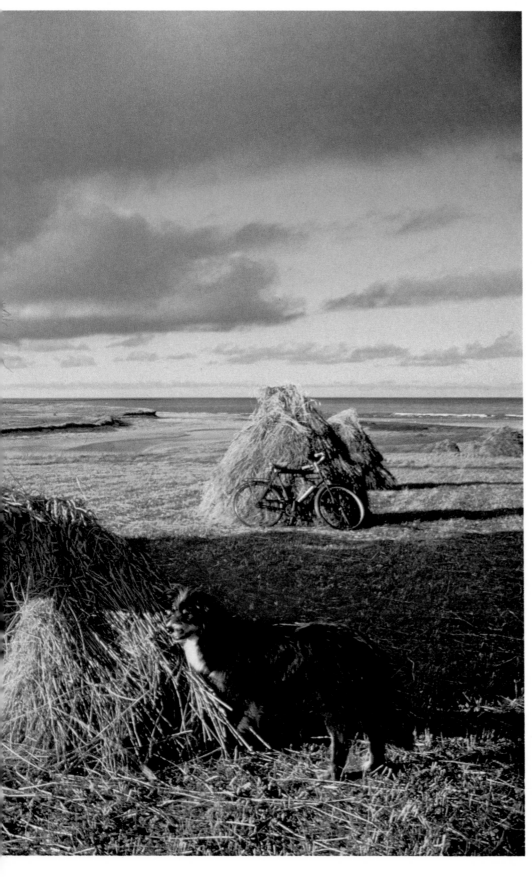

The magic light of summer evenings suffuses landscapes with a golden romantic glow. Add to this a theme of traditional rural toil and the result is unashamed nostalgia. Adelman captured this scene on a photo trip to the Outer Hebrides, whose exhilarating open spaces are suitably conveyed with a 24mm lens on his Nikon F2 body. Although apparently spontaneous, the image in fact depends on a slight touch of artifice: to help balance the composition and strengthen the sense of depth, the photographer moved the bicycle to a strategic point. A shutter speed of 1/60 was just slow enough to blur the forkload of hay – a nicely judged decision that adds zest to the picture.

It takes skill and experience to pull a great picture out of a humble street scene. In this shot the vital ingredient was raking early-morning sunlight, which backlit the boy and gave crisp definition to the architectural features of the terrace and to the cobblestones. Additionally, Adelman has exploited an old compositional trick here – the use of diagonals in a picture to emphasize a sense of movement. Placing the cyclist right at the edge of the frame further reinforced the dynamic feel. The exposure setting – 1/30 at f/5.6 on Kodachrome 25 film – was pure guesswork, as there was no time to take a meter reading. A 105mm lens, used with a lens hood to prevent flare, gave adequate depth of field even at this wide aperture.

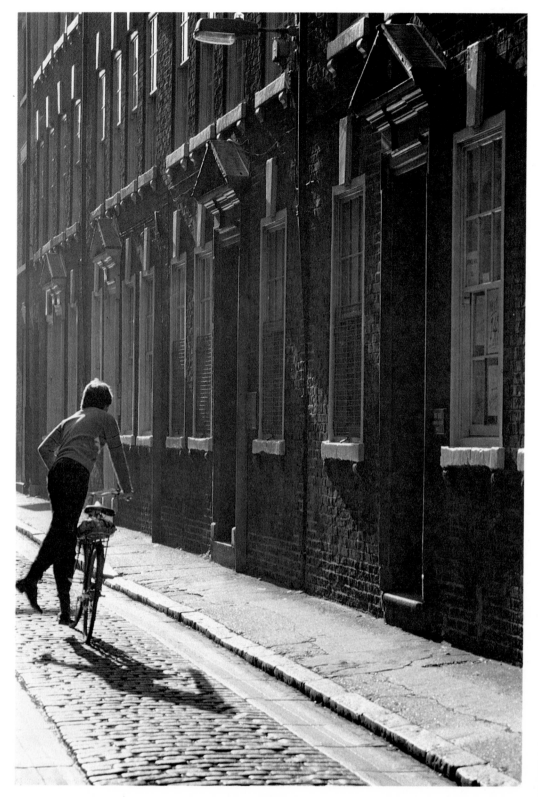

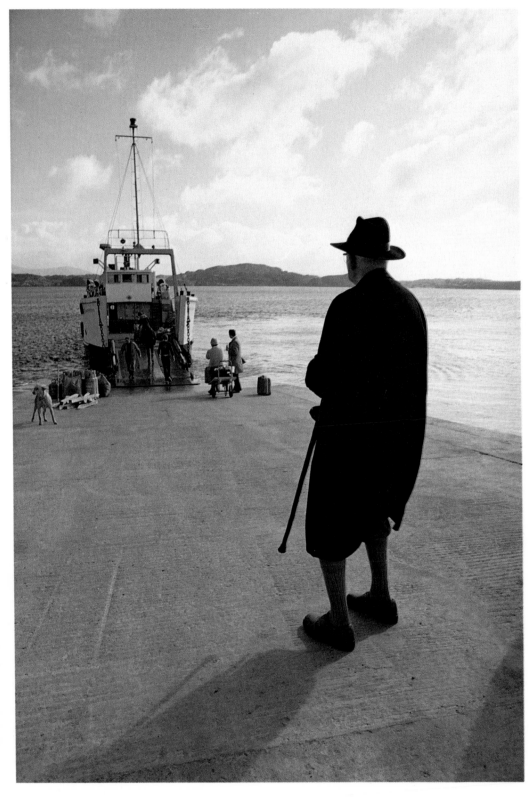

Another candid picture taken from behind the subject – but whereas the cyclist image opposite is charged with movement, this one of a priest watching the last passengers boarding a Hebridean ferry boat has an impressive stillness about it. Heaven-sent moments such as this are usually fleeting, and the photographer has to rely on the speed of his reactions. Here, Adelman's procedure was exemplary – first two or three quick grab shots in case the opportunity would not recur, then some additional shots taken with more regard for composition. This was the third exposure. Luckily, Adelman already had his 24mm lens fitted to his Nikon. By shrinking the boat in relation to the bold black shape of the priest, the lens subdued all the distracting details of the embarkation, thus simplifying the composition.

Patterns based on the repetition of identical shapes have become something of a photographic cliché: perhaps the classic example is a close-up of a stack of logs viewed from one end so that the picture frame is filled with circles. In the extraordinary photograph illustrated here, Adelman breathes vigorous new life into this familiar idea. The scene is an oil refinery in Nigeria, the subject a collection of oil drums in the midst of which stands a manicured ornamental tree. The impact of the picture comes from the carefully symmetrical framing and from the bizarre juxtaposition of subject matter. So peculiar is the tree that it looks at first sight like a strange furry animal, laid out along the row of drums. Using an 85mm lens, Adelman left the rear stack of oil drums slightly blurred to prevent the picture from looking too flat.

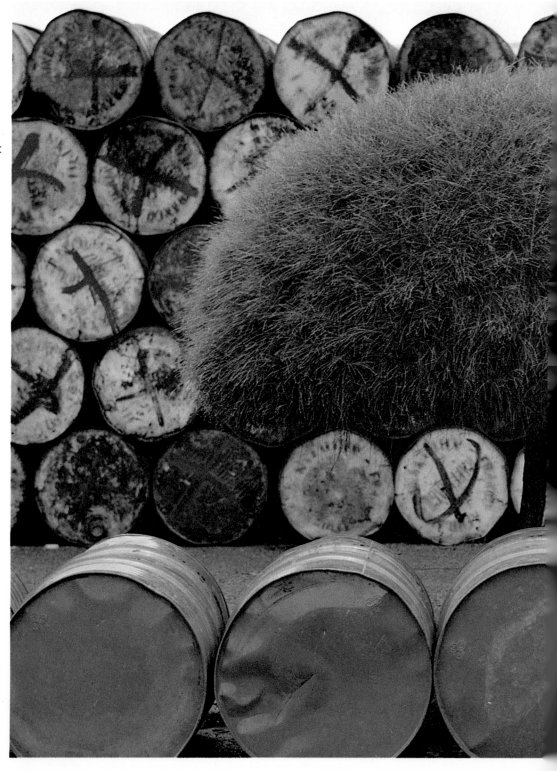

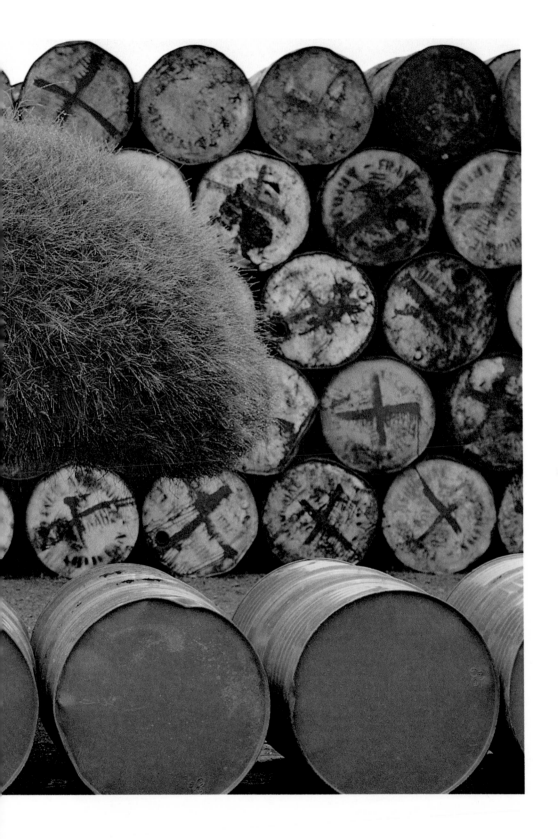

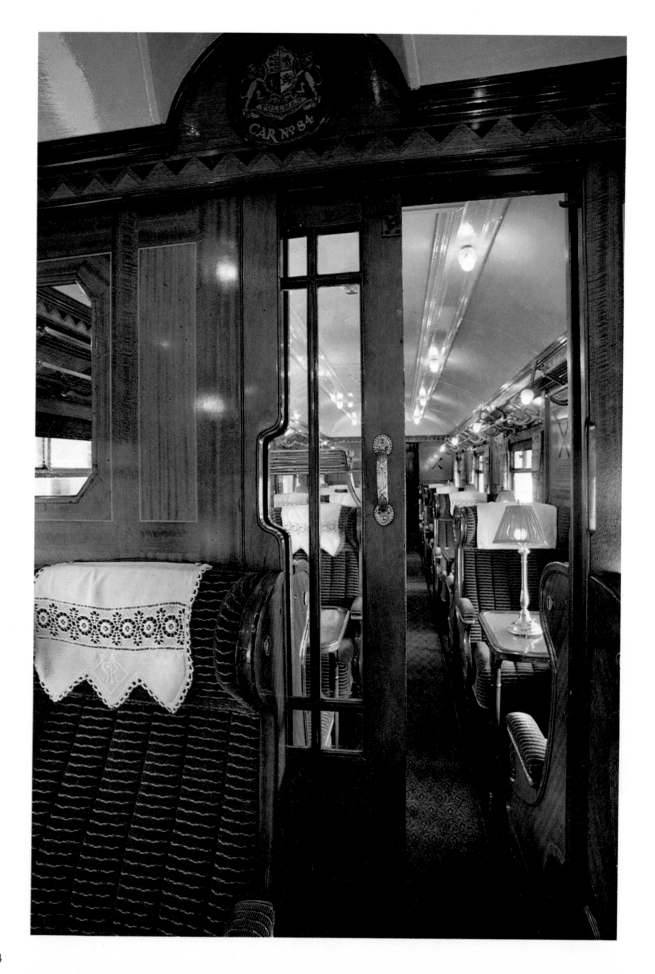

This interior view of a restored Pullman railway carriage is an affectionate evocation of the age of steam. The narrow corridor offered a limited choice of viewpoints and demanded a careful choice of lens to do full justice to the subject. Adelman used his 24mm lens, which took in important details of the door frame and exaggerated the length of the carriage to add to the sense of grandeur. By partly closing the door he created just the right balance of foreground and background and prevented the picture from being dominated too much by the converging lines of the passageway. The door frame also served to obscure a distracting notice at the far end. The tungsten carriage lights recorded on Kodachrome daylight film brought out the full warmth of the veneered surfaces — an effect intensified by the 30-second exposure (at f/22). The reflected highlights in the door-surround could easily have been eliminated by unscrewing the bulbs. However, it seemed preferable to retain them, to convey the high polish of the woodwork.

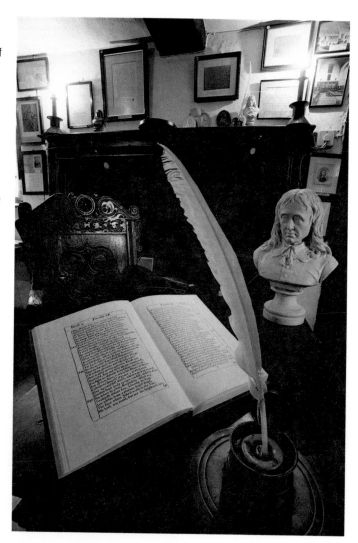

The study used by 17th-century English poet John Milton again presented the challenge of taking photographs in a cramped space. Adelman wanted to capture an old-world aura as well as a factual record of Miltonic memorabilia. He therefore decided to combine a thoughtful still life with a broader view of the room. With the curator's permission, he adjusted the three objects until the effect seemed exactly right through an 18mm lens. The miniature bust immediately announces the presiding genius of the scene, while the quill pen and open copy of *Paradise Lost* are effective emblems of his achievement. The orange glow of the tungsten lights and the deep pools of shadow convincingly simulate candelight. The quill that boldly intersects the picture and the exaggerated perspective of the open book give this image a tremendous compositional authority.

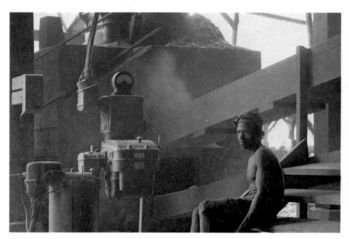

Capturing the flavour of life in a factory or other industrial complex is a major challenge to any photographer. The clutter of machinery or materials that litters most complexes makes it difficult to build coherent compositions in which irrelevant details are excluded. This picture of a worker in a Ghanian timber mill demonstrates Adelman's ability to triumph over such obstacles. What makes the picture, tying together all the various shapes and creating a coherent mood, is the monochrome colour effect, which strongly suggests a 19th-century sepia print. Instead of attempting to capture the strain of manual work, Adelman waited for a break in the workflow to produce a more introspective view. To make the worker stand out vividly against the machinery, he set his 85mm lens to an aperture of f/5.6, which defocused the background slightly. The telephoto also enabled him to stay well away from the dust clouds, and helped to prevent the worker from being discomforted by the camera's presence.

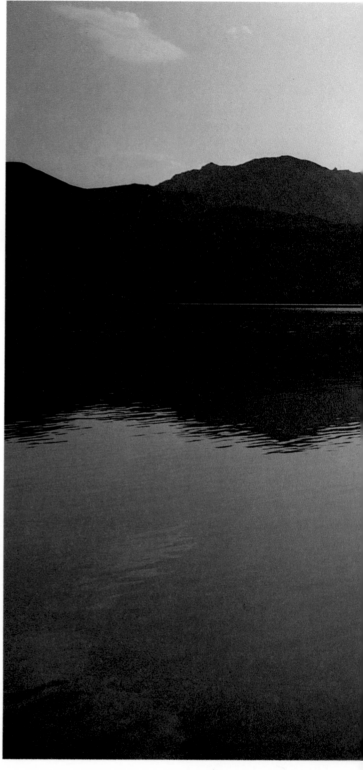

By employing filters to change the colour and quality of light, you can reinforce the impact of a landscape picture without making it obvious that any special tricks are involved.

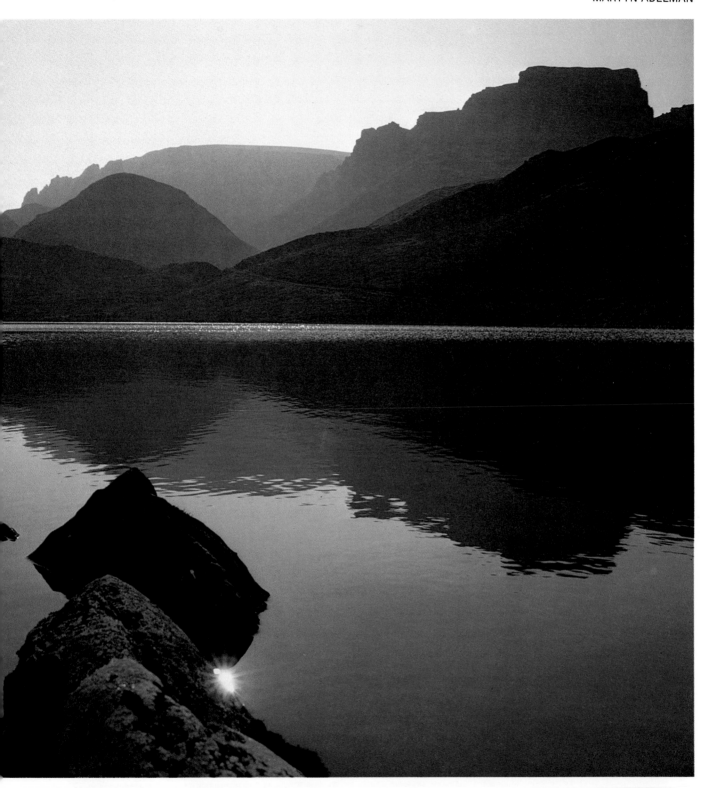

This was the approach taken by Adelman in this shot – a serene evocation of a loch on the Isle of Skye, Scotland. Initially, Adelman took a half-dozen or so frames without filters, using an 18mm lens to make a dramatic feature of the foreground rocks pinching the sun's reflection. Then he tried a subtle manipulation using two square plastic filters – a blue one over the water area and a red one to warm up the sky with a fake sunset glow. Careful positioning of the filters disguised the join between them. Colour filters often deceive a camera's TTL meter, so the photographer bracketed exposures and chose this one as the best result.

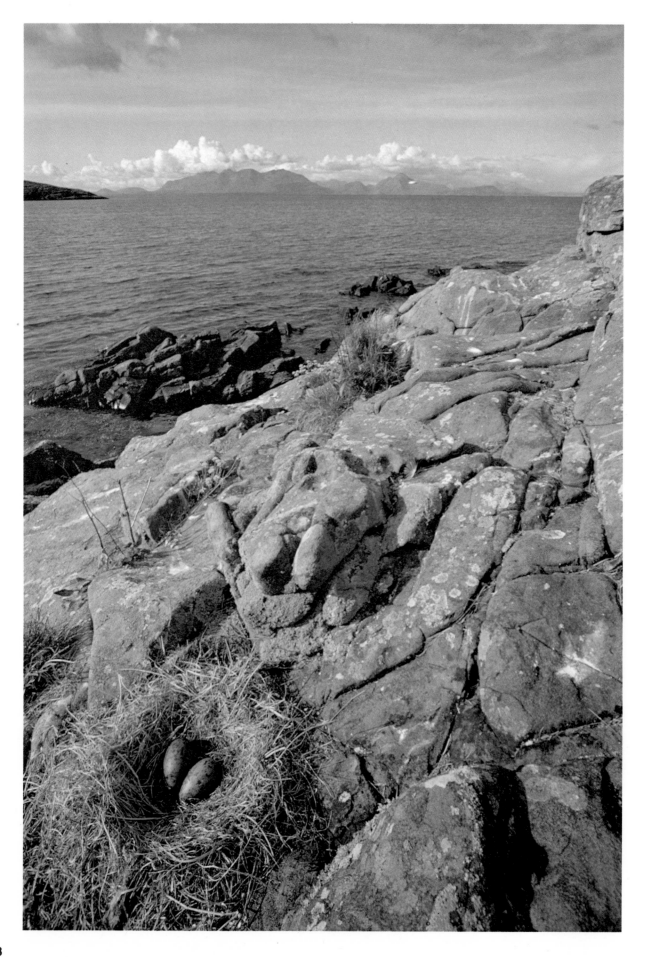

This image in Adelman's Hebrides series (left), a vista from the Isle of Rhum looking toward Skye, again examplifies his inventive use of foregrounds in wide-angle shots. Like the oil drum in the picture of horses on page 52/3, the gull's nest functions as a dramatic focal point, around which the rest of the image is organized. But whereas the colourful oil drum immediately draws attention to itself, this nest merges inconspicuously into the background of lichen-spotted rocks. Many photographers would have centred the feature at the bottom of the image, but instead Adelman decided to create an interesting and adventurous effect. Extreme wide-angle lenses, such as the Nikkor 18mm used for this picture, noticeably stretch the image at the corners of the frame. So by placing the nest where it is, Adelman distorted its shape and made it seem precariously placed, as if about to fall out of view. This bold positioning adds tension to the picture and reinforces its artistic impact.

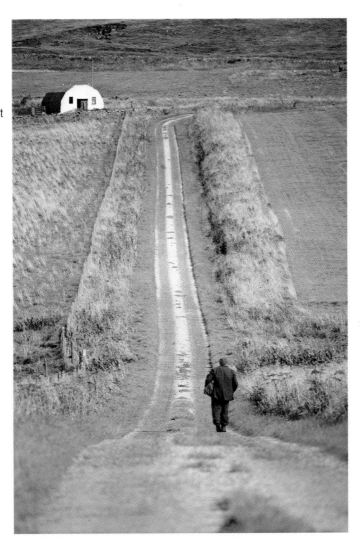

Amateur landscape photographers usually prefer to exclude roads and other human paraphernalia from their views, preferring to give the illusion of a wilderness untouched by man. However, this is not necessarily the best strategy. In this location (Skye again) there was plenty to tempt the eye, including sweeping panoramas towards the neighbouring islets. However, Adelman decided to ignore the sea this time and make a humble country lane the basis of a composition, using it to lead the eye into the picture frame. The viewpoint was chosen so that we share the lone walker's view. By fitting a 105mm lens to compress the perspective, he has given equal emphasis to the figure and to the austerely shaped dwelling. And by doing so he has underlined an implicit question: is the dwelling the man's destination, or will he follow the bend in the road? Setting f/5.6 to blur the foreground has helped the composition by leading our eye instantly to the figure.

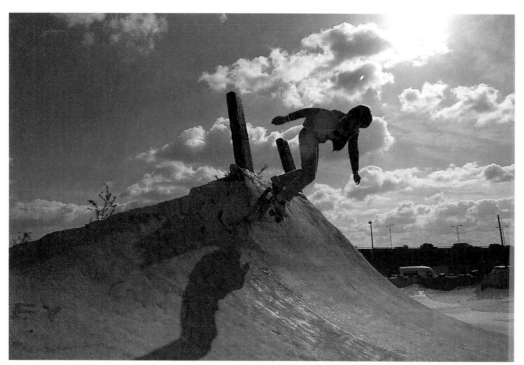

After action, inaction. Adelman's liking for this fine candid picture (right) taken in Accra, Ghana, is shown by the use of it on the back of his business card. Apart from the extraordinary size of the woman, there are several remarkable features of the image which combine to make it such a powerful statement. First there is the irony of the juxtaposition: the woman is clearly "parked" despite the prohibition of the roadsign. Equally important is the colour coincidence — the perfect match between the clothing and the sign. To discover the woman sitting against the sign rather than, say, merely next to it was an astonishing piece of luck. Moreover, the luck continued: to Adelman's delight, the woman turned her head to watch a passing lorry, enabling him to capture this view of her perfectly framed features. He took the photograph with an 85mm lens from the opposite side of the street, setting an aperture of f/8, which slightly blurred the background and made the subject's shape more prominent.

Successfully capturing a peak of action in a photograph is seldom the result of pure luck. You can take a rapid sequence of shots with a motordrive, only to find that the climactic moment fell between frames and is lost forever; or that in your eagerness to get the timing right you neglected the niceties of exposure or focusing. This shot of a skateboarder's dizzying turn, taken with a 35mm lens, shows

Adelman in the unfamiliar role of action photographer — and exhibiting complete mastery of the skill. Anticipation was a key factor: Adelman knew that the skateboarder would become almost stationary for a fraction of a second and that he had to press the shutter release an instant *before* this peak to allow for the delay in his reaction. Equally important, however, was the need

to obtain the right lighting effect. Following a meter reading from the sky would have silhouetted the boy, but Adelman preferred to retain some detail in the foreground. He therefore gave a 2/3 stop more than the meter indicated; this proved just enough to reveal the boy's clothing and the graffiti on the concrete track. A shutter speed of 1/125 froze all movement.

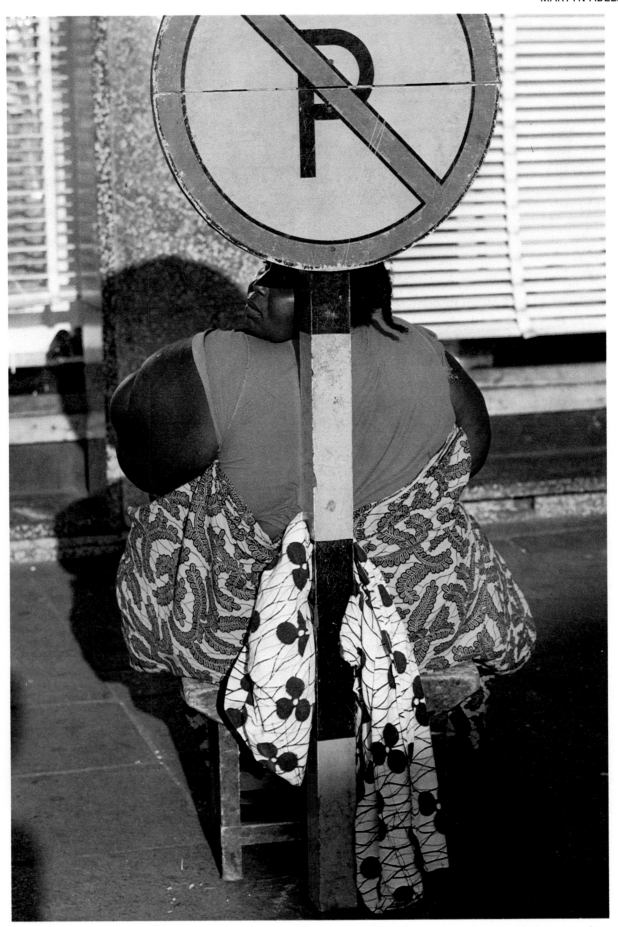

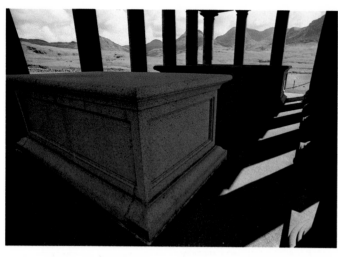

Adelman's liking for exaggerated perspective effects is illustrated by both pictures on these pages. Above is a glimpse of a mountain range on Rhum through an elaborate foreground frame – a private mausoleum consisting of tombstones inside a mock Greek temple. Deliberately aiming for drama, Adelman fitted his 18mm lens to his Nikon body and circled the temple trying out various viewpoints. This one produced the most satisfactory effect. To make the vertical lines of the composition converge dramatically toward the bottom of the picture, Adelman tilted the camera slightly downward. Before pressing the shutter release, he carefully lined up the corner of the foreground tomb with the exact bottom edge of the frame. An exposure of 1/8 at f/16 on ISO 25 film revealed the texture of the tomb but without bleaching out the background panorama. Part of the picture's success depends on its juxtaposition of architectural straight lines and geometrical shapes with the fluid profile of the mountain range.

In brilliant sunshine, streets that run north-south tend to fill up with shadow except around noon when the sun is near its height. This often causes problems for photographers of urban views: black shadow areas have a habit of unbalancing a composition and obliterating important details. Our eyes tend to compensate for shadow areas but film – especially slow slide film, which is high in contrast – is incapable of such adjustments. A characteristic of Martyn Adelman is his ability to anticipate how shadows will behave on film and to exploit them creatively. Looking along this street toward Lichfield Cathedral, in the English Midlands, Adelman observed that the foreground block of shadow had a straight edge that stopped just short of the pavement, revealing a narrow strip of cobbles which remained in bright sunlight. The polygon of shadow balanced the grey shape of the cathedral and made the sunlit wall of the terrace seem all the more brilliant by contrast. To capture this striking scene, Adelman fitted an 18mm lens, tilting the camera upward to make the houses lean toward each other and to give a dramatic form to the pinnacled church towers.

Portraiture in black-and-white is another side of Martyn Adelman's talent. All the portraits shown here and on the following pages were taken with a Hasselblad fitted with an 100mm lens. In all the images, the lighting is supplied by electronic flash.

A willingness to take creative risks is a hallmark of Adelman's studio photography. For example, this study of writer Timothy Mo boldly defies the convention that the subject of a portrait be made recognizable. Not only are the eyes hidden, but there are no tell-tale features, such as a distinctive beard or hairstyle might provide. Writers are typically shown clothed in their studies, but here the chest and the setting are bare. In short, Adelman has stripped the subject of his identity, and there is an irony in this, because writers are people who excel in *creating* identities. The angled forearm with its sinuous undulation at the wrist makes such a distinctive shape that the viewer may at first be tempted to see the picture as a study in pure form. However, this interpretation would ignore a few gentle hints consciously included by the photographer. The gesture of wiping the eyes, the bare chest, the stubble on the chin, the absence of a watch (an absence made conspicuous by the strap marks) and even the low-key lighting all suggest that Mo is waking up after sleep. This simple narrative, shrewdly under-stated yet unmistakable once it has been pointed out, gives the images an extra dimension that increases its effectiveness.

In the picture opposite, the eyes are again obscured but there is no mistaking the personality — the jazz musician Ronnie Scott, suffering after a late, boozy night at his famous London club. This portrait, on Kodak Plus X Pan film rated at ISO 250, was taken for *She* magazine. Adelman arranged the picture so that the chair and the saxophone would together make a frame for Mr Scott. The initial meeting was especially relaxed, and Adelman was able to grab this shot right at the beginning of the session, before the musician had time to compose himself. The result is an apparent contradiction in terms — a candid studio picture. As in the portrait of Timothy Mo, the background — a sheet of black velvet — absorbed all the light falling on it, creating a block of dense black that concentrates our attention on the subject. Other noteworthy features are the tight framing, with the sax just grazing the top of the picture, and the way the cigarette's position echoes the mouthpiece.

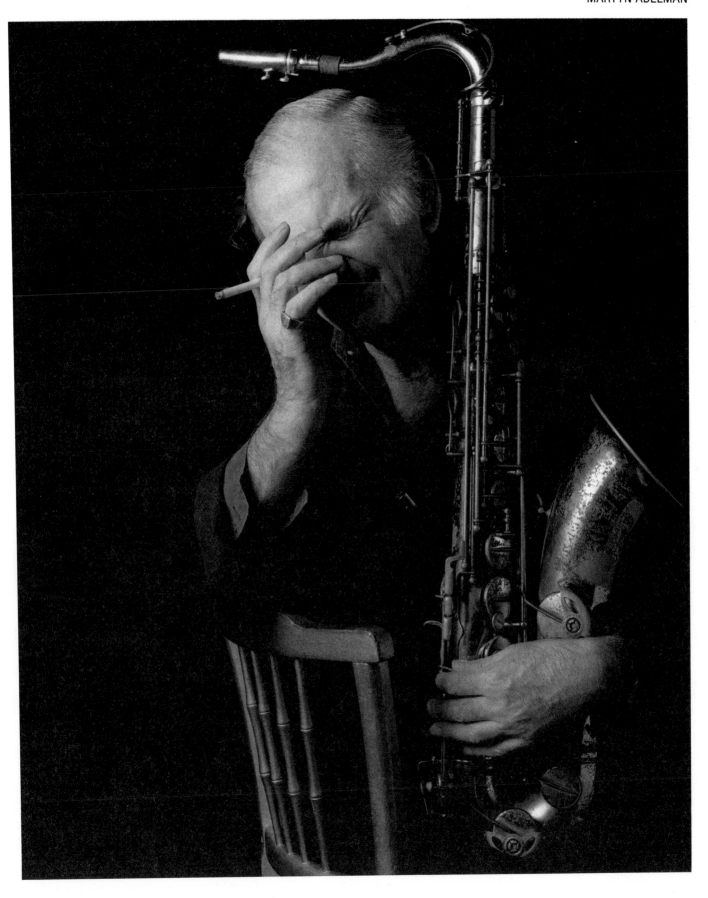

Details of a subject's dress, or
perhaps something he or she
happens to be carrying, can often
spark off an idea for a portrait.
Playwright Doug Lucie turned up
for a photo session on a bitterly
wintry day, and the mittens he
wore suggested this novel
composition. To emphasize the
interesting contrasts of textures
and tones, Adelman came in close.
Off-centre framing strengthens the
composition, but to avoid a blank
area of background at the
right-hand side of the image,
Adelman positioned his flash unit
so that it would create a bright
nimbus of light on the grey
background paper.

Spotlighting and an extravagantly sweeping cape give a definite air of theatricality to this portrait of art director Richard Krzyzak. The lighting, positioned just above eye level, was designed to emphasize the subject's bone structure — particularly the cheekbones. There is just enough light on the "cape" — actually, a black velvet background cloth hung over a studio stand — to reveal its sagging folds. By placing the face in one corner of the frame, Adelman has added an intriguing tension to the image.

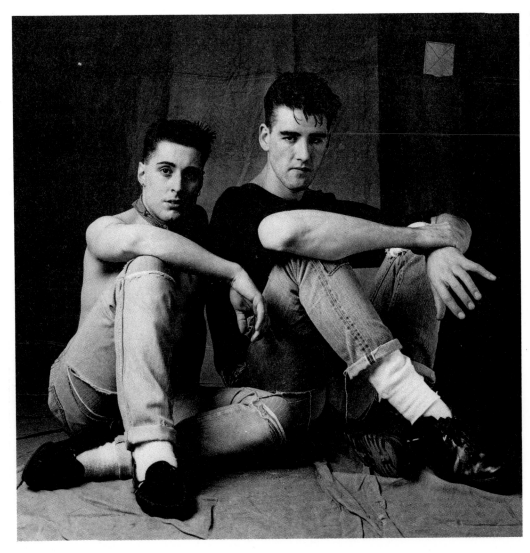

"These boys seemed to move in unison," Adelman commented when asked about this picture of two young men who for a while ran a club known as Dirt Box. The poses, which echo each other without being identical, suggest this spirit of kinship. Double portraits present a number of special photographic difficulties which are here solved with effortless flair. The lighting has been carefully arranged to give equal emphasis to both subjects — a diffused flash unit to the left of the picture frame and a large crumpled foil reflector on the opposite side to fill in shadows. Special care was needed to prevent one of the pair casting shadows onto the other. There is a danger in full-length double portraits that the composition will become too complex, but Adelman anchored the picture by asking the boys to adopt a neutral stare directly toward the camera, making the faces the main focus of interest. The square patch of canvas (top right) is nicely positioned to balance the composition.

Unconventional personalities demand an unconventional photographic approach (left). Nick Seaman, the illustrator, is a restless, somewhat roguish person with a taste for extrovert dress, and to convey these qualities Adelman encouraged this flamboyant pose. It was important that the pose give prominence to the hands, as the bracelets and heavy rings deserved to be a focus of interest. A large fan was used to sweep back the mane of hair, and give movement to the image. Out of several dozen pictures, this one, capturing a hint of mischief in the features, seemed most expressive of the subject's personality. Instead of a plain black background, the mood called for something rougher, less respectable, so a large patched sheet of canvas was brought into service, its tentlike appearance perhaps suggesting a nomadic, rough-and-ready lifestyle. Broad, relatively high-key lighting was appropriate to Seaman's open character.

MARTIN DOHRN

Born in 1957, Martin Dohrn lived in his native New
Zealand for the first ten years of his life. He and his
sister were then brought by their parents to England,
where the educational possibilities seemed more
attractive. At a Rudolf Steiner school in Sussex he
was taught according to the belief that a creative,
enquiring attitude toward the world is at least as
important as academic training. By the age of 15 he
was already thinking of becoming a journalist, but
soon realized that his writing ability was probably
not of the required calibre. Photojournalism seemed
an appealing alternative: he had recently acquired a
Zenith B rangefinder camera and was hugely
enjoying using it. After a course at the Guildford Art
College (Surrey), doubts set in about the direction
chosen. Photojournalism had become too
fashionable, and was attracting a flood of graduates.
So Dohrn turned instead to an earlier enthusiasm –
butterfly photography. After a year he had enough
pictures to make a submission to the Bruce Coleman
natural history picture library. A few lucky breaks led
to commissions for numerous books on landscape,
architecture, science, nature and photography.
Dohrn is now planning to slim down his thematic
range, concentrating on nature and landscape, with
some photojournalism.
A key characteristic of Dohrn's approach to
photography is his fondness for the magnified view –
whether of distant details of the landscape or
cityscape, or the minutiae of the natural world. By
closing in, he often reveals patterns with sumptuous
contrasts of texture, colour and tone – yet almost
always stopping well short of abstraction. With both
telephoto and close-up equipment, his flawless
technique and the pains that he takes to avoid
camera shake lead to crisp, precise images. When
he uses a wide-angle lens (usually a 28mm), it is
usually for the sake of a broader view rather than to
create exaggerated perspective effects. Whatever
the focal length, compositions are kept clean and
simple. His eye seems attuned not to oddities or
bizarre juxtapositions, but simply to the beauties –
often commonplace – of the manmade and natural
worlds, which are allowed to speak eloquently for
themselves.

An image of ruthless violence in the animal kingdom: a young raft spider dines on a red damselfly. In the original 35mm slide (Ektachrome 64), this chilling scene was captured at 2/3 life size. Dohrn wanted to avoid disturbing the spider, so he chose his 100mm f/2.8 lens for this shot, mounting it on two extension tubes — a 20mm tube and a 30-55mm adjustable one. A Gitzo "Performance" tripod, notable for its versatility, allowed a viewpoint from close to the ground. To fill in shadows, a 402 Metz flash unit used at full power bounced light off a homemade white card reflector. The exposure setting was 1/30 at f/16, which gave ample depth of field.

This beautifully scalloped pattern
was formed by wavelets lapping at
a shingle beach on the Dorset
coast in the south of England.
Dohrn saw the potential of the
scene while taking a clifftop walk
in the early evening sun. He was
fascinated above all by the
striations of tone along the water
line, caused by varying degrees of
wetness. He decided that his
300mm lens, with its pronounced
effect of compressing perspective,
would be the right choice for the
picture. However, it seemed risky
to set up a tripod on the uneven,
crumbling cliff edge, so he
stretched himself out flat and
supported the lens on a tussock of
grass at the very verge. The
camera was loaded with ISO 50
slide film (Fuji). Setting the lens to
its maximum aperture – f/5.6 –
allowed a shutter speed of 1/250,
which prevented camera shake
and froze the action of the waves.
A skylight 1B filter cut down the
amount of blue light reaching the
film.

Another coastline view taken with a 300mm f/5.6 lens, this time on a tripod-mounted camera loaded with Kodachrome 25 film, which was chosen for optimum rendition of detail. The subject is a weird rock formation at Cemaes Head in north Pembrokeshire, south Wales. The late sun catching the edges of the folded sheets of rock has helped to define the formation's structure. However, to prevent these reflections from interfering with the clarity of detail in the image, Dohrn fitted a polarizing filter over the lens. This has also had the effect of enriching the green colour caused by a band of algae. The exposure setting was 1/60 at full aperture.

The South Downs Way, one of England's most popular long-distance footpaths, undulates along the spectacular chalk precipice of Beachy Head, offering views of this candy-striped lighthouse. This photograph conveys the breathtaking drama of the scene. To obtain an image that would stand considerable enlargement, Dohrn used his Mamiya RB67 medium-format camera, which he fitted with a long-focus 360mm lens – the equivalent of around 200mm in a 35mm format. The tiny walkers dotted along the cliff edge provide a startling yardstick of scale, while the mist over the English Channel adds atmosphere to the image. To keep the tripod-mounted camera steady at a shutter speed of 1/60, f/16 plus a half-stop (Ektachrome 64 film), Dohrn took the picture with the camera's mirror raised. An 81A filter helped to combat the blue haze and warm the picture's tones.

The City of London, although scarcely bigger than a small market town, is densely packed with architectural wonders, ranging from baroque churches to towering modern office blocks. Both the 35mm pictures on these pages, taken from the same viewpoint, reflect this cultural richness. They also show Martin Dohrn's ability to organize the chaotic profile of an urban skyline into harmonious compositions that express the character of individual buildings. In each picture, the secret of success lies in the choice of viewpoint, lens and time of day.

The first image shows the Monument, built in 1671 to commemorate the Great Fire of London, against the National Westminster skyscraper which sprang up over three centuries later. To obtain such a tightly framed close-up and to dramatize the contrast of styles, Dohrn stationed himself on a distant rooftop and chose a 300mm f/4 lens in combination with a 2x converter. This gave an effective focal length of 600mm but reduced the maximum aperture to f/8. The fastest shutter speed possible with ISO 50 film was a mere 1/125. In the blustery wind that was blowing, this made camera shake a serious danger: extreme telephotos are easily buffetted by even a modest wind, as they present a large area to the air stream. To minimize the risk as much as possible, Dohrn retracted the lens hood and took his pictures with a cable release, and with the mirror locked up. He also used his body as a windbreak. Despite these precautions, half the pictures were blurred. Yet this one shows the reward of such persistence. The monument, etched by winter morning sun, stands out sharply against the dark-toned tower block and creates an eloquent image, full of fascinating textures and details.

A louring black cloud forms a dramatic backcloth for the splendour of St Paul's Cathedral, gilded by a burst of mid-morning sunlight. It is impossible to obtain a view of the whole cathedral without including other buildings in the frame. Dohrn tackled this difficulty by choosing a viewpoint that revealed only two other structures, both of them compatible in style with the baroque masterpiece, though later in date: the Old Bailey (whose green dome carries the statue of blind Justice with her scales) and the grand building in the foreground. The effect of using a 300mm lens was to flatten the perspective, making all the architectural components in the picture seem like parts of one fantastically rambling edifice. On the rooftop vantage point where Dohrn stood, camera shake was again a risk, despite the use of a tripod, so he took the shot with the camera's mirror raised to avoid vibration. An 81A filter removed any traces of blueness from the scene. The exposure was 1/125 at f/5.6 on Fuji ISO 50 film.

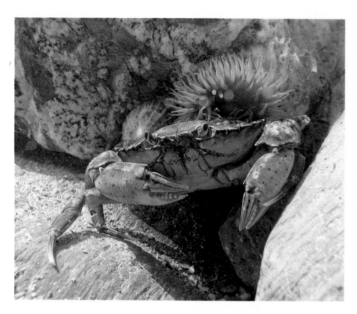

Rockpools left by the retreating tide are a rich habitat for all kinds of fascinating plants and sea creatures. To record a rockpool's inhabitants on film, you can photograph from above the surface in the ordinary way, but there are various drawbacks to this approach: glare off the water surface tends to obscure detail, ripples distort the shape of the subject and the overhead viewpoint is frustratingly limited. Dohrn realized that he would have to photograph from below the surface to overcome these restrictions and gain a greater sense of immediacy – of entering the sea creature's world. He therefore constructed a special thin-walled glass tank for his Mamiya RB67 medium-format camera and used it to photograph, among other subjects, this common shore crab and beadlet anemone. He rested the tank on the pool's sandy bottom and lowered the camera through the open top. Confronted with an unexpected enemy, the crab remained still enough to record sharply at an exposure of one second, midway between f/22 and f/32 (Ektachrome 64).

Dohrn confesses to being strongly magnetized toward coastal scenery, where the restless, boiling action of the sea against complex rock formations is an inexhaustible source of subject matter. It was this compulsion that brought him to Skokholm, a small island off the south-west coast of Wales, whose Old Red Sandstone cliffs dominate this picture (right). This meeting place of water, rock and plant life was so rich in textures, forms and subtle colours that Dohrn could have spent a week photographing its beauties, without risk of repetition. He eschewed sophisticated techniques and let the subjects speak for themselves, with all the detail that medium-format film guarantees. In this view from a clifftop, he deliberately excluded any indication of scale, with the result that the picture has a semi-abstract quality. Ektachrome 64 film, used with an 81A filter, does justice to every nuance. Dohrn used his 50mm wide-angle lens and judged the exposure by experience: 1/60, at f/16 plus a half-stop.

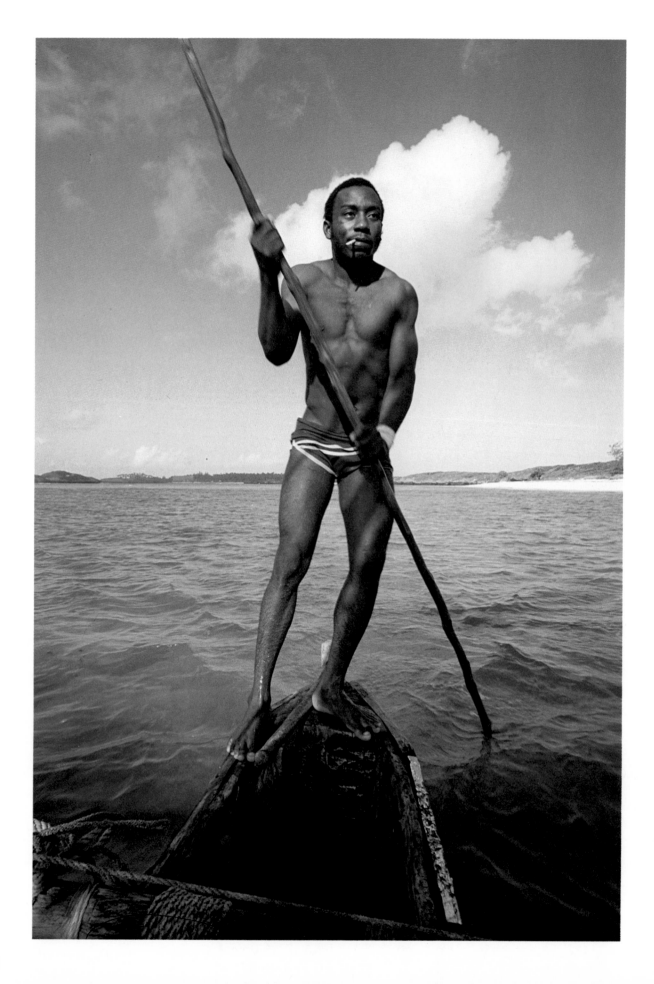

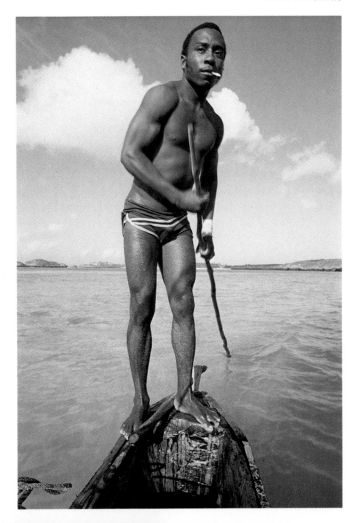

Used at close range, extreme wide-angle lenses unacceptably distort perspective: this is a photographic truism. Yet with careful composition you can use even a 20mm or 18mm lens for showing the human figure at relatively close quarters. The secret is to keep all parts of the subject at equal distances from the camera: an arm or leg projecting forward will tend to look disproportionately large Dohrn has achieved natural-looking proportions in this 20mm shot taken from the bow of a boat off the coast of Kenya (left). Timing was the essence of the picture. On the boatman's downstroke, he leaned forward into the frame, so that his head and torso appear too large in relation to his legs in the shot at right. Dohrn decided that the best moment for picture-taking was when the man stayed motionless between strokes. This

not only eliminated distortion, but also produced a more balanced composition, with the pole making a pleasing diagonal. The vast area of sea and sky made the correct exposure uncertain, so Dohrn bracketed at half-stop intervals. 1/60 at midway between f/8 and f/11 (ISO 50 film) showed plenty of detail in the stern of the boat but bleached too much colour out of the background (right). Stopping down to f/11 yielded a much better effect (left).

Blue and yellow are complementary colours – which is why they look so striking together in this picture of dead reeds in a pond in Surrey, England. Dohrn took the picture from the shore using a 200mm f/4 lens mounted on his Canon F1 body. When handholding a camera, the minimum shutter speed you can use to be sure of avoiding camera shake is the reciprocal of the focal length of the lens. Dohrn knew from this formula that he could safely set 1/500 at the maximum aperture without having recourse to a tripod. This was also amply fast enough to freeze the motion of the reeds as they wavered in the breeze.

Intense heat and thick smoke present a serious danger to personal safety – as well as to photographic equipment. Many photographers would have been content to shoot this forest fire from a safe distance with a zoom or telephoto lens. Dohrn, however, saw the potential for a dramatic 28mm wide-angle shot, with a crescent of flame in the foreground contrasting effectively with the charred ground behind and balanced by a treetrunk placed centrally at the top of the frame.

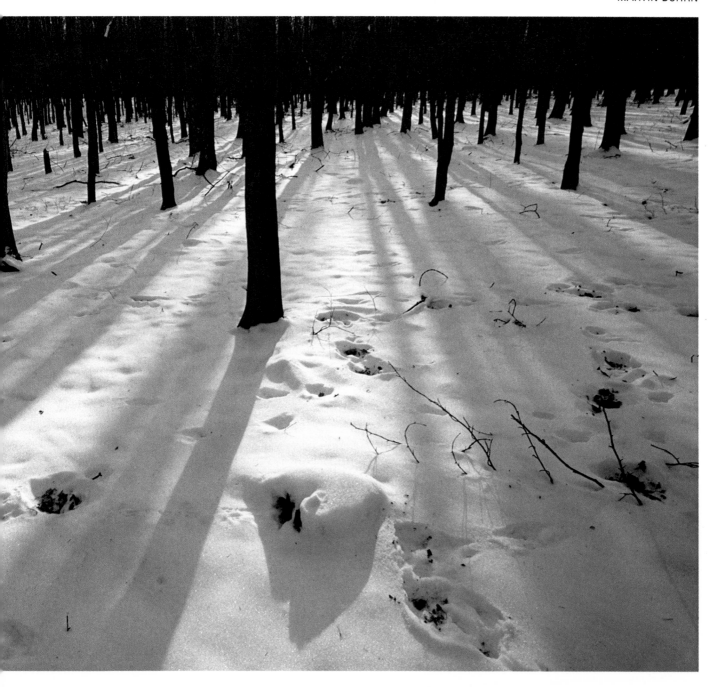

He preset the camera and then moved swiftly to the chosen viewpoint, only a few feet from the flames, to grab the shot. An exposure of 1/60 at f/11 (Ektrachrome 64 film) brought out the rich crimson of the flames.

Forestry plantations are abhorred by many lovers of the landscape: their regimented layout and the lack of any undergrowth seem a crime committed by commerce against nature. Photographers, also, tend to find them devoid of interest. Here, Dohrn has built a lively composition out of a difficult subject: the beech plantation at Ranmore, Surrey, beneath a carpet of snow. He chose a view directly toward the low morning sun, so that the rays of light, split up by the treetrunks, formed a radial

pattern exaggerated by the use of a 20mm lens. High contrast gave a monochrome effect, with not a single splash of colour. Exposing for the snow – 1/60 at f/11 on Fuji ISO 50 slide film – produced a black band of shadow at the top of the composition and silhouetted the trunks to suppress the details of their bark.

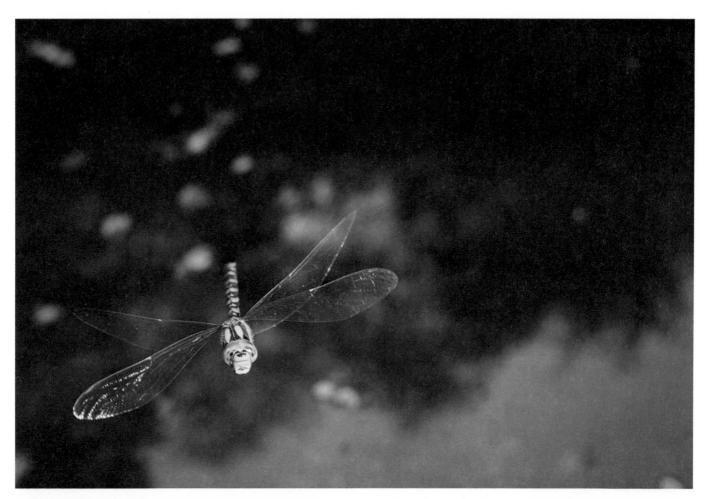

What nature subject could be more elusive than an insect in flight? To photograph this Southern Aeshna dragonfly as it flitted around a forest pool, Dohrn had no choice but to follow it around with a handheld camera. The failure rate, as we might expect, was high: out of 150 exposures, there were 10 acceptable images. A 28mm lens fitted with a 5mm extension tube to decrease the minimum focusing distance seemed the best choice of equipment. Flash was necessary to freeze the wingbeats, so Dohrn set his Metz 402 flashgun to approximately 1/16 power. This showed the subject in its natural colours without overwhelming the background, and gave a flash duration of about 1/4000. The film in use was Ektachrome 64, uprated by one stop to ISO 130. The exposure setting of 1/60 at f/16 gave sufficient depth of field. To prevent reflected highlights on the wings from recording as a blur in the available light, Dohrn took care to photograph the insect only when it was in shadow. He judged the subject distance by experienced guesswork.

Frost patterns are one of the bonuses of winter photography, but to make the most of them you need to use close-up equipment. To zero in on these frost-patterned bramble leaves, Dohrn fitted his 50mm macro lens with a 25mm extension tube and took the picture at 1/4 second at f/16 plus a half-stop on Fuji ISO 50 film. The camera was tripod-mounted. Overcast weather provided the ideal lighting conditions, revealing texture and detail without casting distracting shadows over the picture area.

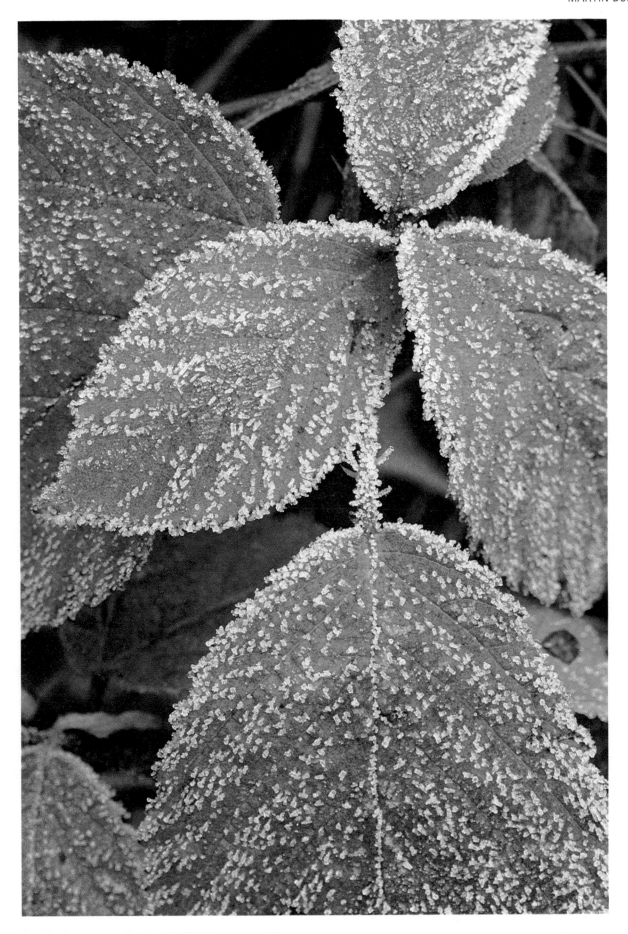

In this telephoto view of a Welsh hillside, a clump of rosebay willow herb forms a vivid pink slash against a contrasting background of greenery. When Dohrn noticed this isolated patch of colour, he set up his equipment and tried out the effect of various lenses, finally settling for his 300mm telephoto on a tripod-mounted camera. He was fascinated not only by the dazzling colour of the flowers but also by the way that the ferns, bushes and other plants seemed to blend into one another, making it impossible to distinguish the lie of the landscape in terms of contours and distances. The 300mm lens made the individual flowerheads just discernible, yet the general effect is one of pure colour and pattern. A polarizing filter brought out the vividness of the hues and cut through the blue haze, while an 81A filter screwed onto the polarizer warmed up the image just perceptibly. The exposure setting was 1/60 at f/5.6 (Ektachrome 64).

A glorious mass of wild flowers can benefit equally well from a wide-angle treatment, especially if they can be made to fill the foreground. To exhibit this profusion of poppies in a field of barley, Dohrn fitted his 28mm lens and stabilized his camera on a tripod. Tilting the lens downward and setting the tripod fairly low gave the ideal composition: a dramatically enlarged foreground, with just a narrow band of sky to add a sense of distance. The depth of field required was three feet to infinity, so Dohrn adjusted the

focusing ring accordingly, reading off the depth of field scale to find the optimum aperture – midway between f/11 and f/16. Polarizing filters can lead to unpredictable exposures, so to determine the shutter speed he took both a handheld and a TTL meter reading, averaged them out and used this as a basis for bracketing two stops each way. A setting of 1/15 yielded the best result. Before taking the final picture, Dohrn altered the viewpoint slightly to ensure that a handful of daisies were conspicuous at the bottom of

the frame to inject a colour accent. As with the other picture on these pages, a polarizer was used to provide maximum colour saturation.

Snow that has settled on a bare tree in winter seems almost to put the life back into it – like an unseasonal growth of fresh, white leaves. To convey this suggestion of winter fullness, Dohrn closed in on a tree in a city park with a 300mm f/4 lens. To avoid walking back to the car to fetch his tripod, he decided to handhold the camera. The use of ISO 100 film in overcast light at the lens' maximum aperture determined the fastest feasible shutter speed as 1/125 – too slow, many photographers might think, to be able to dispense with camera support. However, Dohrn pulled off this difficult shot, thanks not only to his steady hand and a convenient lamp post he was able to lean against but also to the use of a motordrive, whose additional weight helped to stabilize his equipment. Before pressing the shutter release, he took a deep breath; this further reduced the chances of camera shake, but also ensured that a cloud of condensed breath would not drift in front of the lens at the crucial moment.

An autumn view displaying a rowan tree's magnificent foliage offers an emphatic contrast with the image opposite – both in mood and in colour. Dohrn took the shot with the same lens at the same aperture setting, but the relatively generous morning sunlight allowed a shutter speed of 1/60 on Ektachrome 64 film. This time, he used a tripod. As with the companion image here, he took care to exclude parts of other trees from the composition, to avoid detracting from the simple organic pattern of branches diverging from an obvious source at the bottom of the frame.

Urban panoramas from an elevated viewpoint tend to work best when there is a single, simple element or idea that dominates the composition. In this impressive view from the top of the Arc de Triomphe, Paris, it is the Champs Elysées, running symmetrically up the frame and extending almost to its edges, that provides this unifying element. The insipid sun of a January morning rush hour has drained all colour from the scene — except for the red splash of a café awning and the red pinpricks formed by car brake lights. To compress the view and equalize the apparent scale of the vehicles, Dohrn used a 300mm f/4 lens fitted with a matched 1.4x teleconverter, giving a combined focal length of 420mm and a maximum aperture of f/5.6. Opening up as much as possible gave a shutter speed of 1/500 (with ISO 100 slide film). To keep the equipment stable, Dohrn rested the lens on a convenient railing.

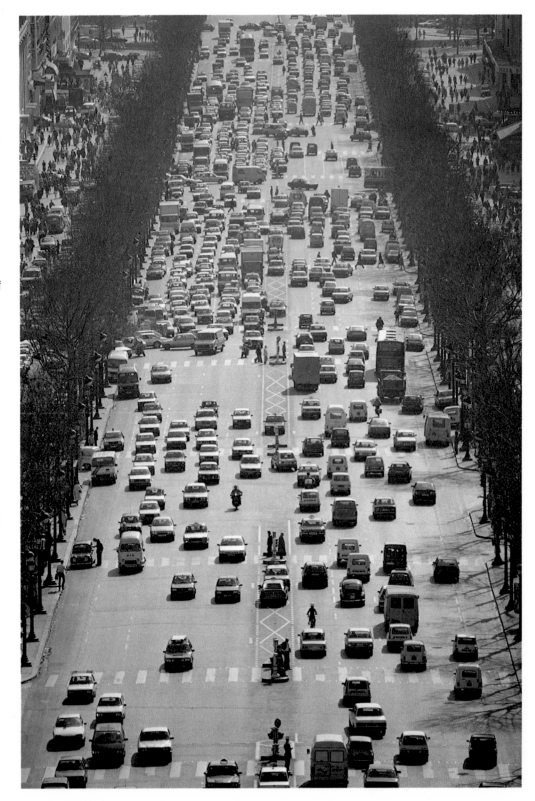

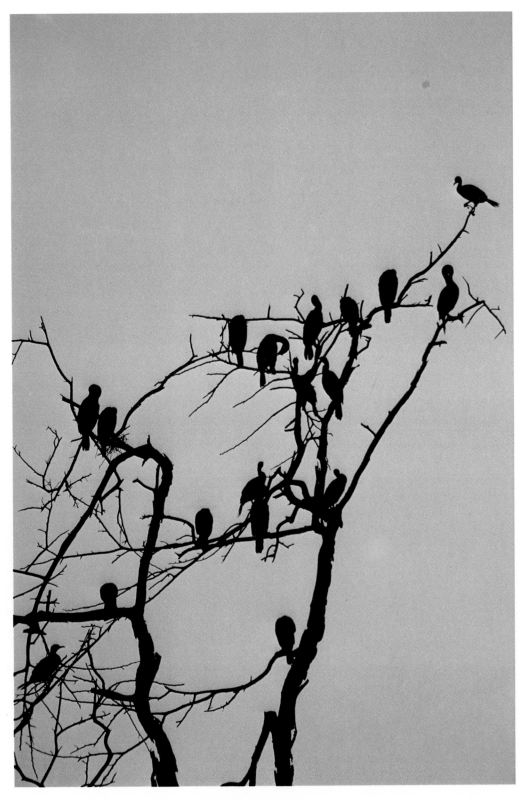

Silhouettes benefit from a subject
that has instantly recognizable
outlines — such as these
cormorants photographed in a tree
on the shores of Lake Nakuru,
Kenya. Dohrn used the same
equipment and film as in the
Champs Elysées shot opposite, but
with a tripod instead of an
improvised support. A viewpoint
into the light and an exposure
setting of 1/15 at f/5.6 measured
from the faintly pink dawn sky
created this minimalist image,
distinguished by the absence of
intermediate tones and by the
suppression of form at the
expense of shape, line and pattern.

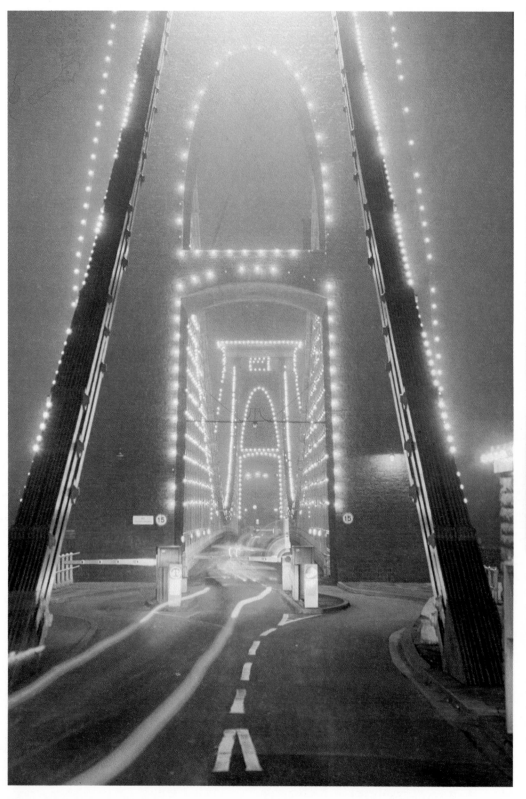

Giant displays of electric lights are not restricted to funfairs, entertainment districts and Christmas: this night shot (left) is a view of the Clifton Suspension Bridge, Bristol. Daytime reconnaissance revealed that a small island between two lanes of traffic would provide an excellent vista along the length of the bridge, exploiting its anchoring cables and brick archway as a foreground frame. With Ektachrome 100 film loaded in his

tripod-mounted camera, Dohrn set his 100mm lens at f/16 to provide adequate depth of field. To allow the cars time to travel between the traffic island and the far side of the bridge, he left the shutter open for 15 seconds. The red trail formed by car tail lights not only adds bright colour to the composition but also helps to lead the eye into the picture and provides an assymetrical touch that counterpoints the symmetry of the bridge.

After a successful photo session — especially one that has demanded a disciplined camera technique — photographers often like to experiment a little with adventurous compositions. And if the experiment fails to produce results, there is no serious loss. The abstract image above was a way of using up the last frame of a roll of film on a journey home to London after a day's shoot in the country. As Dohrn was being driven by his assistant through busy traffic on the approach to the capital, he fitted a 20mm lens to his Canon body, set the aperture at f/11 and with the camera held close to the windscreen took this shot at a one-minute exposure. The outcome was a dynamic yet intricate pattern, in which the lights of cars, street lamps and roadside buildings converge on each other, zigzagging like lines on a graph.

TESSA MUSGRAVE

Tessa Musgrave was born in London in 1956. Her first lesson in photography, at the Wimbledon Art School, was from photojournalist John Benton-Harris, whose words struck a chord: ''Go and photograph what excites you, but don't come back with any pictures of a tramp on a park bench.'' Musgrave's recent work – characteristically spare, experimental, often highly abstract – could scarcely be further removed from documentary realism. She bought her first camera, a Pentax SP500, in 1974, to record a holiday in America. After the trip she began a three-year degree course in interior and furniture design, but soon became disenchanted with the subject and spent every spare moment absorbed in what she describes as ''art school'' photography – that is, explorations of form, texture, patterns and shadows. After graduating, she began systematically to show her portfolio to professional photographers and landed a job as assistant to Theo Bergstrom. Now she has her own studio in London's Soho district, specializing in still life and documentary location work, using a Hasselblad and a Nikon. For her 35mm work, she has switched lately from Kodak slide film to Fuji, which she prefers for its colour saturation and exposure latitude.
Behind many of Musgrave's pictures there is a gentle teasing: she robs the viewer of the usual certainties of scale, viewpoint and subject matter. Quite literally, we are often shown the world from a new angle. City scenes and individual buildings are made to yield interesting configurations of line, shape and colour. Musgrave frequently uses selective focusing (and sometimes camera movement) to emphasize areas of a composition or to evoke an atmosphere. It is perhaps surprising that such an experimental photographer should consistently shun special-effects filters, but this accords with her belief in keeping equipment simple, relying on her eye alone to seek out effective images. ''Possibly the most useful pieces of equipment are a ladder and tripod, not forgetting the assistant to carry them.'' Wherever possible, she uses natural light. For exposure judgements with the Nikon, she relies on the camera's TTL meter or on guesswork, bracketing by at least one and a half stops either side of the anticipated ''correct'' exposure. With typical forthrightness she confesses to being ''still amazed when the result comes back correctly exposed''.

One technique for producing an abstract – or at least semi-abstract – effect in a photograph is to deprive the viewer of any clues as to orientation. Tessa Musgrave adopted this strategy here, deliberately aiming for a teasing image. The picture was taken in the Grand Canyon, Arizona, with a camera directed vertically upward, yet the foliage in the top-right-hand corner helps to convey the misleading impression that the camera was held level, in the usual way. An aeroplane plummeting so steeply back to earth seems scarcely credible, so instead we are encouraged to interpret the vapour trail as the path of a meteor or rocket – a reading that adds to the picture's air of unreality. The viewpoint was contrived to bring the plane into close proximity with the edge of the rock and, at the same time, position the sun where it would cause an intriguing halo. Adding three stops to the meter reading revealed colour in the rock. However, it was important that the rock should not become too dominant, so the 55mm lens was set at its widest aperture to limit the plane of sharp focus.

A New Delhi sunset provided spectacular lighting conditions for this arresting composition, captured at the airport from the top step of a wheeled embarkation staircase that had been temporarily parked near the plane. By dividing the scene into two horizontal bands of roughly equal proportions, Musgrave has broken a rule of photographic composition. Yet the result is to give the image a compulsive restlessness that augments its appeal: our eyes oscillate from the simple shape of the tail to the indistinct detail of the shadowed half of the fuselage and the puzzling runway markings. Although sunset views are normally restful and reassuring, this one is full of tension. The colours in the picture are entirely natural: the only filter used was an 81A, which had a warming effect. The camera was rested on a handrail during a 1/15 exposure.

A telegraph pole stands isolated in silhouette against a mottled red sky in this atmospheric picture, taken in Queensland, Australia, with a 55mm lens on a handheld Nikon FE camera. As in the airliner shot, the framing divides the image into two equal halves, this time vertically; yet the irregular shape of the pole and the unbalanced arrangement of wires prevent too static an effect. Although so fine as to be virtually invisible if you half-close your eyes, the wires make an important contribution, spreading the foreground across the entire frame and leading our gaze beyond the edges of the picture. Notice the silhouetted bird (bottom left) which adds variety of scale.

Including human figures in a spacious landscape not only conveys scale but also suffuses an image with a sense of human frailty. This strolling couple (left) had risen early to see dawn break over Green Island on Australia's Great Barrier Reef. Musgrave closed in with a 100mm lens following a meter reading taken from the sky, to silhouette the figures and suppress foreground detail. The bright highlight near the bottom of the frame, reflected off a pool of marooned seawater, is just large enough to provide a

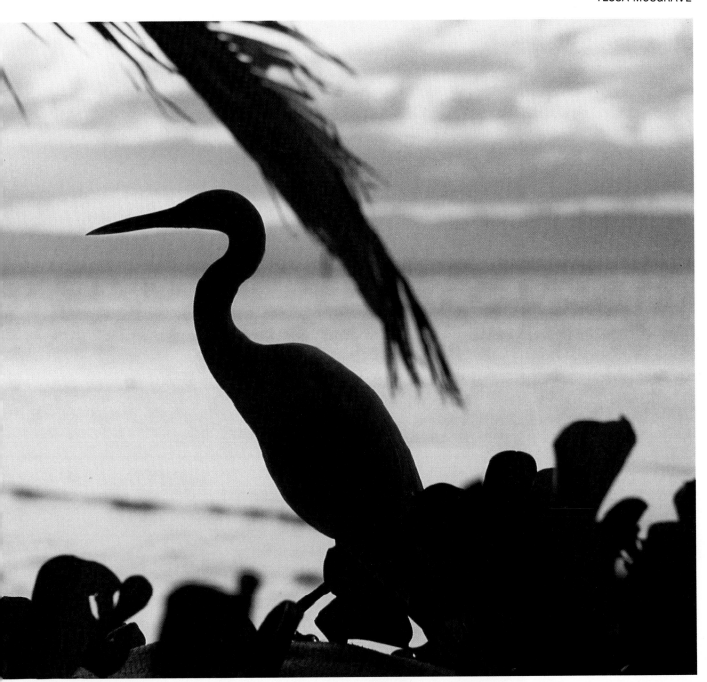

counterweight to the tiny human subjects. Compare the picture on page 115 for a radically different view of the same length of coastline – although again with a figure in the middle distance, used to similar effect.

This clutch of rock herons, also discovered on Green Island, were implacable enough to be captured with a 55mm lens from only 10 feet away, although Musgrave spent half an hour slowly creeping up on them, so as not to cause disturbance. The central bird obliged by displaying its characteristic profile, which puts the less easily recognizable shapes of its companions into a clear context. The purple colouring of dusk adds a romantic atmosphere to the shot, while the palm frond suggests the birds' hideaway.

This is a classic example of Tessa Musgrave's penchant for provocatively minimalist images. Any indications of subject matter, scale or viewpoint are ruthlessly excluded from the picture frame, so that we react more purely to shape, form, colour and pattern. The delicately scaled surface and the curving white rib might suggest a close-up of a dragonfly's wing. Yet the subject is actually Sydney Opera House – more often compared with turtles than with an insect! A directly upward view taken with a handheld Nikon FE fitted with a 35mm lens yielded this graceful image. A polarizing filter darkened the blue of the sky and cut down reflected highlights on the opera house's mosaic canopy.

In this satisfyingly composed close-up, Tessa Musgrave follows her characteristic method of showing the effect but concealing the cause, with the aim of deliberately tantalizing her viewer. The subject is the steps leading up to the altar in a church in south-west France, and the coloured spangles of light on the flagstones are cast by the stained-glass east window. Although relatively pale, the polychrome discs of light are shown up to good advantage on the neutral-hued flagstones. By adjusting the focus to keep the whole image slightly unsharp, Musgrave has created an ethereal effect appropriate to the subject matter. She used her Takumar 55mm lens on her Pentax SP500 body, handholding the camera.

Slatted window shutters on the
island of Paxos, Greece, make a
pattern whose repeated motifs are
relieved by contrasting touches of
irregularity — the off-centre
framing, the mottled paintwork, the
red colour accents around the
hinges and the chewed slat at the
bottom of the right-hand panel.
This was one of a series of similar
patterns taken in the same locality,
which together make up an
effective picture essay. Using
Ektachrome 64 film, Musgrave
closed in with a 55mm macro lens.

As in the image of the shuttered window on the previous page, this view of a doorway, also from the Paxos series, makes a graphically patterned composition out of a simple close-up of homely, unpretentious architecture. Again, the shadows play an important part in the composition. But instead of reinforcing the main pattern, as they do in the picture of shutters, they here provide a subordinate arrangement of free-form shapes that tones down the vertical emphasis of the doorframe, treetrunk and planks. The overall effect is semi-abstract, but with distinct overtones of a Mediterranean siesta. Frontal lighting suppresses form at the expense of colour, pattern and shape. The image would also have worked well in black-and-white.

A pattern that is spread evenly across a photograph will sometimes tend to look excessively static. One way to prevent this effect is to provide some dominant element within the picture, as a kind of visual nucleus to which the repeated, patterned components are subordinate. In this view of pavement furniture outside a French café, the circular table provides such a focus. Because the colouring of the table matches that of the chairs, the effect is harmonious rather than

jarring. Notice the pattern within the pattern: the three table tops echo each other just as emphatically as do the chairs in their more complex way. An overcast sky provided the ideal lighting conditions for this shot, as shadows would have overcomplicated an already busy image. A 55mm lens was used for the picture, with an exposure setting of 1/60 at f/8 (Fujichrome ISO 50 film).

Early-morning dew (right) gives a fresh sparkle to foliage, and reveals features that might otherwise be virtually invisible, such as the delicate tracery of these two spiders' webs, photographed in the countryside of south-west France. The mist has scattered the light and muted the colours, the monochrome brown unmistakably conveying the feel of a November day. By including a second, more distant web in the top left-hand corner of the picture frame, Musgrave has supported the centrally framed main subject with a smaller, off-centre element that is similar but not identical, and in doing so has followed one of the classic rules of composition.

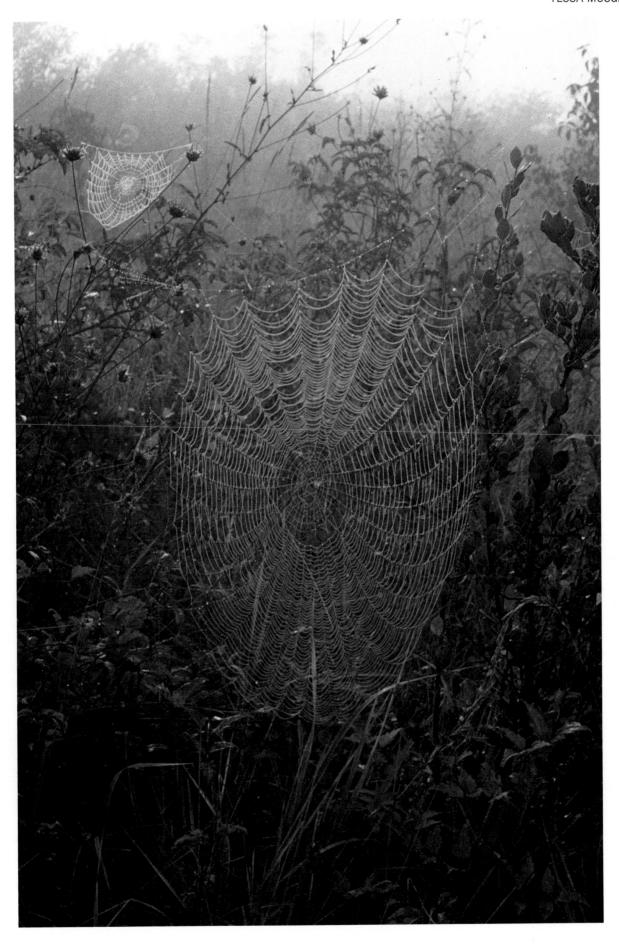

This tower, pointing skyward like a giant finger of basalt, is the main London office of the National Westminster Bank: see Martin Dohrn's photograph on page 76 for a different treatment of the same subject. Like Dohrn, Tessa Musgrave has built her picture upon hard-hitting contrasts of style, shape and tone, but using a frame – a balustrade on St Paul's Cathedral – instead of an isolated foreground element to supply the contrasts. The bulging bases of the balustrade help to confine confusing urban detail to a small area at the bottom of the picture, where it forms a strong juxtaposition with the geometric clarity of the tower. To take the photograph, Musgrave used her Nikkor 80-200mm zoom with an 81A filter, setting the lens to around 180mm. An aperture of f/8 kept the foreground frame slightly unsharp to avoid a conflict of interest.

On a photo tour of Melbourne, Australia, Musgrave scanned the city from a wide range of viewpoints, often pointing her camera upward for compositions that cut out the complexities of life at street level. This view of three adjacent buildings is one of the most successful architectural pictures taken on this tour. The essence of the picture is very simple: two geometrical patterns are offset against each other and balanced by a third, more irregular shape – a detail of a Victorian church. Time of day plays a significant part in the photograph's impact: the windows of the smaller modern block reflect a pink-tinted evening sky, which blends harmoniously with the colour of the church's stonework. By contrast, the background block is monotonously grey. Dividing these two areas of colour – the lower half warmly pinkish, the upper half steely grey – there is a complex zigzagging roofline. All these ingredients are part of the aesthetic logic of the picture, but this does not mean that Musgrave subjected the scene to such rigorous analysis before pressing the shutter release. Instead, she merely shifted her 100mm lens until the balance of colour and pattern in the viewfinder seemed instinctively right. The outcome of relying on feel rather than formula was a flawless composition that makes an immediate impact on the eye.

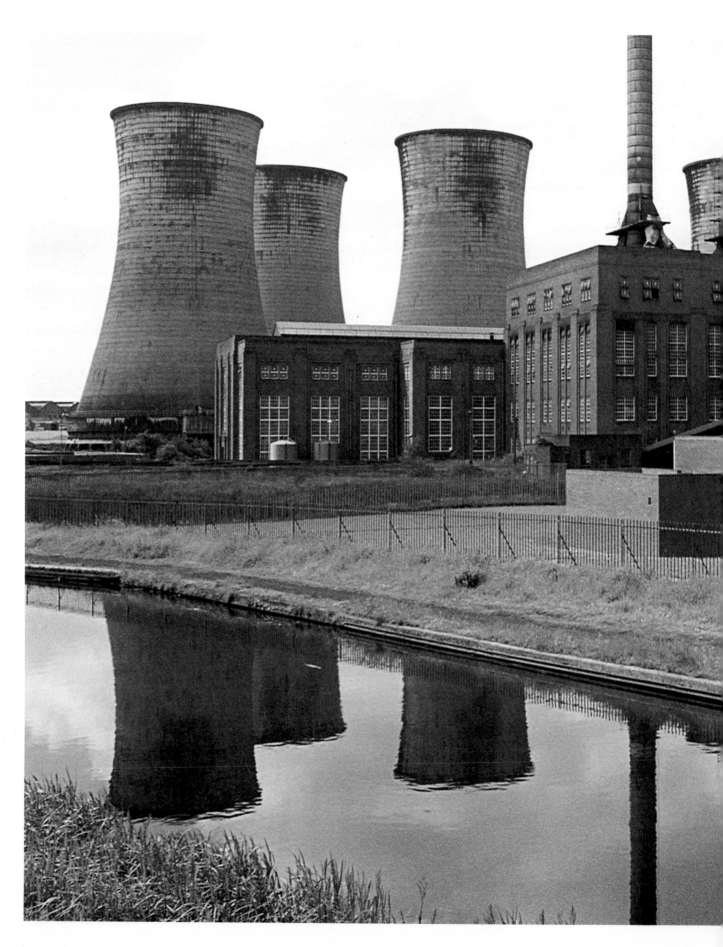

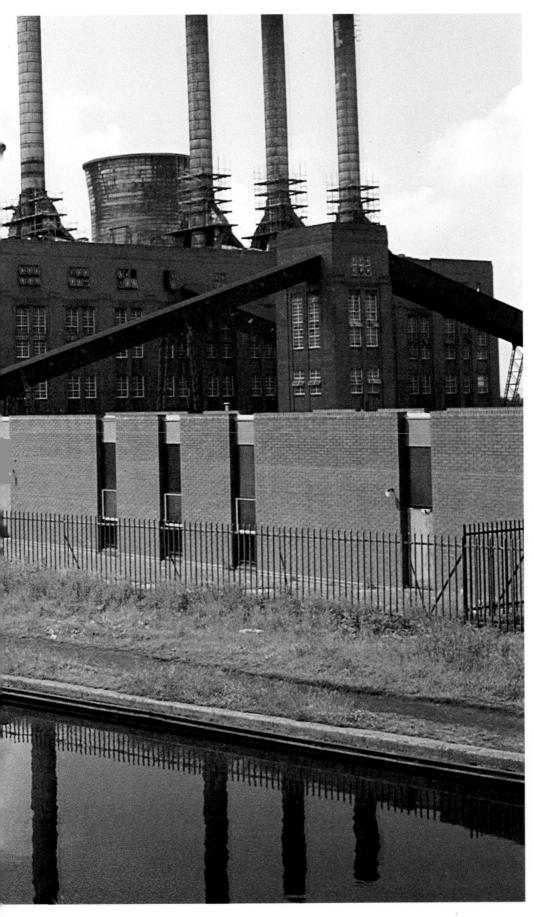

Power stations, factories and other aspects of the industrial landscape are often photographed on fast black-and-white film for a grainy, grittily realistic effect, often with an undercurrent of protest against the threat posed to the environment. Or alternatively, these subjects are dramatized by being pictured against a crimson sunset or massed black storm clouds. But here, Musgrave has avoided the lure of these stereotypes and instead taken a dispassionate look at this power station near Birmingham, in the heart of England's central industrial belt. Drawing upon her ability to see subjects in purely visual terms, she shows the power station not as a symbol of energy or blight, but as an unemphatic pattern that makes a simple aesthetic statement. Captured on Agfachrome with a 35mm perspective control lens (to keep the verticals precisely parallel), the scene has an almost pastoral stillness — thanks in part to the reflections in the undisturbed water of the canal.

All cities are rich in incongruous juxtapositions, which the camera can isolate to make eloquent statements. The intention may be humorous, documentary or, as in this image taken in Bangkok, primarily aesthetic. Musgrave loved the diversity of this crowded city, its intermingling of eastern and western cultures, and looked out for images that would summarize this impression of a teeming cultural meeting-place. As so often, she found a telling composition above street level. A temple pavilion and a telephone pole sprouting with wires seem to lean toward each other in a shot taken with a 35mm lens from a low viewpoint. The gilt ornament of the temple and the purely functional appearance of the pole make a pointed contrast. A polarizing filter saturated the colour of the building and darkened the blue sky.

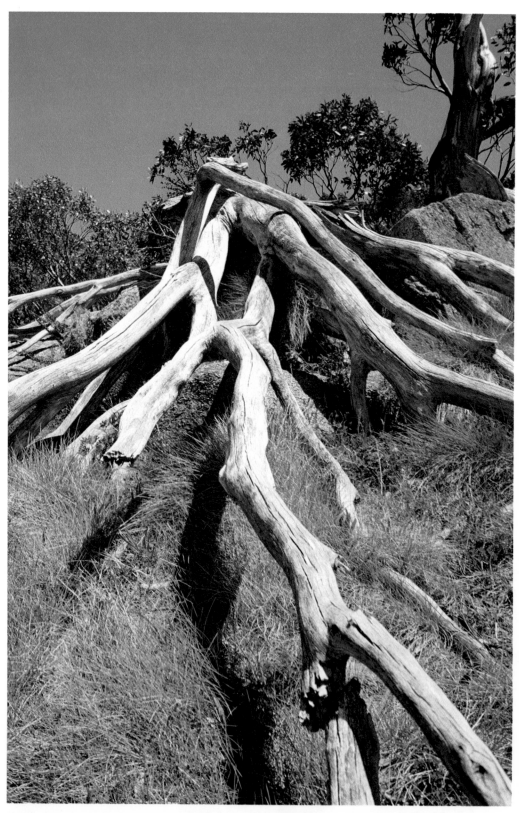

These tree roots, although dry and bone-like, seem to writhe with a sinewy strength. To dramatize their apparent vigour, Musgrave fitted a 28mm lens to her Nikon FE and placed the camera on the ground, lying down in the grass to compose the shot in the viewfinder. The low viewpoint was carefully chosen to make the leafy canopies at the top of the frame and the roots in the foreground seem like parts of a single giant organism, whose tentacles reach out threateningly toward the viewer. Because the camera angle was at exactly 90° to the position of the sun, the polarizing filter has had a maximum effect, deepening the sky and bringing out the colours of the grasses.

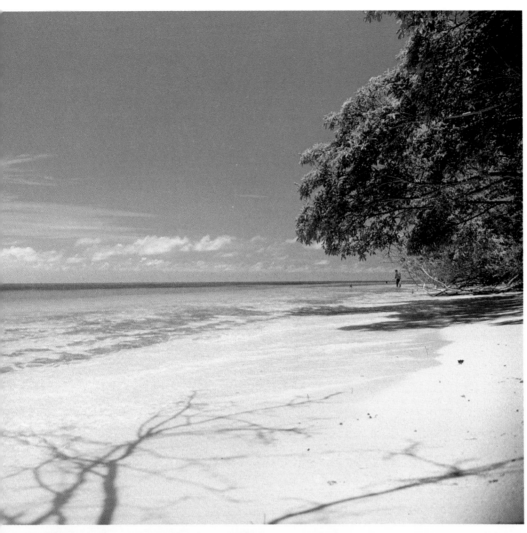

Polarizing filters are especially useful at the seaside: by removing reflections from the surface of the sea they often reveal a rich turquoise colour in the shallows. In this picture, showing a beautiful stretch of coast on Green Island in Queensland, Australia, a vivid blade of turquoise cuts right across the composition, leading our eye toward the overhanging tree, which in turn draws to our attention the tiny figure. By contriving the composition in this way, Musgrave has made a focal point out of what might otherwise have seemed an irrelevant detail. As with the other two pictures here, she used a 28mm lens and took the shot on Fujichrome ISO 50 slide film.

The unusual streaks of colour on these eucalyptus branches caught Musgrave's eye as she was trekking in Australia's Snowy Mountains. She closed in with a 55mm macro lens, arranging the composition to create a picture with a strongly diagonal emphasis. Setting the lens's widest aperture and focusing on the thickest branch threw the rest of scene out of focus, with the background more blurred than the foreground. Other exposures taken at narrower apertures, showing the whole subject in sharp focus, lacked the compositional coherence of this image.

A view across water can help to make compositional sense of a complicated city skyline, as demonstrated here by a nighttime view of Sydney. Musgrave took the shot while there was still some daylight left, to show the sky as a twilit blue and record the outlines of the distant skyscrapers and the boats at anchor in the harbour. The fluorescent lighting of the office blocks has shown as an attractive green on daylight-balanced Fujichrome ISO 50 slide film. To stabilize the camera (which was fitted with a 28mm lens), Musgrave supported it on a folded scarf which she placed on a low brick wall. Out of over a dozen bracketed exposures, there were four acceptable results, but this one (8 seconds at f/5.6) was the most effective.

CLAY PERRY

Clay Perry (born at Reading in 1940) is a graduate of the Guildford School of Art, where he studied under Ifor Thomas – one of the first teachers of photography to award the subject equal status with painting and sculpture. Today Perry is well-known to readers of Sunday colour supplements as an original portraitist and reportage photographer. He also works for a range of advertising clients in Britain and abroad. Recently, he was commissioned to take the pictures for a book on English country gardens.
Perry's special interest is the portrait in context. Personality is shaped by environment, which means that a portrait can only be fully informative if it takes in something of the subject's surroundings. Often the character and the place share the same ambience: they belong to each other in a profound way. To capture such relationships, Perry almost invariably uses a Pentax LX camera with a 28mm lens. He is fascinated by the space and depth created in wide-angle shots – yet has always avoided more extreme wide-angle lenses, which seem to him to push the subject beyond the limits of realism. Although he often carries a 200mm telephoto lens to maximize his picture chances, he uses it infrequently, preferring to stretch space rather than compress it.
After leaving college, Perry developed a relaxed, freeform style of candid photography, inspired by the work of Henri Cartier-Bresson. Now his approach is more disciplined. He has learnt to direct his subjects firmly yet tactfully – without quenching the essence of personality. He always uses a tripod if possible, but generally avoids flash if there is adequate available light. Shadows are frequently used to add drama or atmosphere.
Recently, Perry has rediscovered the advantages of rollfilm, although he remains committed to the 35mm format in situations where it is necessary to act quickly – for example, when the light is changing rapidly at the beginning or end of the day.

In portraiture, props are often used as indicators of identity, but they can also serve other functions. In this half-length portrait of a fisherman at Wells-next-the-Sea, Norfolk, the coil of rope not only points to the subject's occupation but also gives him something to do with his hands and prevents the blue tunic from becoming too dominant an element. The portrait has an improvised feel to it, which derives from the use of available light and from the casual, easy-going way that Perry asked the man to pose: there were no elaborate instructions, off-putting reflectors or pernickity adjustments to the background. However, careful attention was given to the lighting. The subject was asked to step back so that his face would be set off against the band of shadow cast beneath the shed where he kept his lobster pots. An incident light meter reading was used as the basis for bracketing.

Animal pictures often work especially well when at least some of the animals in the picture are shown reacting to the photographer. Although Perry took this shot of goats on the Greek island of Milos from many yards away with a 200mm lens, some of the creatures sensed his presence, and their alert, tense expressions and postures give variety to the grouping. The main focus of the composition is a small but significant detail — the leader's magnificent curved horns. But, of course, what attracted the photographer in the first instance was the colour contrast of white pelts with the scattered red blooms of the poppies. To allow an exposure of 1/125 at f/5.6 (on Kodachrome 64 film), Perry rested his lens on a convenient gate.

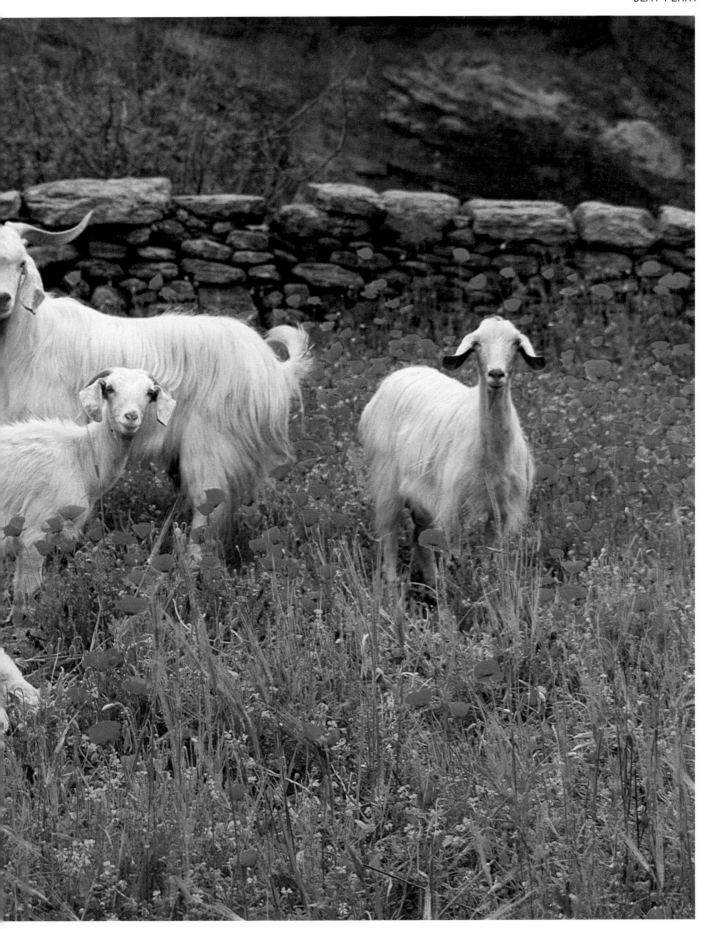

As in the portrait of a fisherman on page 119, Perry has here pointed his camera into a shadowy interior, exploiting the lighting contrast to add mood and compositional strength to a portrait. The setting is the shed housing the now obsolete lifeboat at Cromer, Norfolk, which is on public display. The stern-looking custodian of the boat is shown holding a portrait of its ex-skipper. But by making the boat itself the dominant theme of the picture, Perry has emphasized the importance that the sea has always played in the life of this small community. Frontal lighting from an overcast sky has entered the vast open end of the shed from behind camera, showing detail on both sides of the lifeboat's prow and highlighting the custodian. The unorthodox pose, which leaves only the face and hands visible, is a bold stroke that strengthens the image's impact. Slight underexposure of the boat's paintwork has enriched the colours.

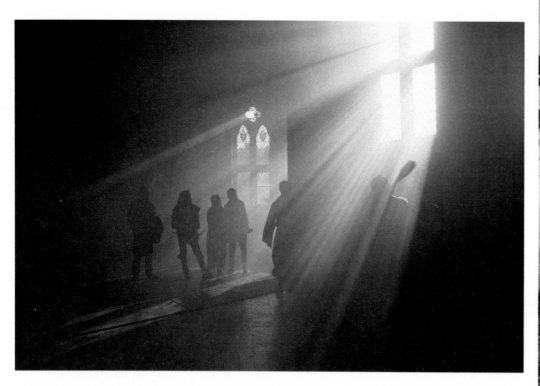

Mysterious figures in unfamiliar dress cluster conspiratorially in the shadowy interior of an imposing building whose single stained-glass panel helps to give the whole scene a romantic, medieval air. Our first impressions are in fact entirely appropriate to the subject of this photograph — a group of costumed participants in a mock-medieval war game ("Treasure Trap") in a castle in the English Midlands. Exposing for the highlights, Perry has made optimum use of the lighting to enter into the spirit of this cloak-and-dagger fantasy. The misty effect comes from the

radiating sunbeams falling on smoke from a firebrand held by one of the gamesters. A tripod-mounted camera was used, with a 35mm lens. The precise effect was impossible to preview in the viewfinder, so Perry shot a whole roll of Kodachrome 64 film, bracketing exposures. He used his hand as a substitute lens hood to prevent patches of flare from breaking up the radiating sunbeams.

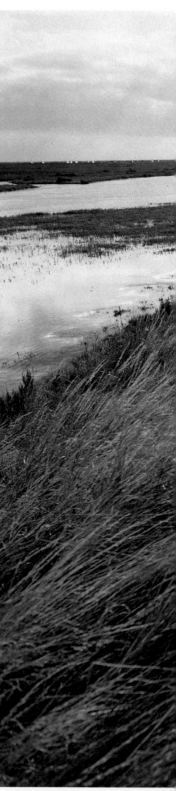

The Norfolk coast, with its vast horizons and delicate lighting effects, has for long captivated the imagination of painters. To record its appeal on film, Perry visited the region on an extended photo trip. He photographed this view from Morston Harbour eastward toward

the village of Blakeney on a dawn expedition, using his Pentax 6 x 7 camera on a tripod with a 50mm wide-angle lens. An effective way to convey an impression of spaciousness in a landscape is to keep the horizon low in the picture frame, so that the sky dominates.

Here, however, Perry has adopted a different approach, exploiting the converging lines of a causeway to lead the eye toward a church tower at the vanishing point and to draw attention to the delicate spokes of sunlight that just manage to pierce the cloudy sky. The composition

conveys the relentless austerity of this haunting but far from picturesque landscape. The camera was loaded with Ektachrome 64 120 Professional film. The exposure was judged by a handheld meter.

Boatman John Wallace is a
well-known local figure in the
Norfolk village of Blakeney, where
Perry took this uncomplicated
portrait expressing the subject's
simple pleasure in his home
surroundings – and the more
extrovert delight of his dog. The
boat makes a perfect frame for the
shot, its white paintwork
contrasting with the dark blue of
Mr Wallace's jersey and the black
of his boots. As always in his
Norfolk pictures, Perry framed
generously, using a 28mm lens to
capture the distinctive flavour of
this coastal region.

To place this sixth-form student in context and contrast her attractive youthful complexion with ancient stonework, Perry chose a cloistered corner of Lancing College as his setting. He used a 35mm lens, bringing the archway into the picture as an effective frame. Sunlight glancing past the pillar gives a healthy glow to the subject's face, whose tones are warmed by an 81A filter. A sheet of newspaper held to the right of the girl threw back the light to fill in shadows. At the beginning of the session, she leaned against the pillar with her coat open, but Perry thought that the grey and pink diamond-patterned jumper was not in consonance with the intended mood of the image. He therefore asked her to button up her coat to create a more subdued effect and an effective background to show up the slightly tense arrangement of her arms.

Again, a prominent area of black emphasizes the hands and face in a posed, semi-formal portrait. The Head Boy at Winchester – another public school in the south of England – shows a dignity appropriate to his high office, with perhaps a hint of wariness. This time, the spreading canopy of a tree provides the shade that Perry so often seeks in his portraiture. The quadrangle beyond, slightly defocused by setting the 35mm lens at its widest aperture, suggests the antiquity of the traditions that the boy has inherited. Bracketing at one-third stop intervals yielded an exposure that preserves foreground detail but without bleaching out the scene behind.

Perry used his Pentax 6 x 7 medium-format camera, loaded with Ektachrome 64 120 Professional film, for both portraits on these pages. The image above shows Lionel Millet, lighting entrepreneur and builder of nuclear fall-out shelters. The photograph was taken in Mr Millet's office, but there were no features here of special compositional interest, so Perry decided to make the background anonymous, concentrating our attention instead on the plans for one of the shelters. He asked the subject to unfold the plan, though without taking his eyes off the camera. Diffused flash to the right of the picture was the only light source.

The actor John Hurt is portrayed here in his London home holding photographs of himself starring in a dramatized version of Dostoevsky's novel *The Idiot*. Available light in the picture comes from a tungsten reading lamp, which Perry angled toward the back wall of Mr Hurt's study to spread its effect. Fill-in flash, diffused through a piece of gauze, was used from right of camera to lighten shadows in the foreground. The cream-coloured rear wall, which received most of the light from the desk lamp, picked up an orange cast on daylight-balanced Ektachrome 64 film — an effect that prevented the wall and the white jacket from merging into each other. To keep the left side of the background dark, Perry draped a sheet of black cloth over a piece of furniture behind the sitter.

In 18th-century English paintings, gentleman landowners are often depicted in the context of their estate, with the house in the middle or far distance. Here, Perry has given a novel twist to this idea: the subject of the portrait is not the owner of Holkham Hall, Norfolk (which we see in the background), but the gamekeeper. Perry walked round the park with him in search of a suitable location that would allow a view of the hall at a discreet size in the picture frame. One problem was the dull sky, which had to be kept inconspicuous. Four or five different trees were tested and rejected before Perry spotted this one with its thick bowed branch that could serve as a mask to blot out the sky. The tree frames both the house and its employee, emphasizing their relation with each other. To give added zest to the foreground, Perry asked the subject to try out various ways of holding his cleft walking stick. This diagonal position, leading our eyes to the face, worked most successfully.

During his stay on the north Norfolk coast, Perry would occasionally venture out at dawn with his Pentax 6 × 7 camera and a tripod to try to capture atmospheric light effects. Along this stretch of coast there are several harbours which offer excellent opportunities for duplicating the impact of an interesting sky through creative use of reflections. This viewpoint at Blakeney was one that Perry revisited several times with this intention in mind. Apart from the weather, the other important variable was the arrangement of boats, whose disposition within the frame could make or break a picture. Usually, there were one or two diagonally arranged masts which usefully linked the sky with the foreground. This picture not only works in its own right but also makes a fascinating sequence with other shots taken at different times of day and in different weather conditions from exactly the same viewpoint.

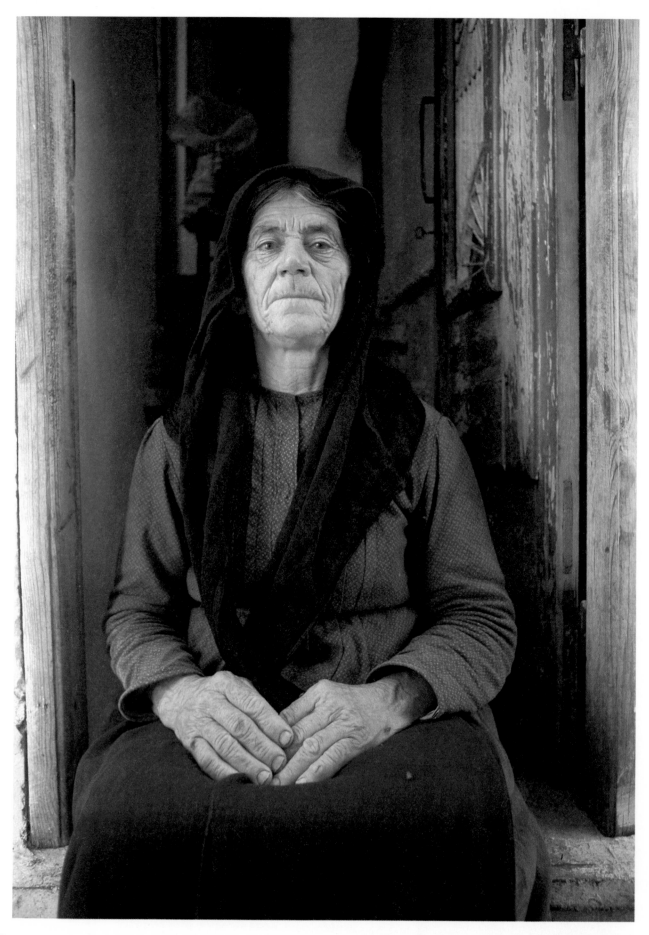

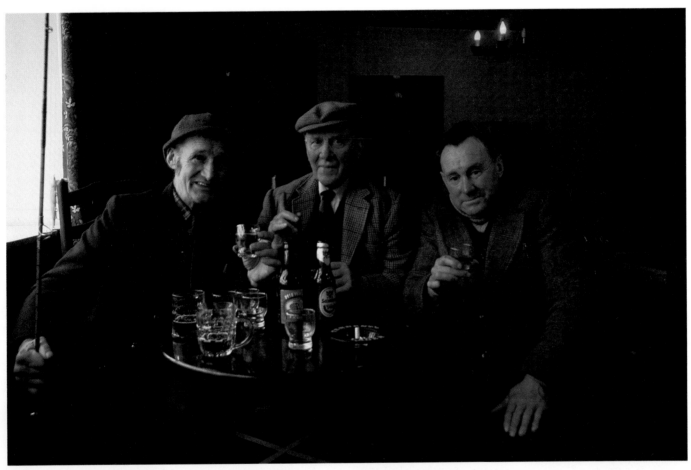

As we age, our faces become lined with the marks of character and accumulated wisdom. The wrinkles and lines of age can be just as good-looking in their way as the bloom of youth. To emphasize the robust health of a woman who had spent all her life in the benevolent climate of Crete (left), Perry brought her out onto her doorstep, avoiding the low-key, shadowy approach that is perhaps a more obvious one to take when photographing the aged. The weather-worn door makes an appropriate setting, underlining the fact that this is a culture where people, like buildings, are allowed to age gracefully, without any attempt at superficial disguises. A 28mm lens enlarged the apparent size of the woman's skirt, giving her a sense of rooted, down-to-earth stability, and also focusing attention on her characterful hands.

Three Scottish fishermen in a pub enjoying a tot of whisky after a spell of trout fishing on the loch, make an image eloquent of simple pleasures gratefully enjoyed. To begin with, the men all had their backs to the window. Had Perry photographed them from a head-on viewpoint, the view beyond the window would have burned out to white, sabotaging the sense of the pub as a homely, cocooning refuge. To avoid this problem, he asked the men to move clockwise around the table so that he could more easily choose a viewpoint that excluded the window panes. Sunlight entering the room obliquely bounced off the deep white edges of the window alcove, spreading the light and reducing contrast to a manageable level. A second window behind the camera position filled in shadows on the right-hand side of the picture. Note how the glassware and the reflective foil of the beer bottle top add sparkle to the picture.

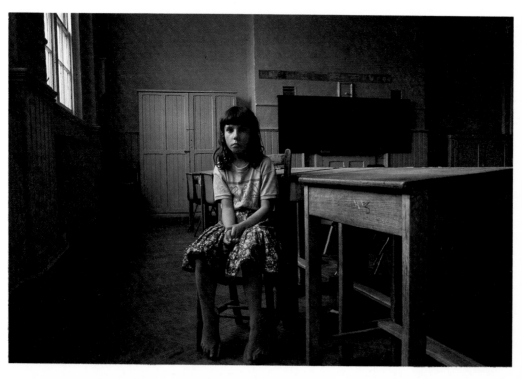

Perry was struck by the bleakness of this Victorian schoolroom in the impoverished London borough of Newham. There were no plants, no colourful mobiles, no shelves of books. The environment seemed designed to make life as uncomfortable for the children as possible. To emphasize the Dickensian austerity of these surroundings, and the sense of imprisonment, Perry decided to show his subject just sitting there in complete isolation, on a chair too high for her – as if she had been made to stay late as a punishment. Deliberately, he excluded any sign of recent activity: the blackboard has no chalk marks, the desktops are empty. A 28mm lens exaggerated the size of the foreground desk, emphasizing that it was designed without any thought of comfort. When Perry visited the room, the lights were on, but he switched them off to take the photograph; the tungsten lighting would have cast a warm, hospitable glow quite out of keeping with the room's true character.

This photograph offers another grim scene from Newham – perhaps a comment on what lies in store for the young girl portrayed opposite unless she can break out of her environment. Perry was fascinated by the room itself, with its tidy but ugly furniture and its busy floral patterns, as well as moved by the lonely plight of the woman. To accentuate the claustrophobic feel of one-room living, he excluded a direct view of

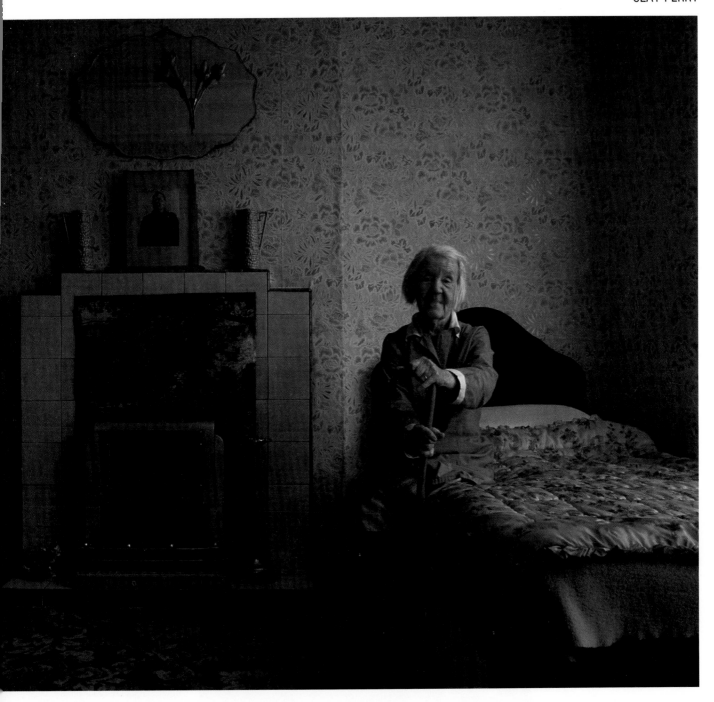

the window: only the reflected
highlight on the TV screen hints at
the world outside. The sitter has
been kept small in the frame and
displaced to one side – as if to
convey metaphorically the fact that
she is no longer in the main stream
of life. To avoid frightening the
lady, Perry kept equipment to a
minimum, but used a tripod to
support the camera.
Underexposure has helped to
evoke the gloomy atmosphere.

Theatre people inhabit a world of unreal lighting effects with brilliant highlights and mysterious shadows – not only on stage but also in the wings and in dressing rooms. Perry was intrigued by this aspect of the theatre when he visited the London Festival Ballet on tour in Norwich. Backstage areas, in particular, seemed to have a dimly lit, old-world atmosphere, which he attempted to capture in photographs. Despite the low-key lighting, he chose Kodachrome 64 film for all the shots on these pages, for the sake of its excellent colour rendition and freedom from grain. The picture at right, taken with a tripod from the wings using available stage lighting during a performance of *Giselle*, shows how extreme lighting contrasts can be exploited creatively. The silhouetted figures of the chorus make an unusual frame not only for the lovers but also for their own, more brightly lit counterparts on the opposite side of the stage. The 35mm lens was set at an aperture of f/8. A shutter speed of 1/8 has blurred the lovers, adding to the romantic mood of the image.

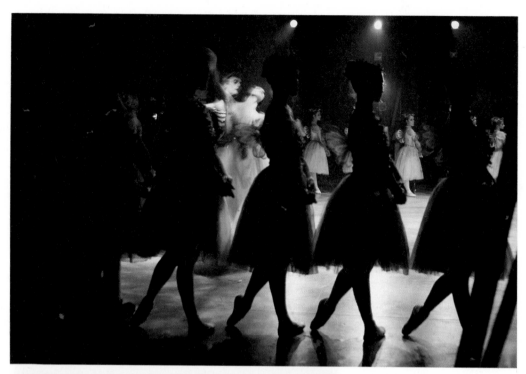

Although flashlit, this view of a ballerina in repose between rehearsals (right) has the atmosphere of an available light picture. To achieve this natural effect, Perry set his Bowens Monolite flash unit to half-power and positioned it some distance to the left of camera. Its relatively hard light has preserved black shadow areas on the right side of the picture. Central framing of the sitter has concentrated full attention on her interestingly compact pose.

This close-up of a trunk full of ballet shoes, taken with a 28mm lens, forms a bright quadrangle of light against a dim background of storeroom clutter. Without appropriate filtration, the fluorescent lighting in the room would have made the shoes look green on daylight-balanced film. Perry therefore used a 40 red filter, which rendered the colour more naturally. The lettering on the lid of the trunk was included in the shot as an instant guide to identification.

KIM SAYER

Born in St Andrews, Scotland, in 1946, Kim Sayer trained at the Portsmouth and Brighton Colleges of Art, then spent two and a half years working as assistant to a succession of advertising and reportage photographers before setting up as a freelancer. Currently, he does both studio and location work for various advertising agencies, design groups and magazines. Landscape and portraiture are his preferred genres, although he dislikes being pigeonholed: in his own words, "so many subjects interrelate that it is beneficial to be confident in a whole range of areas."

Without undervaluing technical expertise, Sayer believes that the final effect should be simple and direct: "photographic techniques should not dominate the picture even if complex methods are used. Landscapes should draw you into them and portraits must reflect the character of the sitter."

Although illustrating his mastery of landscape and portraiture, the following portfolio places more emphasis on a third aspect of Sayer's creativity – his skill in photographing people reacting together in complex, dynamic situations, whether at a regatta or a military ceremony. The mood may range from sombre to joyous, depending on the event and on Sayer's reactions to it.

Alertness at all times is the key to the success of many of Sayer's photographs. The advantages of being prepared for the unexpected are tellingly shown by the picture opposite, taken only a few minutes after a long session photographing H.R.H. Prince Andrew. Many photographers would have relaxed after completing their assignment, but with typical pertinacity Sayer scanned the fringes of the action and captured this graphic image with one of the last frames in the camera.

Some of the best chance shots look as though they are the results of the most elaborate preparation. This dynamic image, built upon a brilliant contrast of naval white with a deep blue sea, has what Sayer calls a "super-clean soap-powder quality". And the perfectly balanced composition, with an apparently posed model, reinforces this impression of an advertising shot taken from a studio platform. However, the picture was actually photographed from an aircraft carrier in the Caribbean, and was absolutely spontaneous. Although the absence of shadows looks unreal, it was the natural effect of the motor launch's position alongside a much larger craft: the whole scene was shielded from the brilliant sunlight, although there was plenty of light reflected off the sea. To make the image more exciting, Sayer tilted the camera. He took the photograph on Ektachrome 64 film with a 105mm lens mounted on his Nikon FE camera. The generous lighting conditions allowed an exposure setting of 1/125 at f/11. No filtration was used.

Like a wild animal, changing weather conditions need to be patiently stalked by the photographer. The "hide" used for this sequence of views of London's Battersea Bridge was a convenient archway that offered shelter from intermittent rain. Sayer took up position while the rain was still a mere threat, loaded his Nikon FE with Ektachrome 64 and framed this view with a 105mm lens. All these pictures were captured within the space of 15 minutes as the storm broke and then quickly blew over. During this time, the sky became a dramatic arena of conflict, with sun and clouds locked in battle. For the first shot

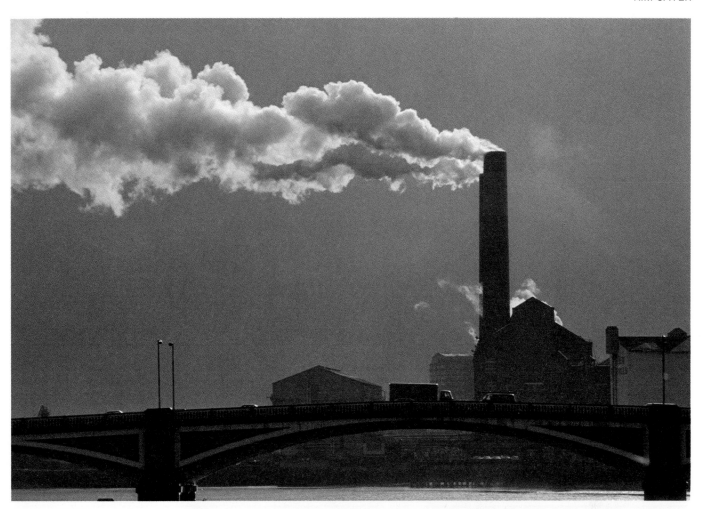

(above left), the exposure was judged from the evening sky and one stop added to yield 1/125 at f/8, which showed a trace of colour and detail in the bridge. When the rain started to fall, Sayer opened up by two stops to create a softer, more pastel effect. For both images on this page, showing the clouds drifting on over the Thames and losing all their menace, he reverted to the original exposure.

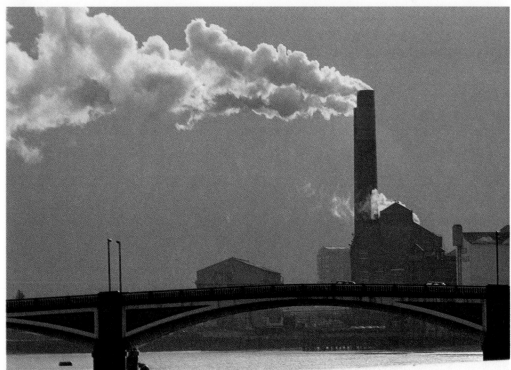

The Widelux F7 panoramic camera used for both pictures of the Henley Regatta shown on these pages has a 26mm lens which rotates quickly when the shutter release is pressed, exposing an image onto 35mm film through a slit in the back of its housing. The angle of view is 140°, and a 36-exposure film yields 21 images. The maximum aperture is f/2.8, and there are effectively three shutter speeds – 1/15, 1/125 and 1/250. These cameras are costly to buy, but many photographers rent them occasionally to cover special events where the panoramic approach is likely to be fruitful. Interesting effects occur when there are moving subjects within the scene. For example, in the view above, the rowing boat was travelling in the same direction as the camera's lens, so that it appears intriguingly stretched in the photograph. Sayer took this shot from a punt moored in the middle of the River Thames, which made a tripod virtually useless. Despite the difficulties of handholding this unwieldy camera, he has managed to produce a lively and technically impeccable picture.

Sayer finds his Widelux excellent for portraying crowds of people. The broad field of view corresponds almost exactly to the scope of the human eye. One problem is that the eccentric format can present difficulties for photojournalists who rely on magazine work – but, of course, there are plenty of opportunities for creative cropping. Sayer took this view of the Henley enclosure (right) for a book on English sport and society, again handholding the camera. The exposure setting was 1/125 at f/5.6, using Ektachrome 64 film.

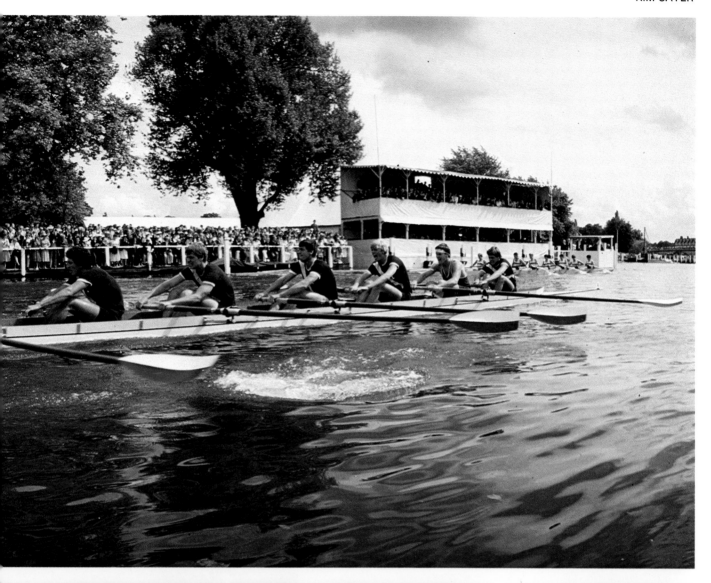

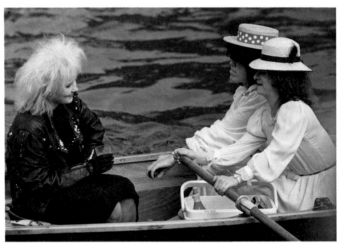

At a regatta, carnival or other festive event, the key to successful photography is to look for fleeting compositions that make sense of all the random and contrary movements, and seize them as they occur. When Sayer noticed this tryst between an oarsman and his sweetheart (left), he instantly saw the photographic potential. Two aspects of the scene were especially striking. One was the limited colour range; the other was the division of the view into two mutually exclusive zones — the lovers and the spectators were invisible to each other, which gives the scene a distinctly stagy quality. Sayer already had his 105mm lens on the camera, and he was able to take several frames before other people intruded on the scene and undermined the image's impact.

From his hired punt in the middle of the Thames, Sayer was ideally placed to capture unusual vignettes of the Henley Regatta as various boats passed by. To record this amusing juxtaposition of dress styles and unusual facial expressions, Sayer closed in with an 80-200mm zoom. The fixed viewpoint made the zoom virtually essential for such closely framed images. Another advantage of the zoom was that it prevented Sayer from having to change lenses or cameras, which would have been awkward on the small boat rocked by passing traffic.

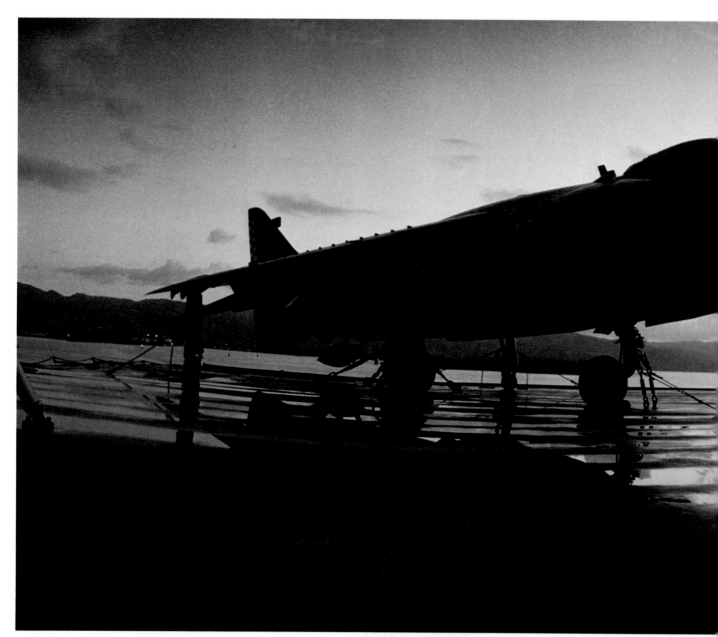

A sleek Harrier jump jet, outlined against a tropical sunset on the flight deck of the aircraft carrier *HMS Invincible*, makes a suitable subject for the dramatizing lens of the Widelux panoramic camera. To be sure of keeping the camera horizontal in order to avoid distortion, Sayer set it up on a tabletop tripod. This does not prevent the line of the deck from arcing into a bow: this camera will show all horizontal lines as curves unless they are at the exact centre of the frame. However, the bowed effect improves the composition rather than weakens it. The wet flight deck reflects a cloudy sky, imbuing the image with a sense of space. The exposure was 1/15 at f/8 (Ektachrome 64 film).

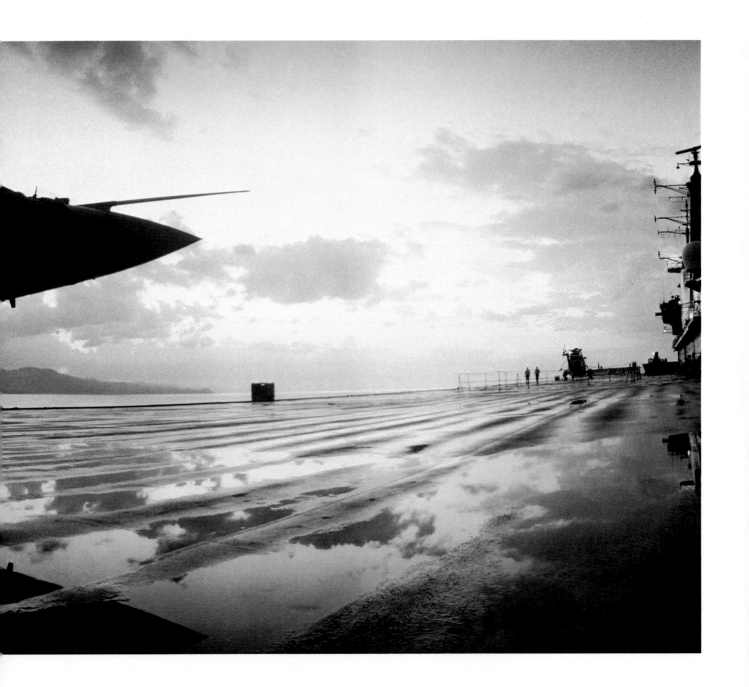

There is a serious risk of camera shake when you attempt to handhold a camera with a 105mm lens at a shutter speed of 1/60. However, this double portrait of a Light Infantry bugler and a Royal Naval Officer of the Watch saluting the lowering of the White Ensign on board *HMS Invincible* was too good to miss, and the light was insufficient to allow a faster shutter. By closing in with the 105mm lens and excluding any details of the aircraft carrier's superstructure, Sayer was able to abstract the context of the shot. He deliberately restricted the sea to a narrow strip. Central framing of the figures has heightened the ceremonial nature of the occasion.

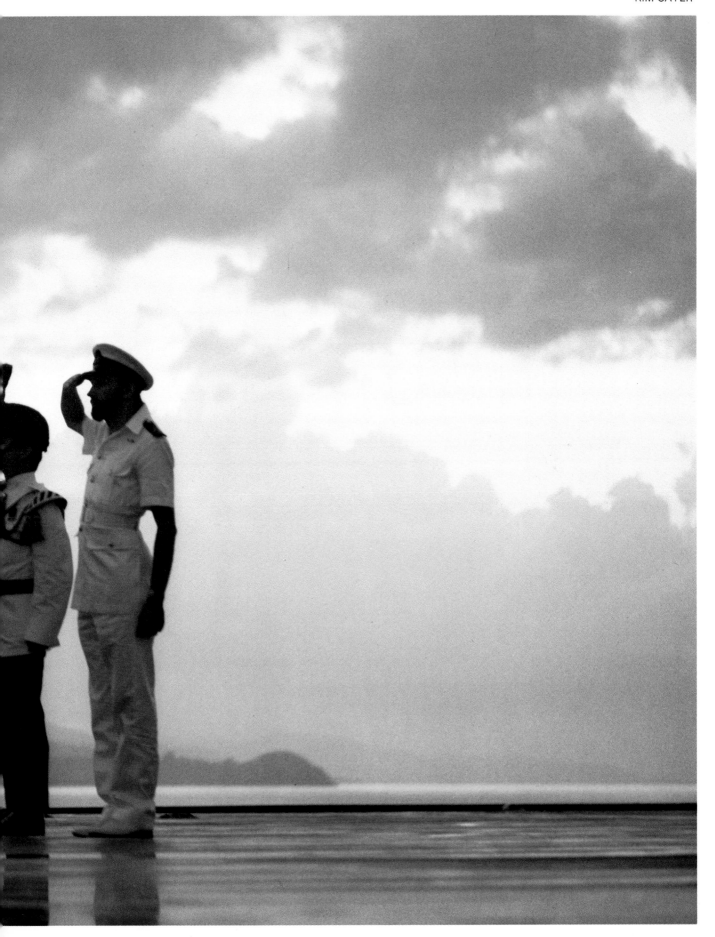

Another image taken during Sayer's photographic trip with the Royal Navy on *HMS Invincible*. The occasion is the presentation of medals to a group of officers in recognition of their service in the south Atlantic. By fitting a 35mm lens, Sayer has created a lively composition in which all the diagonals converge on the figure of the admiral, where the officers' eyes are also trained. The picture is thus an effective image of naval hierarchy. The pale ceiling and the white uniforms helped to distribute the available light, allowing an exposure setting of 1/60 at f/8 (Ektachrome 64 film) with a handheld camera.

Life aboard *HMS Invincible* was not all ceremony. This brooding stormscape, helping to evoke an atmosphere of impending action, makes a striking contrast with the medal-giving scene on the previous pages. The blustering winds and the seesawing of the ship would have made a tripod ineffective, but Sayer felt that he could get a sharp picture with his 50mm lens if he let his legs absorb the engine's vibration and the buffetting of sea and wind. A shutter speed of 1/125 at f/5.6 facilitated this crisp result and froze the whirling action of the rotorblades. To emphasize the ominous clouds, Sayer used a graduated neutral density filter. The yellow and red colour accents enliven a predominantly monochrome scene.

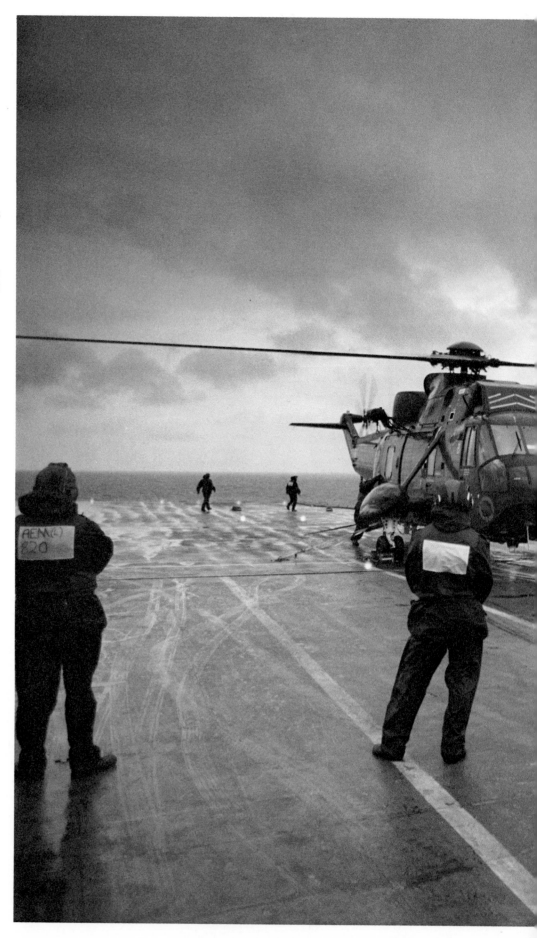

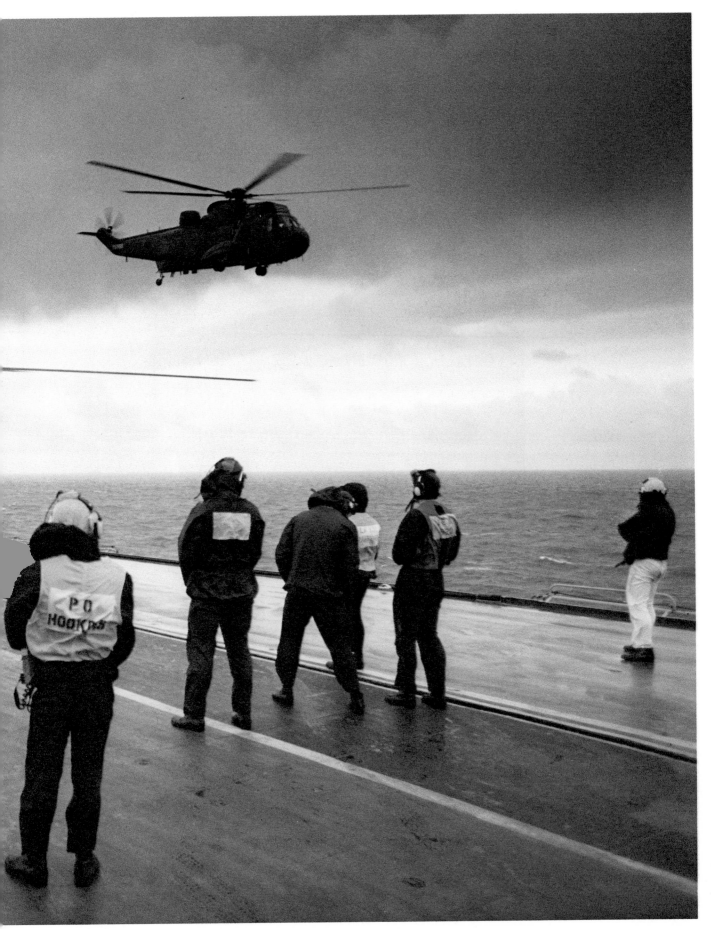

A cricket match in leafy surroundings is the epitome of an English summer afternoon. Sayer took this view from the boundary of the field with a 50mm lens, at 1/60, f/8 (Ektachrome 64 film). Taking a creative risk, he allowed a blank foreground to occupy half the frame — a gamble justified by the patches of yellow which speckle the grass, and by the way that the foreground leads our eye toward the players. The viewpoint was chosen to show the familiar tower of Magdalen College in the background, to indicate the location as Oxford. An 81A filter warmed up the tones.

Cricketers check the scorebook after a village match in this early-evening shot, taken on Kodachrome 64 film with a 35mm lens (1/60 at f/8). The sportsmen were so involved in what they were doing that they remained unaware of the photographer, despite the close viewpoint. The warm sidelight gives a summery atmosphere to the scene, though without throwing a colour cast on the brilliant whites of the sports clothes. No filtration was used. The fringe of leaves at the top of the frame pulls together the composition, yet is not obtrusive enough to become a cliché. During printmaking, the original image was cropped slightly: a cricketer walking out of the frame at the left and some ground-level clutter at the right were shaved off to create a tighter picture.

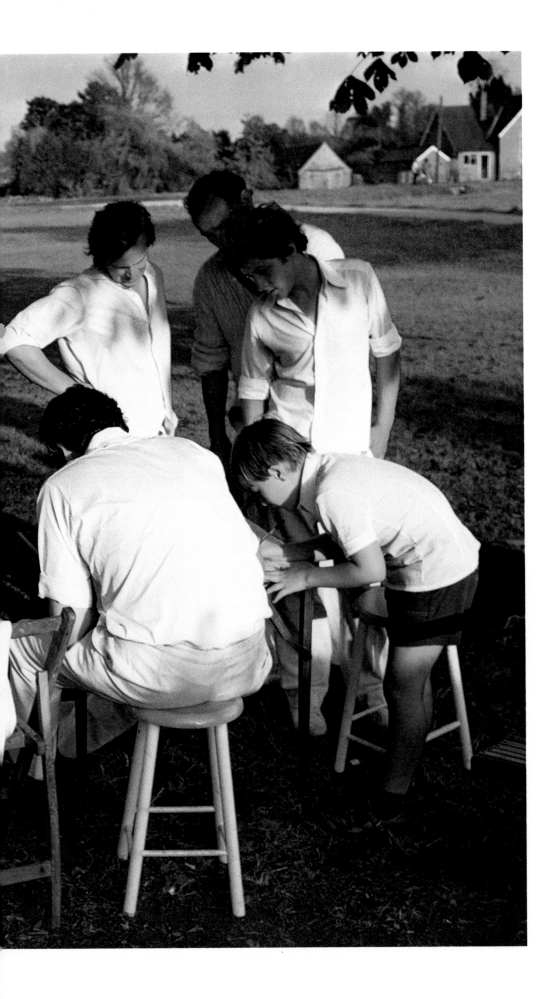

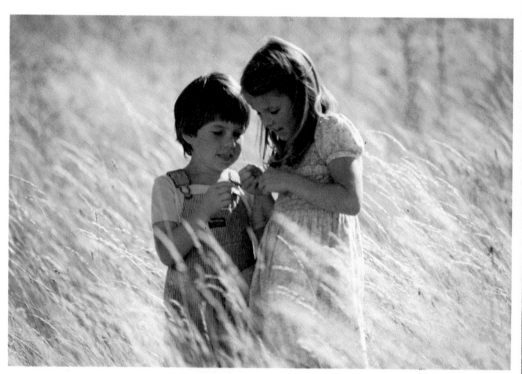

This double portrait in a field of grass was a set-up shot, but to ensure a natural feel Sayer encouraged the children to look for wild flowers and took the photograph from a distance with a 300mm lens. Handholding the lens gave him more opportunity to change his viewpoint as the subjects wandered freely in the field in search of specimens. An aperture setting of f/5.6 blurred the background to isolate the backlit figures and allowed a shutter speed of 1/250 to prevent camera shake (Ektachrome 64 film). The pale tone of the grasses reflected light onto the subjects, evening out the contrast in the scene.

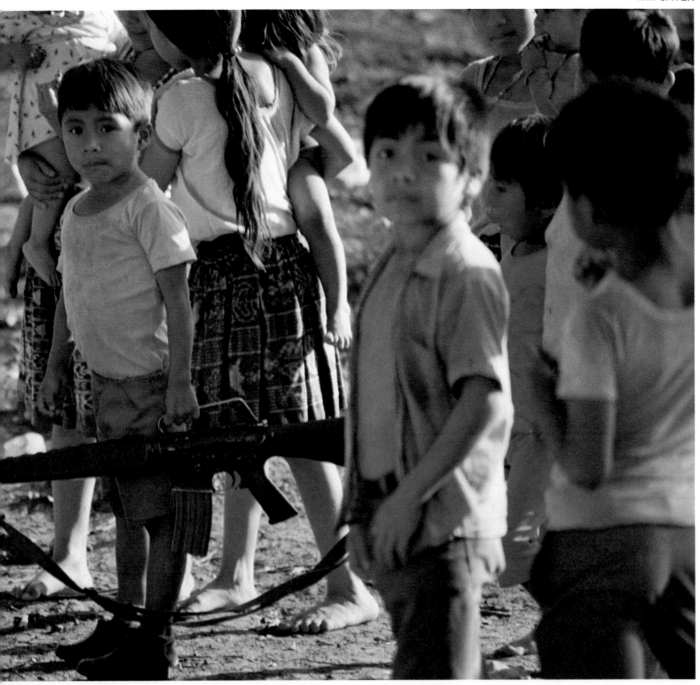

The innocence of children can become poignant and even frightening when the harsher realities of adulthood intrude. This reportage picture, taken in Belize when Sayer was on a photo mission with the Royal Navy (who were deploying British Army troops), depicts a fraternization exercise with a border village; however, the soldier's gun in the child's hands has chilling overtones. To emphasize this central part of the picture, Sayer focused selectively, setting his 105mm lens at setting f/8, which reduced depth of field sufficiently to blur the foreground figures and the rocks in the background. The camera was handheld.

A studio portrait of William Rushton – broadcaster, writer and entertainer – gains in impact through close cropping at the picture taking stage, rather than during printmaking. The equipment used was a Hasselblad EL fitted with a 150mm lens. Rushton was leaning on a tabletop, but by excluding all details of the support Sayer has made the subject seem larger than life. A more practical purpose behind the off-centre framing was the intended use of the picture on a double-page spread in a magazine: there had to be space for the text, and it was important too that the head should be clear of the central join. A key feature that breathes life into the shot is the catchlights in the eyes, formed by the reflection of a studio flash unit with brolly. This light, frontally positioned, was brought up close to the subject to give good coverage and prevent too soft an effect. The background was lit separately, so that it would burn out to a featureless white.

JERRY TUBBY

Jerry Tubby (born at Calcutta in 1943) never took a photograph until he was 23 years old. At that time he was in the midst of a dentistry course at Durham University. Rapidly becoming addicted to photography, he decided not to qualify as a dentist but instead headed to London and found work as second assistant to fashion photographer Bill King. It was then that be began to learn the importance of skilled work in the darkroom – a principle to which he still passionately adheres, as evidenced by the portrait opposite. After leaving King, he freelanced as an assistant for five years – ''I think I was the first ever freelance assistant!'' – and then set up on his own, working initially for book publishers and magazines and later for advertising clients. Currently, his scope is extensive, encompassing room sets, food and still life in the studio and both interior and exterior location work and reportage. Tubby's approach to photography resists any attempts at tidy categorization: there is no easily recognizable style, because he approaches each subject without preconceptions, choosing the equipment and technique that will do justice to the scene's inherent qualities. Generally, he prefers to create a natural ambience if the brief permits, preferring to manipulate available light by reflectors if necessary, rather than resort to flash. He is acutely sensitive to atmosphere, particularly when it is strengthened by a subdued range of colours; however, he is also attracted to graphic close-ups, and textures have a special appeal. When working with 35mm film, he uses a wide range of lenses, including 300mm (sometimes with a converter), 105mm, 50mm and, perhaps most frequently, 28mm wide-angle.

The scissors and cut strips of film in the foreground of this medium-format studio portrait help with identifying the subject – a film director, well-known in the industry for his work on commercials. The sidelighting was supplied by a heavily snooted "fish fryer" (large studio light) placed relatively low, with a spotlight trained separately on the background. Because the spot was positioned to skim the background paper at an extremely fine angle, it has exaggerated the wobbles in the paper's surface, creating an attractively smokey effect. A white card reflector to the right of the camera prevented the shadows from clogging up completely to pure black. Even so, because of its rich range of tones, the negative demanded careful printing.

Tubby noticed this beautiful sunset developing while walking near the Chiltern Hills, which overlook the Thames valley. Realizing that he had perhaps twenty minutes to catch it, and that the view would be much better from a nearby escarpment, he hurried to his car and drove furiously up the hill — only to find that the outlook from the top was heavily obscured by mature trees. It looked as if the best prospect would be obtainable from some gardens of private houses built along the scarp edge. Tubby therefore knocked at a door and asked permission to photograph from the lawn. By this time, the sun had sunk low and had the illusion of seeming larger because of its close proximity to the horizon. A 300mm lens and 2x converter further exaggerated its apparent size. The exposure was around five seconds at f/11 (Kodachrome 25 film).

A restricted range of hues lends impact to this closely framed image of a cottage in a small village in Eire, photographed on Kodachrome 64 film with a 28mm lens (1/30 at f/8). The urbane colour scheme seemed quite out of place in such a remote environment: "this could have been the weekend home of a trained graphic designer," Tubby commented. The flowers behind the ground-floor windows pick up the predominant colour theme, while the grey of the woodwork blends with the pavement and road.

These beach huts in Normandy had a pristine quality, as if they had never been used, and to enhance this impression Tubby photographed them on a blustery day when both the promenade and the beach were deserted. He chose the viewpoint carefully to ensure that all the rooftops except those to the extreme left of the picture would fall just short of the horizon: a lower viewpoint would have brought the roofs into the sky area, interrupting the straight skyline and robbing the image of its sense of forlornness. As in the picture on the previous pages, the view depends for its effect on limited colour. It was taken on Kodachrome 64 film with a 28mm lens.

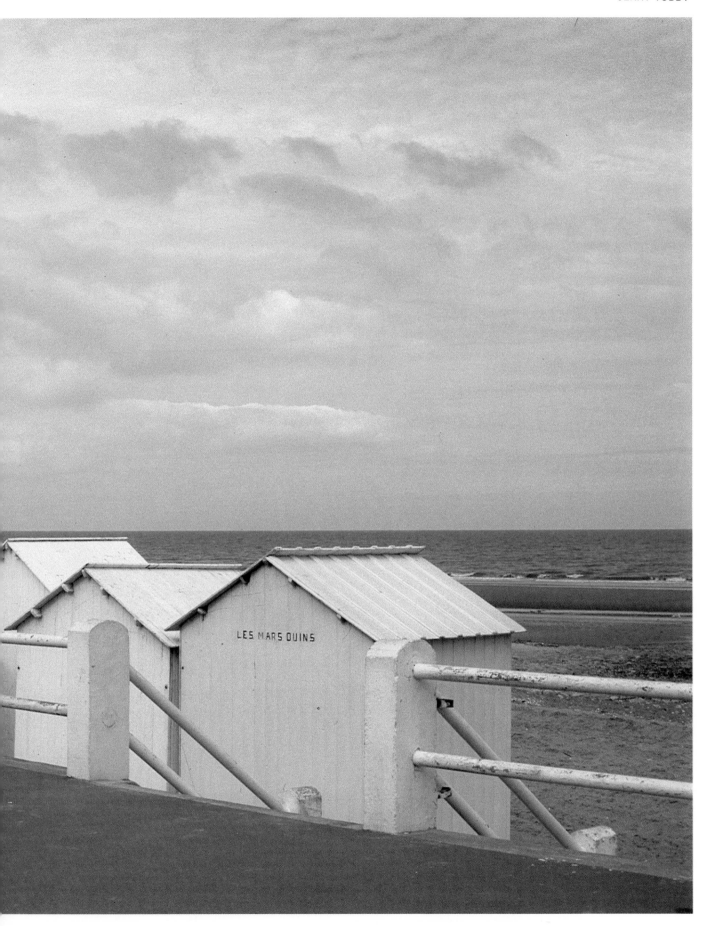

Little preparation or reasoned thought went into this image – it is frankly a grab shot. Nevertheless, Tubby considers it one of the most satisfying pictures he has taken. The scene is a pavement café in Le Havre, France. The appeal of the photograph derives not only from the vivid colour contrast but also from the complementary textures. In the photographer's own words, "the sympathetic surfaces send the eye spinning non-stop around from the terracing on the pedestal to the ribbing on the socks, from the perforations of the shoes to the structure of the drain, and from there to the concrete in the foreground." To frame these effects from a close viewpoint, he set his 40-80mm zoom lens to its shortest focal length.

Panning is a technique that lends itself to creative experiments. The standard approach is to set a relatively slow shutter speed – perhaps 1/60 or 1/125 – and swing the camera round to follow the subject, pressing the shutter release at some point along this arc. Tubby has here tried a freer variation on this technique, setting a slower shutter speed. He took the shot while visiting a school where various products of extruded and moulded plastic were being tested by the manufacturer. Not surprisingly, the children began to use some of the equipment for a purpose not envisaged by the original designers. To capture the high-spirited enjoyment, Tubby fitted a 28mm lens, set the camera to 1/15 and panned with this boy as he was propelled along at hectic speed in his improvised go-cart – passing within two feet of the photographer! Because the cart was slewing sideways as well as sliding forward, all parts of the picture except the left side of the boy's face have become distorted, conveying the reckless energy. The photograph shows the advantage of including colourful areas in panned shots: the streaked highlights of the runner express movement far more effectively than the even-toned background, where the streaking is much less apparent.

The shadow patches cast by foliage can be used to add pattern or tonal variety to a portrait, provided that the basic composition is kept simple. Here, a bright highlight under the eye helps to concentrate our attention on the man's face, and balances the broader sunlit areas on the shirt. The subject is a Spanish farmer, photographed while Tubby was on holiday at Nerja, near Malaga. The man had the unnerving ability to materialize suddenly out of the landscape, or to dissolve back into it, without making a sound — a tendency hinted at by the camouflaging effect of the shadows and dangling grapes. A 105mm lens produced a flattering view of the face, though without forcing the photographer beyond conversational range of the subject. The farmer was flattered to be asked to pose, and received a print as a token of thanks. The exposure was 1/125 at f/5.6 (Kodachrome 25 film).

Fruit is a traditional subject for a still life, but by filling the frame with these peaches and limiting the colour range, Tubby has treated the familiar genre with refreshing originality. Slicing one peach open and carefully arranging the halves has contributed to a harmonious composition. The picture was taken by available light from a window from above and behind the subject. Two strategically placed brown paper bags lightened the shadows and enhanced the warmth of the colours — a white reflector would have had a perceptibly colder effect. A 28mm lens was used at its closest distance on a tripod-mounted camera. The exposure was half a second at f/16 (Ektachrome 64).

Some landscapes, especially those that have been regularized by modern farming practice, are ideally suited to an abstract treatment, emphasizing line, pattern and colour rather than contours and picturesque detail. Such an effect is best achieved with the selectiveness of a telephoto lens. This is the approach that Tubby took toward a field of bright yellow oilseed rape near the Berkshire Downs in southern England. A 300mm telephoto flattened the appearance of the gently sloping hillside. However, Tubby wanted to avoid making the scene appear entirely two-dimensional, so he waited some time for a cloud shadow to fall on the horizon to add just a hint of depth. To reduce the risk of camera vibration in the high wind that was blowing, he placed all his weight down on the tripod. Even so, at a shutter speed of 1/8 second (f/8, Ektachrome 64), the image is slightly soft, although this by no means detracts from its impact.

Symmetrical framing and a restricted colour range go a long way toward explaining the appeal of this view of a tennis player on a practice court at Deauville, France. Tubby was also attracted by the hint of the absurd: the man was trying out his strokes without a ball, and indeed there were no balls anywhere to be seen. Using a 28mm lens, the photographer came in close, resting the lens through a gap in wire netting. An exposure of 1/30 (f/8, Kodachrome 25) froze the player's movements but gave an expressive blur to the racquet.

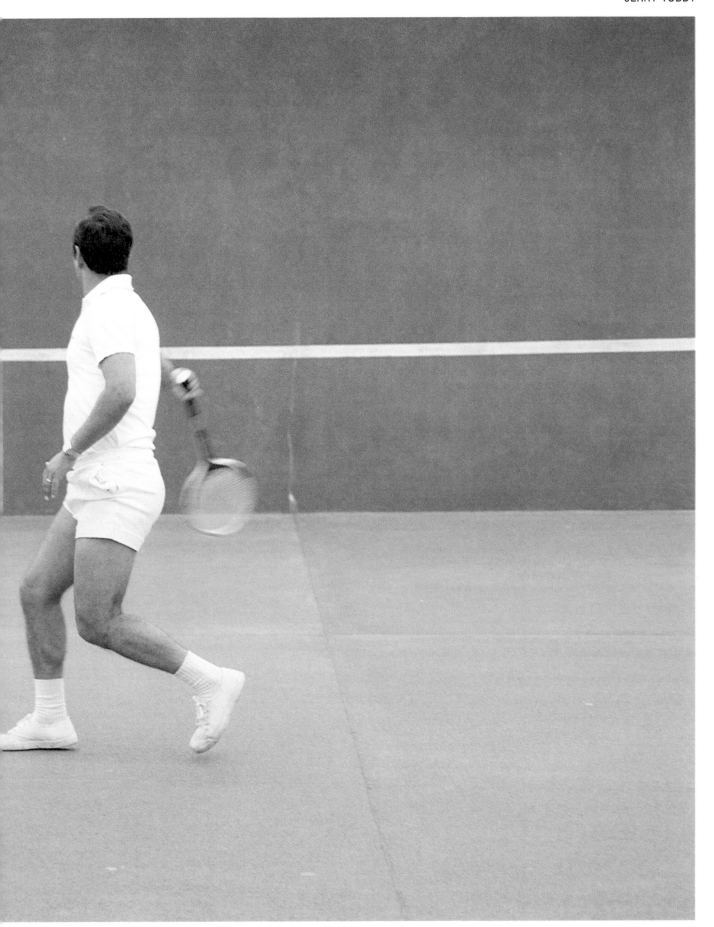

Paris, the city of the Impressionist painters, seemed an ideal subject for impressionistic photography. To create this image of a Parisian dawn, Tubby set his 50mm normal lens at its maximum aperture (f/1.4) and closest point of focus and handheld the camera at a shutter speed of 1/15. Although he would have preferred a little more blue in the light, he decided not to filter for fear of killing the glow of the car headlamps. The camera was loaded with Kodachrome 64, although Ektachrome would probably have given the cooler effect Tubby sought.

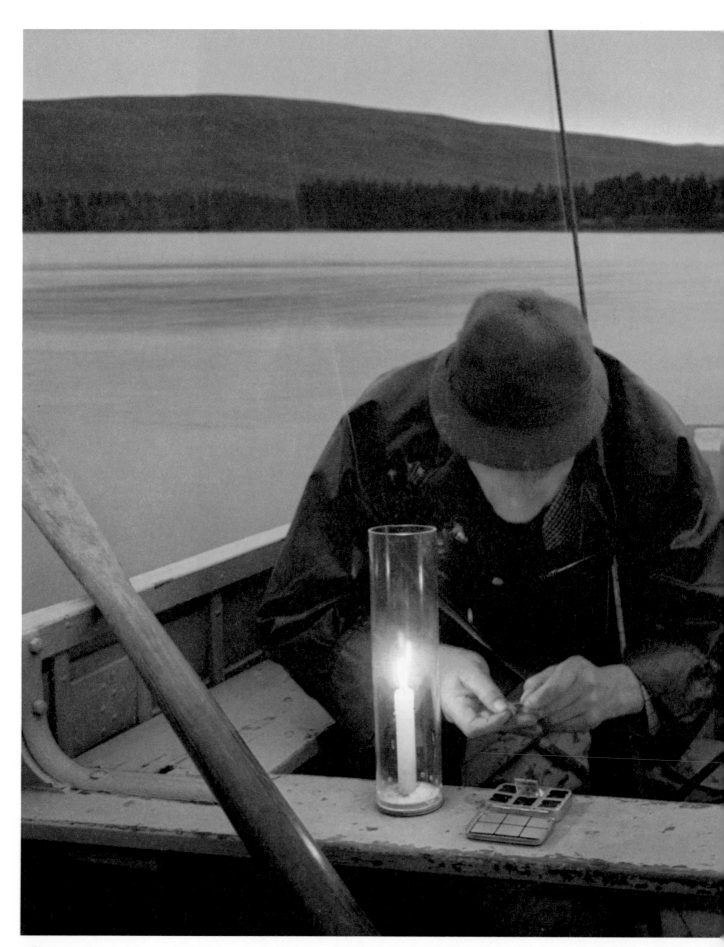

"Dusk photographs are notoriously unpredictable, and it is necessary to start shooting early and finish late. Exposures can get very long, but the results are far from ordinary." Tubby's reflections on this difficult but rewarding time of day are confirmed by the photo session that produced this image of a fisherman changing trout flies by candlelight. He spent an hour of the wintry cold evening setting up the shot and exposing a roll of film. This image, the most successful of them all, demanded a 15-second exposure (at f/16, Ektachrome 64). A 28mm lens created a sense of involvement with the subject. To keep the background sharp, Tubby exploited the simple but marvellously effective solution of beaching the boat.

TIM WOODCOCK

Tim Woodcock was born in Middlesex in 1951. He trained as a photographer before taking up a career as a photographic journalist in 1979. For four years he was assistant editor on one of the UK's leading photo magazines, as well as contributing to the photographic press worldwide. During this period, he was able to explore a multiplicity of different areas within the medium, experiment with the latest equipment and materials and gain valuable experience in the mechanics of publishing and printing photographs. With such a broad base of experience, it was natural that when he switched from the pen to the camera he should choose not to specialize in any particular subject matter nor be tied to any one format.

Despite this versatility, it is as a landscape and architectural photographer that Woodcock is best known and respected. By contrast, his other favoured subject is children. In his own words, "Child photography provides a nice counterbalance against a subject like landscape. Making a landscape photograph is about light and form. It takes time and consideration. The essence of child photography is the 'moment', and often a session is over within minutes. But there is one aspect that is common to both areas and that's patience – although in the case of landscapes, perseverance is probably a more apt word."

An adult's eye view of a child can sometimes make an eloquent image — not least because the downward-tilted camera offers a good way to simplify backgrounds. In this picture the converging planks of a seaside pier not only make a striking visual contrast with the vibrantly patterned t-shirt, but their exaggerated perspective also helps to reinforce the main theme of the image — a child appearing somewhat lost in a world designed on an adult scale. To take the photograph Woodcock used an Olympus XA 35mm compact camera. The camera's fixed 35mm lens was ideal for the composition — wide enough to create an exaggerated perspective effect, but not so wide that it took in irrelevant background detail. The film used was Ilford HP 5, rated at ISO 300.

This evocative image of the stairs to the Chapter House in Wells Cathedral, Somerset, clearly shows the advantage of a perspective control lens (also known as a shift lens) for architectural photography. To take in the top of the arch, it would normally have been necessary to angle the camera (a tripod-mounted Pentax LX) slightly upward. With a conventional 28mm lens, this would have caused the vertical lines in the picture to converge on each other toward the top of the frame. By choosing a 28mm perspective control lens, Woodcock avoided this difficulty. As with a large-format camera, this lens can be moved up or down in relation to the film surface, in order to manipulate perspective. The photograph owes much to careful choice of viewpoint, resulting in a balanced composition: the shadows from diamond-leaded windows add interest to the foreground steps, while in the middle distance the edge of the staircase carries the eye onward through one arch toward another at the back of the picture. An arcing shaft of sunlight highlights the famous feature of this staircase – its unique double-branched layout. The exposure setting was 1/30 at f/16 on Fujichrome ISO 50 slide film.

The Chapter House of Wells Cathedral is undoubtedly the most beautiful in England. Woodcock wanted to photograph its interior, but realized that there would be a limited choice of viewpoints. After considering the possibility of closing in on sculptural details (such as the kings' heads on the stall canopies), he eventually opted instead for a broad symmetrical view revealing the glorious tracery and carved bosses of the vault as well as the arcade encircling the interior below window level. A 20mm lens was chosen to do justice to the scene. As in the adjacent picture, Woodcock tilted his tripod-mounted camera slightly upward; the gently converging verticals, far from spoiling the image, help to underline the monumental beauty of the architecture, and prevent the scene from appearing too static. Luckily, direct sunlight did not penetrate the chapter house, so the lighting is even enough to exhibit all the subtleties of form and texture.

Tim Woodcock is a firm believer in the advantages of carrying a monopod instead of a heavy tripod – especially on longish walks in the countryside. The wisdom of this approach is borne out by this serene *contre-jour* landscape of a yacht on Horsey Mere in the Norfolk Broads. The monopod gave ample stability to a Pentax LX used with an 85mm lens at an exposure setting of 1/30 at f/11 (Fujichrome 50). Instead of silhouetting the scene, Woodcock gave one stop extra exposure to a reading taken from the sky, thus retaining colour and detail in the boat and the surrounding reeds. By positioning the horizon a third of the way up the frame, he has given due weight to the dappled sky and emphasized the sense of spaciousness that characterizes this region of England.

The greenish background gives this botanical study a natural air, but in fact it was photographed in the studio. To close in on the orchid, Woodcock fitted a 50mm macro lens to his Pentax LX, setting the aperture at f/22 to maximize depth of field. Before taking the picture, he checked the area of sharp focus using the camera's depth of field preview button. A studio flash unit with a white brolly, placed just to the left of the camera position, gave a convincing impression of natural light. To distribute the light evenly, a white cardboard reflector with a hole in its centre was placed over the lens. The modelling is just sufficient to prevent an excessively flat effect, but without casting distracting shadows. Fujichrome ISO 50 film revealed the subtle colouring of the flower.

The meeting of a setting sun with clouds hanging low over the horizon can produce some spectacular skyscapes – especially when the sun tinges the clouds' edges with orange light, as it does in this remarkable shot (right). Woodcock anticipated the glorious effect, but realized that the composition would benefit from a vertical element to add an extra touch of drama. A distant church spire seemed to offer the missing ingredient. Acting quickly, Woodcock drove to a viewpoint that showed the sun apparently grazing the spire and captured the view with a 105mm lens on a tripod-mounted camera. An exposure of 1/125 at f/11 (Ektachrome 64) recorded the spire and the nearby clump of trees in silhouette. The spire neatly links the three zones within the picture – the trees, the band of clouds and the glowing sky.

The soaring shapes and exciting materials of modern architecture tend to demand a bold, unconventional approach to composition — by contrast with a historic building like Wells Cathedral (see pages 190-91), which calls for more restraint on the photographer's part. Woodcock was drawn toward the reflective glass walls and geometric stepped structure of this office block on London's Euston Road, so he decided to explore the area in search of suitable viewpoints. This steeply angled view through a 28mm lens distilled the essence of the building, and also made a pattern that is satisfying in its own right. To dramatize the effect, Woodcock angled the camera not only upward but also sideways. The red lift just visible in one of the central wells of the building adds an unexpected colour accent, which contrasts with the blue sky. A polarizing filter would have darkened the sky effectively, but would also have cut down the reflections on the glass walls, so Woodcock wisely chose not to use one. The exposure setting was 1/60 at f/8 on Fujichrome ISO 50 film.

Children often have a quiet, self-possessed dignity, which remains intact even when they are shirtless and splattered with mud. Woodcock photographed this eight-year-old boy in his own environment – a hut in an adventure playground – which boosted the child's confidence in front of a stranger. The boy was cut off from the sight of his companions, so there was nothing to unsettle his serious demeanour. The two humorous touches in the picture – the cheeky face apparent through a gap in the hut wall and the shoes made gigantic by a 20mm lens – serve only to heighten the subject's calm, unsmiling gaze. Fast Ektachrome film (ISO 160) allowed an exposure of 1/30 at f/8, which made it possible to handhold the camera: setting up a tripod may well have caused the boy to lose interest in the photo session.

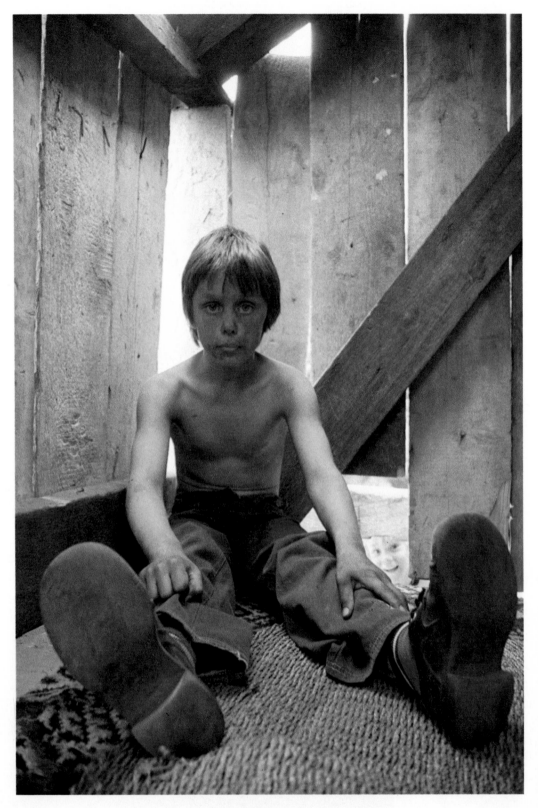

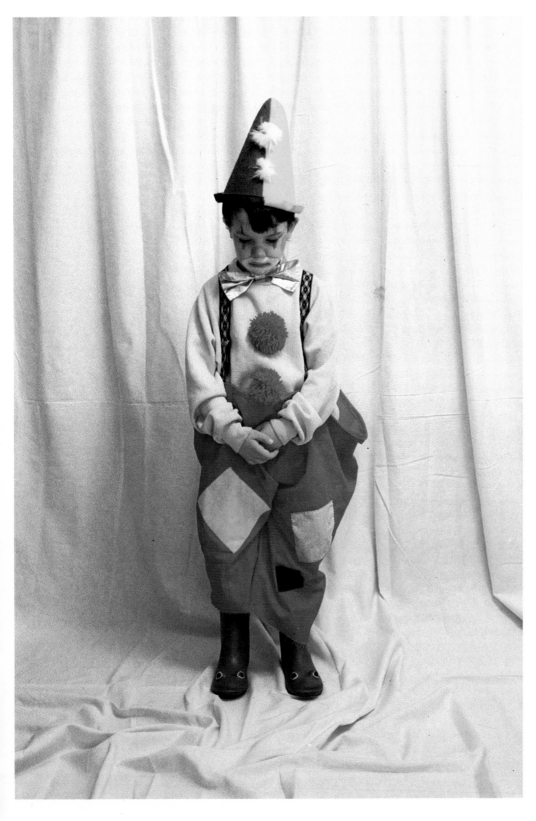

A photographer's studio can be an intimidating place for a child, especially when he or she is subjected to the glare of electronic flash. This boy was delighted with his new clown's outfit, but remained abashed by the presence of so much mystifying photographic equipment. Woodcock's easy manner soon brought forth the smiles, but it was this picture taken early in the session that seemed most powerful – partly because it speaks rather touchingly about the vulnerability of childhood. The intention of the white cloth background was not only to isolate the colourfully dressed subject, but also to conjure up the Big Top. The shot was taken with a 50mm standard lens, necessitating a close viewpoint that eventually helped the photographer to establish a rapport.

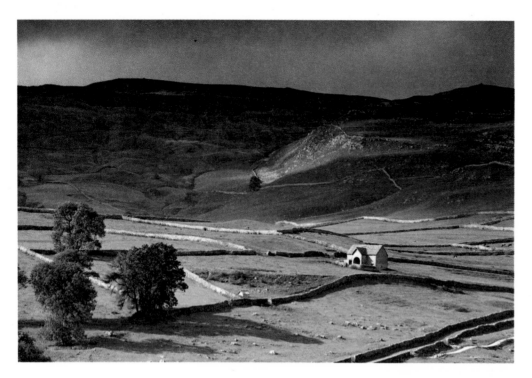

The limestone countryside of the Yorkshire Dales is rich in subject matter suitable for both panoramic views and closely framed telephoto shots, as this complementary pair of images taken near the village of Malham convincingly demonstrates. The stone walls that snake over the lower hillsides in this area create patterns that are distinct yet not too rigid. In the composition above, taken with a 50mm lens, Woodcock exploited late-afternoon sunlight, which emphasized the walls by rimlighting and highlighted the interesting architectural structure of the field barn to the right of the frame. Fascinated by the contrast of both weather and topography in the top and bottom halves of the frame – the lush sun-raked valley and the bleaker uplands veiled in cloud – he decided to exaggerate the juxtaposition. To do this, he fitted a half neutral density filter over the lens, so that the grey half would make the sky and hills more sombre. The exposure was 1/125 at f/8 on Kodachrome 64 film.

A 500mm f/8 mirror lens brought the farm building closer (right), without losing the impact of the field patterns. Although mirror lenses can often be comfortably handheld, for maximum sharpness it is preferable to use them with a tripod, as Woodcock did here. The fixed aperture of f/8 allowed a shutter speed of 1/125 (with Kodachrome 64). The blueness of this image, when compared with the 50mm view above, is due to haze, which the long-focus lens exaggerated.

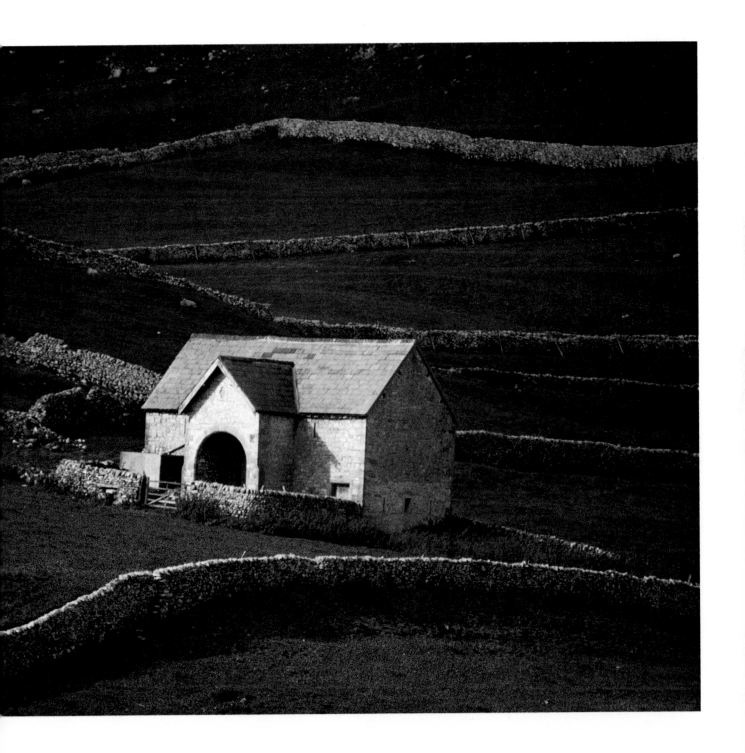

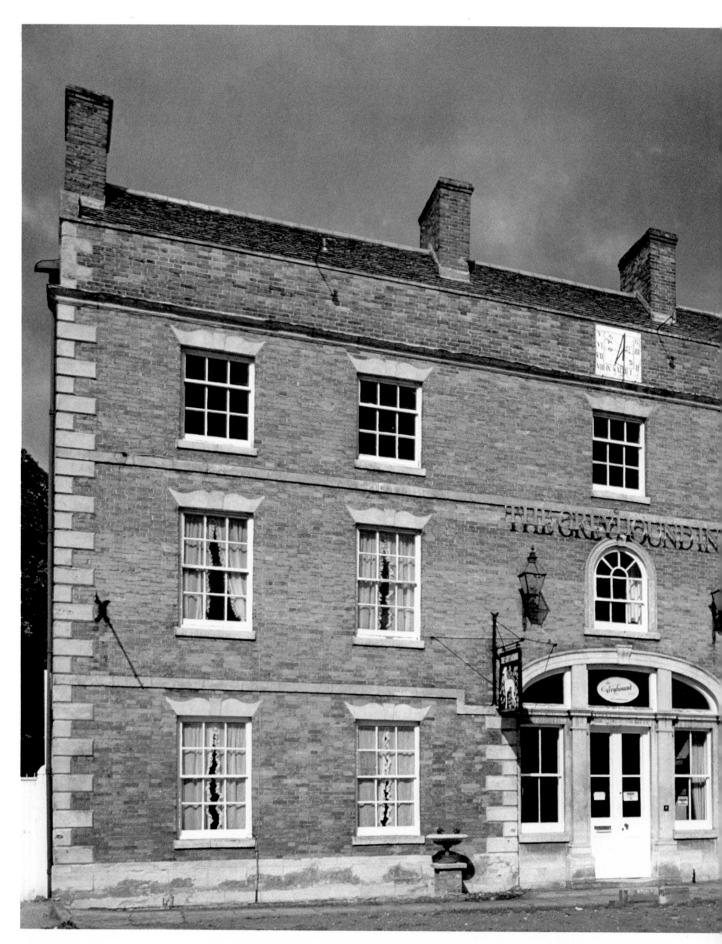

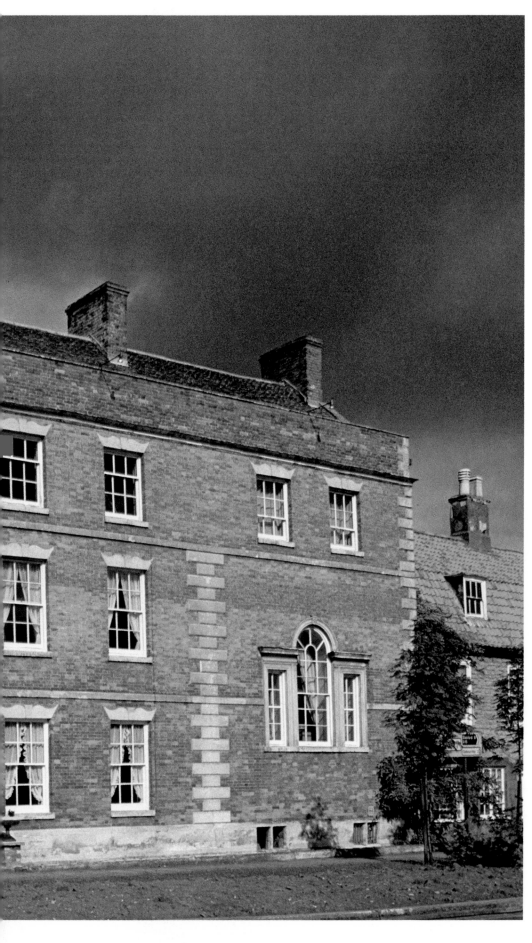

The warmth of evening sunlight effectively brings out the rich earthy colours of brickwork – an effect exploited in this portrait of the 18th-century coaching inn at Folkingham, Lincolnshire. Woodcock used his 28mm perspective control lens to keep the sides of the inn parallel in an upward-angled view. The dark storm clouds create a dramatic background. A monopod allowed an exposure setting of 1/30 at f/11 without serious risk of camera shake: an ordinary 28mm lens could easily have been handheld at this setting, but perspective control lenses are a little more unwieldy.

High contrast is a problem commonly encountered by photographers of large interiors. An exposure for the areas illuminated by the windows will often result in dark blocks of shadow on the opposite side of the room. Conversely, an exposure measured from the shadows will tend to cause bleached-out highlights on the window side, with sacrifice of important detail. Flash may even out the lighting, but with the side-effect of wrecking the atmosphere of the shot; in any case, it may not be permitted in churches, museums or stately homes. In a vast mansion it is always worth looking out for rooms where the décor and architectural features provide a ready-made solution to such lighting problems. This loggia on the ground floor of Hatfield House, Hertfordshire, offered Tim Woodcock an opportunity that was available in no other room in the house. Not only is the outer wall generously pierced by windows, but the white plasterwork ceiling and the chequerboard floor throw back light into the interior — so that even the subtle carving on the end of the timber chest is clearly visible in this photograph. Woodcock used a perspective control lens to straighten not the verticals this time, but the horizontals. The lens enabled him to choose a central viewpoint to avoid distorting the shape of the arch at the end of the loggia, but at the same time allowed him to show more of the window wall than the inner wall and thus benefit from the dynamic effect of off-centre framing. The exposure was 1/15 at f/16 (Fujichrome 50).

These glossy superb starlings were photographed in the Samburu game park in Kenya, using a 150mm lens on a tripod-mounted camera. No hide was necessary, as there was plenty of brush for concealment. There were about a dozen birds in the flock, all gathered in the same tree. Woodcock advanced stealthily to scatter a handful of food scraps on the ground below the tree, then retired to a distance and waited patiently. Noticing that a particular branch was a popular take-off point for the short drop to the bait, he manoeuvred himself to a more favourable viewpoint, still under cover from the brush, and turned his lens on the branch. Before the food supply was exhausted, he managed to shoot several rolls of film, pressing the shutter release whenever there were three or more birds in the frame. The impact of this simple composition depends partly on the diagonal line of the branch and the alternating directions of the starlings' stares. The exposure setting was 1/125 at f/8 (Ektachrome 200 film).

Landscape pictures taken with a normal 50mm lens seldom startle the eye in a way that is possible if you exploit the perspective effects of a telephoto or wide-angle lens. However, the fact that they record a scene in the same perspective as the eye sees it – though obviously more selectively – can be a source of quiet strength. Woodcock felt that this restrained approach was appropriate to the undulating pastoral landscape of the Usk Valley in Powys, South Wales. The patches of woodlands, the variegated colours of the fields and the starker but still far from threatening mountains in the distance form an intricate though harmonious pattern that speaks for itself, without requiring compositional support from foreground features. Another reason to avoid choosing a telephoto lens for the scene was the problem of haze, which a long-focus approach would have exaggerated. By fitting a polarizing filter to his 50mm lens, Woodcock reduced haze to the point where it merely softens the distant hills, without veiling detail.

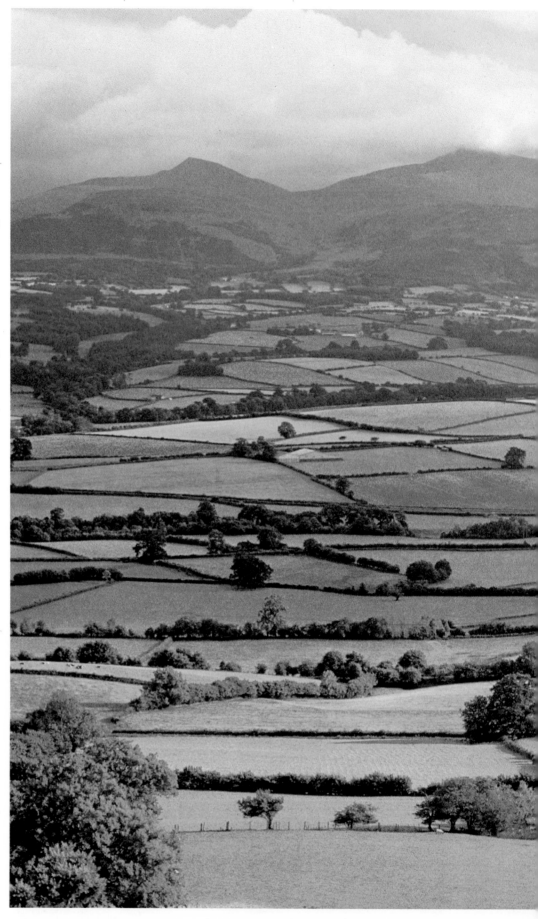

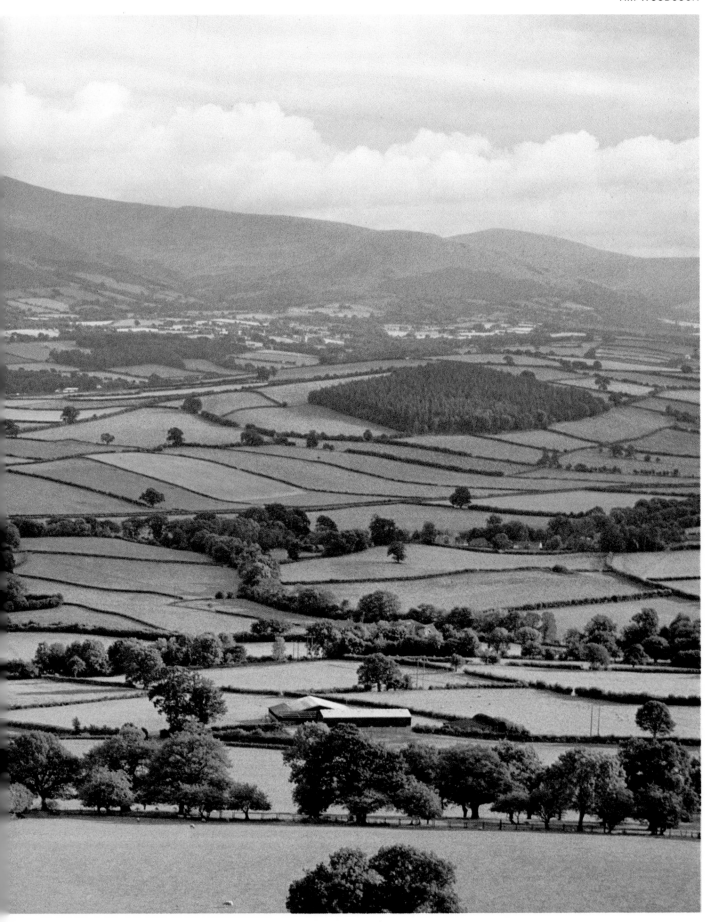

GLOSSARY

Aberrations Lens defects likely to mar the image produced. Commonest variants are astigmatism, chromatic aberration, coma, distortion, and spherical aberration.

Additive synthesis Method of producing colour images by mixing the primary colours – blue, red and green.

Aerial perspective Impression of depth in a landscape photograph, largely created by haze, which renders farther planes softer than nearer ones.

Against-the-light shooting Photographing a subject when the light source is behind it (popularly known as *contrejour*). Requires exposure increase to give detail in subject side facing the camera, but the rim-lighting effect is attractive.

Agitation Circulating solutions round sensitized materials, especially film, during processing.

Air-bells Bubbles which form on a film because of ineffective agitation during development. They leave clear spots on the negative.

Airbrushing Method of retouching prints. Airbrush uses high-pressure air to spray dye over selected area.

Anamorphic lens Lens able to compress a wide image in one direction.

Angle of incidence Angle formed between an incoming light ray and the normal (at right angles to the surface).

Angle of reflection Angle formed between the reflected ray and the normal. Equal to the angle of incidence.

Angle of view Optimum angle between two light rays passing through a lens.

Antifoggant Agent added to developer to hold off the formation of chemical fog. Especially useful for prolonged or higher temperature development, or when film is outdated.

Aperture Hole in a lens through which the image-forming light passes. Adjustable, by an iris diaphragm, in controlled marked steps called *f*-stops.

Artificial light Illumination other than daylight; main sources employed in photography are photofloods or flash from bulbs, flashcubes or electronic flashguns.

ASA American Standards Institute. The most commonly used film speed rating system. The faster (more sensitive) the film speed, the higher the ASA number; doubling, e.g. 50 to 100 ASA, denotes an increase equivalent to one aperture increment or shutter speed setting.

Astigmatism Lens aberration that makes simultaneous sharpness in vertical and horizontal lines unattainable.

Automatic camera Camera in which the exposure is partly or completely controlled by the internal system. In completely automatic cameras, sensors adjust exposure without aid. Partial automation may require the user to choose either an aperture or shutter speed setting, the camera's exposure automation adjusting the other function.

Auto-winder Camera attachment that employs a battery-driven motor to wind on film automatically, some models permitting automatic operation for two consecutive frames. Simplified form of motor drive.

Available light photography Taking pictures without addition of supplementary lighting, more usually in weak daylight conditions. Best tackled with fast films.

Average reading metering Camera TTL metering method that measures light over most of the screen area of the viewfinder.

Backing Coloured layer coated on the back of films and plates to minimize halation.

Back projection Projecting a slide (or a film) on to the back of a translucent screen. Used in commercial still photography (as well as cine and TV work) to provide false backgrounds, or where projection space is limited.

Ball and socket head Tripod fitment which permits controlled securing of a camera at virtually any angle.

Barn door Hinged flaps for spotlights and floodlamps to control direction and width of light beam.

Base Usually the cellulose esterfilm, polyester film, glass or paper support on which the emulsion is coated.

Bellows Flexible extension between lens and camera body usually on large-format cameras or older small-format models.

Bellows focusing unit Means of flexibility extending the film-to-lens distance. Thus objects much closer than the closest marked distance of the lens can be focused sharply.

Between-lens shutter Shutter type consisting of thin blades, opening from the centre outwards, mounted between lens elements. Permits flash synchronization at all speeds.

Bleaching Chemical process that converts the black metallic silver image into a colourless silver complex.

Boom-light Light attached to a long arm, allowing overhead position.

Bounce-flash System of reflecting the light from a flash unit to the subject from a nearby reflective surface (usually a ceiling), or by directing the flash into a light-coloured umbrella near the subject.

Brightness range Range of luminance between brightest-lit and darkest areas of an image. Scenes with a wide range are known as contrasty, low-range scenes as flat.

Bromide paper Most popular of sensitized papers for making prints. Available in several grades (usually 6 or 7) to permit contrast control over a wide range of sizes and surfaces.

B setting "Brief" time camera speed setting, at which pressure on the release button holds open the shutter until it is released.

BSI British Standards Institute. Now obsolete film speed rating system.

Bulk loader Container from which long rolls of 35mm film can be dispensed in measured short lengths for loading, in total darkness, into cassettes. Aids economical film buying in bulk lengths.

Cable release Bowden-type cable attaching by screw-thread to the shutter for releasing it smoothly by means of a plunger depression at the other end, thus minimizing camera shake risk during long exposures.

Cartridge Pre-loaded film container, usually made of plastic.

Cassette Metal film container holding small-format film sizes.

Catch lights Pinpoint reflections of light in the eyes of a portrait subject.

Centre-weighted metering Camera TTL metering method in which the reading is biased towards the intensity at the centre of the viewfinder.

CdS cells Exposure meter cell of resistance type requiring an external power source supplied by a battery. More sensitive to low light level than a selenium cell; but takes time to adapt to rapid wide light level changes.

Characteristic curve Graph line plotting the proportional reaction of a film to the influence of light density on development. The steeper the curve the more contrasty the film or other sensitive material.

Chloride paper Low-sensitivity printing paper with silver chloride emulsion, used for contact printing.

Chlorobromide paper Printing paper of medium sensitivity that produces warm-tone images.

Chromatic aberration A lens with this fault cannot bring light of different colours to the same place of focus.

Cinching Pulling the film over-tight in a cassette; bad practice, as it may cause scratches.

Clearing time Time between first immersing and clear film when a film is being fixed. Fixation is complete after twice the clearing time.

Close-up lens A form of spectacle lens, correctly called a supplementary, in a mount. It is screwed into the camera lens front, permitting closer range focusing, according to the strength (graded in diopters) of the close-up lens.

Coated lens Coating of air-to-glass surfaces in a lens to improve light transmission and reduce flare. The coating is usually magnesium fluoride.

Cold cathode enlarger Diffusion type of enlarger using a fluorescent tube as the light source. Used mainly for large formats, it gives soft illumination that suppresses negative defects, and is cool-running.

Colour analyser Metering device for assessing the necessary degree of colour filtration and exposure in colour printing.

Colour casts False hues in a colour picture. May be caused by reflection from a nearby strong colour, by incorrect processing or in printing. Casts can be removed in printing by addition or removal of filters.

Colour compensating filters Filters used when printing colour materials to achieve correct colour balance. They are usually purchased in sets of three colours – cyan, magenta and yellow – each in a range of densities. Commonly known as colour printing filters.

Colour conversion filters Filters used on the camera lens to match the colour temperature rating of a colour film to that of a specified light source, e.g. so that daylight film can be used in artifical light and artificial light-type film can be used in daylight.

Colour light balancing filters Camera filters for use with colour film to give a colour-balanced result. They modify slightly the colour temperature of the light in use to that for which the film is balanced, avoiding a too-warm or too-cool appearance. Bluish filters raise the temperature. reddish or amber ones lower it.

Colour negative Film that produces a negative image in colours complementary to those in the subject – blue as yellow, green as magenta, red as cyan. It is used to give colour prints, but black and white prints and colour transparencies can be produced.

Colour reversal film Popularly known as slide film. Gives a positive transparency, viewed against a clear light source or by projection.

Colour sensitivity Relative response of film to the colours of the spectrum.

Colour synthesis Additive or subtractive methods by which a final colour photograph is formed.

Combination printing Enlarging a section of two or more negatives on to one print. Most common use is in adding an attractive sky to a landscape with bald sky area.

Complementary colours Two colours that together produce white light. Colour films absorb light of the complementary colour. Complementaries of the three primary colours red, green and blue, are cyan, magenta, and yellow respectively. Also used to denote colours opposite each other in the colour wheel.

Computer flash Electronic flash units that eliminate the need to calculate the flash exposure and set aperture accordingly. A sensor assesses the strength of light reflected back from the subject which the flash fires. Internal circuitry gauges when the amount of light delivered is adequate for a correct exposure.

Contact prints Prints made by direct contact with negatives. Usually used for quick reference, especially when an entire film is contacted.

Contrast Relationship between tones of an image; a print with wide tonal differences is said to be contrasty, one restricted in tonal range is flat.

Contrast filters Tinted lens filters for use with black and white films that darken or lighten tones considerably. They give greater separation of colours which would appear as similar tones in a monochrome print. Often used for deliberately exaggerating an effect; a red contrast filter, for example, renders a blue sky almost black.

Converging lens Simple convex lens causing rays of light to converge to a

point.

Converging verticals Distortion caused by pointing the camera upwards at, say, a tall building. Can be corrected with cameras that have perspective control movements, with a perspective control lens, or in enlarging by tilting the paper support.

Converter Accessory lens for use in combination with a camera lens to give a longer focal length, usually doubling or trebling that of the main lens. Fitted between main lens and camera, though a few types attach in front of camera lens. Best results when used with lens of longer than standard focal length.

Convertible lens Compound lens of which a part can be unscrewed to give a new lens of longer focal length.

Correction filters Filters used on the lens to modify slightly the tonal rendering of colours on black and white film so as to give a more natural appearance on the print. Most common is a yellow or yellow-green filter, which gives a light grey rendering of blue sky.

Cropping Leaving out parts of a negative when printing to enlarge only a selected area.

Cut film Sheets of film cut to a specific size for use mostly in large-format cameras.

Delayed action (DA) A camera function (or separate accessory) which delays shutter operation for a few seconds (sometimes adjustable) after the release button is pushed.

Density Degree of darkening of a negative, transparency or print, by exposure and development.

Densitometer A meter for measuring accurately density in selected parts of an image, and thus for assessing overall tonal range.

Depth of field Zone between nearest and farthest parts of a scene extending either side of the focused subject that reaches acceptable sharpness.

Depth of field previewer Button or lever on a reflex camera that stops the lens down to a selected aperture, allowing visual assessment of depth of field.

Depth of field tables Tables setting out acceptable depth of field ranges for given focusing distances and apertures. The depth varies according to the focal length of the lens, distance focused on, and aperture. Engraved scales around camera lenses also give an approximate estimation.

Depth of focus Very small range of acceptable variation of lens-to-film distance within which critical sharpness can be maintained. Term often wrongly used for depth of field.

Development Processing in a specified chemical (the developer) of film or other light-sensitive material to render visible that latent image produced by exposure. There are many developers to suit different materials and results required from them. Results may be influenced considerably by the degree and method of development.

Diaphragm Means of controlling light passed by a lens. Usually a cluster of thin blades, the iris, that opens from the centre. Degree of opening is marked by f-numbers. Opening and closing can be controlled automatically as shutter release is operated.

Diaporama Continental term for slide-sound show, usually employing techniques of dissolving one slide into the next during changes.

Diapositive Alternative term for a transparency.

Differential focus Controlled use of focus point and depth of field so as to enhance the feeling of depth in a photograph, such as rendering the subject sharp against a background well out of focus. One of the most valuable pictorial tools of photography.

Diffusion Slight scattering of light to soften image rendering of lens or quality of light source, usually by means of a diffusion filter in front of camera or enlarger lens or translucent fabric on light source.

DIN Deutsche Industrie Norm. The film speed rating widely used in Europe. An increase of three units – e.g. 21 to 24 DIN – denotes a doubling of film speed, equivalent to one exposure stop difference. Logarithmic, whereas ASA is arithmetical.

Dissolve Fading out of one slide or film image as another is introduced.

Distortion Lens aberration. Two main types are barrel distortion, in which straight lines at the edge bow out (most noticeable in wide-angle lenses), and pin-cushion distortion, the opposite effect.

Diverging lens Concave lens, one which causes rays to bend away from the optical axis.

Dodging Giving less than the overall exposure to parts of a print which would otherwise appear too dark. Done by interposing a small, appropriately shaped object in the light path of the area of the image to be dodged during exposure. Also called shading.

Double exposure Superimposing one image over another on a film frame or print. Sometimes unintentional, though most modern cameras have built-in prevention. It is often created intentionally for striking or amusing effect, either at taking or printing stage, though it is often called photomontage if done deliberately with the enlarger.

Double image Inadvertent sharp movement of camera or enlarger, causing duplicated images to appear.

Drying marks Tear-like stains on a film caused by impurities in wash water being left behind as film dries. Occurs especially in hard-water areas.

Dry mounting Bonding a print to a still mount by means of interposed shellac tissue, the bond being made by applying heat and pressure.

Duplication Making identical copies of negatives or slides ("dupes") by rephotographing them.

Dye transfer Method of making colour

prints from transparencies and other colour prints using separation negatives and printing colour dye matrixes in register.

Electronic flash Artificial lighting, in the form of a repeatable high-intensity short-duration flash. The flash unit discharges a high-voltage impulse of electrical energy through a gas-filled tube when a circuit is closed by the camera's shutter synchronization mechanism. Units use either dry-cell batteries, rechargeable cells or mains power.

Emulsion The medium that carries the image on film or photographic paper. Usually takes the form of silver halides suspended in gelatin.

Enlargement A print larger than the negative made by projecting the negative image to desired enlargement on to light-sensitive printing paper.

Exposure Amount of light given to film or paper to form the latent image. Controlled by a combination of the aperture, which controls the intensity, and the shutter, which governs the exposure time.

Exposure bracketing Taking of extra pictures at exposures more and less than "correct", to allow for error.

Exposure counter Camera function for recording number of exposures made.

Exposure latitude Tolerance of a film to record satisfactorily if exposure is not exactly correct. Colour films generally have less latitude than black and white films, while fast black and white films have most latitude.

Exposure meter Light-measuring instrument using the principle of light energizing a photosensitive cell to produce a current that actuates a pointer to indicate a reading. Meters may be either separate units or built into a camera, the latter sometimes setting exposure automatically.

Fill-in light Additional light to the main light source which directs light to the shadows to cut down contrast. Much used in portraiture.

Film speed Accurate measure of a film's sensitivity. Most popular scales are ISO and DIN.

Filters (optical) Pieces of clear glass, gelatin or other translucent material that modify the nature of light passing through. They may be used at the taking stage, with black and white or colour film, or in colour enlarging to give correct colour balance. Also used in darkroom safelights to give the right light quality for a specific material. Main types are colour compensating, colour conversion, contrast, correction (last two used with black and white film), infra-red, polarizing and ultraviolet.

Fisheye lens Lens with extremely wide coverage angle, possibly 180°. Distortion is inevitable, and image may be circular.

Fixing Process whereby the developed image on film or paper is made

permanent so that no further darkening or fading takes place. The material is immersed in a fixer solution for a short time, then washed to remove it.

Fixed-focus lens Lens on a simple camera with focus that cannot be altered. It is set to a distance which will give greatest depth of field.

Flare Non-image-forming light in a lens, usually caused by reflections, which degrades the image.

Flash Instantaneous form of artificial light. Provided by electronic flashgun, flashbulb, flashcube, or *Flipflash*. After igniting to give a brilliant flash, a flashbulb is thrown away; flashcubes contain four such bulbs; *Flipflash* units have six or more in a bank.

Flash exposure Calculated by means of a guide number, stated for the particular flash unit and film being used. The flash-subject distance (in feet or metres according to the guide system used) is divided into this number. The result is the approximate aperture setting.

Flash synchronization Means of ensuring the shutter is open while flash is at peak of intensity. Main types are x for electronic flash, requiring a relatively slow shutter speed, usually about $\frac{1}{60}$ sec with focal plane shutter, and M, which permits between-lens shutters to be synchronized at all speeds with flashbulbs.

Floodlight An artificial, constant light source employing high-wattage lamps placed within reflectors to give even lighting over a wide area at fairly high level. Photofloods are a popular form, usually rated 500-watt, some having built-in reflector system.

f-number Number on a lens diaphragm that indicates its light-passing power. It is derived by dividing the focal length of the lens by the diameter of its effective aperture. A standard scale of f-numbers is used to give progressive halving of light-passing power to quantify exposure setting.

Focal length Distance from the optical centre of a lens focused at infinity and the film plane. The longer the length, the more enlarged the image.

Focal plane Image line at right angles to the optical axis passing through the focal point. Forms the plane of sharp focus when camera is focused at infinity.

Focal plane shutter A shutter that operates just in front of the film plane. It takes the form of a blind with a variable slit moving horizontally or vertically, exposing the film progressively in transit. Varying the slit width varies the shutter speed. Used in most SLRs.

Focal point Point on the focal plane where the optical axis intersects it at right angles.

Focusing screen Screen, usually ground glass in reflex cameras, which permits easy viewing and focusing of the scene to be photographed.

Fog Veiling of an image caused by light

leak to the emulsion, by chemical means or by poor or over-long storage. Chemical or poor storage fog can be minimized by adding an antifoggant chemical to the developer.

Format Size of negative, camera viewing angle or printing paper.

Fresnel lens Special design of lens; used to give even brightness all over a reflex camera ground-glass screen.

Gamma Means of comparing contrast in the subject and that in the image when developed. It indicates the degree to which a change in exposure will affect photographic material. Developer instructions usually state a time and temperature required for a film to reach a specified gamma, this being further related to the type of enlarger to be used.

Gelatin Used in sensitized emulsion for suspension of light-sensitive silver halides. Also material for cheaper filters.

Glazing Imparting a high glaze to glossy surface printing papers by drying them in close contact with a high-glaze surface, usually with the addition of heat.

Gradation Tonal range of a negative or print. Few tonal steps indicate hard gradation, and the image is said to be contrasty. Many steps mean soft gradation – a flat image.

Grade Means of denoting printing paper gradation character. Most ranges have six or seven grades from 0 (very soft) through 2 or 3 (normal) to 5 or 6 (very hard). This permits a high degree of contrast control.

Grain Tiny black particles of silver halide in the emulsion which form the image.

Graininess Clumping together of the silver halide grains forming the image to give a rough, granular appearance, especially noticeable in areas of even tone at high degrees of enlargement. Use of fast films, long development, and overexposure are the chief contributory factors.

Grey card method Using a grey card of 18% reflectance, used to give an average-subject reading for an exposure meter.

Ground-glass screen Focusing and viewing screen of advanced cameras.

Half-frame Format utilizing half the normal 35mm frame (24 × 18mm). Half-frame cameras give 72 shots on a full 35mm load rather than the 36 of full-frame.

High key Photograph using mostly the lighter tones, conveying lightness and delicacy in suitable subjects.

Highlights Brightest areas in a print or transparency, densest areas of a negative.

Hot shoe Metal slot on cameras for taking flash attachment, and providing cordless synchronization.

Hyperfocal distance The nearest point to the camera giving acceptable sharpness at a given aperture when the lens is focused at infinity. Focusing on this distance extends depth of field, since everything will be sharp from half the hyperfocal distance to infinity.

Hypo Common name for the fixer agent sodium thiosulphate. Also used in Farmer's reducer.

Hypo eliminator Solution for removing hypo more rapidly from film or print and thus speeding up washing.

Incident light reading Taking a reading of the light falling on (incident on) the subject rather than reflected from it. Generally done by pointing a meter fitted with an incident light attachment (a translucent covering) towards the camera position.

Infinity Far distance, and in photographic terms anything beyond 1,000m/3,330ft. Symbol used is ∞.

Intensification Chemical strengthening of the density of a weak negative image.

Intermittency effect Illustrates that a number of brief exposures does not give the same density as a single exposure of equivalent duration.

Inverse square law Law stating that illumination on a surface is inversely proportional to the square of the distance from it of the light source; twice the distance, one quarter the light.

IR mark This, on lens focus mounts, is the focus setting index when using infra-red film, as this comes to a focus forward to the visible light setting.

ISO (International Standards Organization) System of rating emulsion speeds which is replacing ASA and DIN. ISO 100 corresponds to 100 ASA.

Joule Unit of measurement applied to the output of an electronic flash and used to compare outputs of flash systems; equivalent to a watt-second.

Kelvin Unit of measurement for colour temperature. Colour film types are balanced for a specific °K rating, such as daylight film at 5400°K.

Latent image Invisible image formed on the film by exposure, made visible by development.

Latitude Extent to which exposure level can be varied and still produce an acceptable result. Usually greater on fast films than on slow ones.

Lens cap Removable protective cover of a lens, Interchangeable lenses should be kept with a cap on both ends.

Lens hood Accessory for shading the front of the lens from bright light outside the field of view. This non-image-forming light is a cause of flare.

Lens mount Means of attaching the lens to camera body. Most are bayonet or screw-thread fitting. Some lens manufacturers provide a choice of interchangeable mounts.

Lens tissue Very soft tissue free of impurities suitable for gentle cleaning of lenses.

Light leak Indicated by fogging of film. Most likely to occur around camera back joints and, in older types, through bellows pinholes.

Linear enlargement Degree of enlargement based on increase in one dimension.

Long-focus lens One with a focal length longer than that of the diagonal of negative it covers (longer than 50-55mm with a 35mm camera, for example). Not an interchangeable term with telephoto. The physical length of the long-focus lens approximates its focal length.

Long Tom Popular name for very long telephoto used for press work.

Low key Photograph using mainly the darker tones, conveying sombre impressions or drama. This effect is created mainly by allowing the lighting to create heavy shadows.

Lumen Unit of measurement of light intensity.

Macro lenses Prime camera lenses which have the facility for focusing closer than normal lenses, often to a closest focusing distance of 20cm/8in and essentially giving life-size reproduction directly, without accessories. Lenses giving relatively close focusing, but not 1:1 reproduction ratio, are not macro lenses.

Macrophotography Close-up photography at reproduction enlargement from life-size to 10 × life-size. Enlargement usually achieved by means of bellows or extension tubes, close-up supplementary lenses or macro lenses.

Magnification ratio Close-up term (sometimes known as reproduction ratio) denoting the size ratio of the actual subject to its image on film. Macro photography denotes a magnification ratio of between 1:1 and 1:10 (actual size to 10 × life-size).

Maximum aperture The largest f-number (opening) on a lens. Lenses with large maximum apertures (wider than f 2) are known as fast lenses.

Microphotography Correct term is photomicrography.

Microprism Viewfinder aid of a prism system allowing a sharp image only when focus is correctly adjusted. Used in many SLR viewfinders.

Mirror lens Compact lens with very long focal length (500mm upwards) which forms the image by means of mirrors rather than lens elements. Has no aperture adjustment.

Monobath developer Processing solution that combines developer and fixer in one solution.

Montage Photograph formed from several others with the enlarger or cut out and mounted together. The second technique is also called collage.

Motor drive Camera attachment that automatically winds on film and releases shutter for a sequence of shots at the rate of several a second. Valuable for sports photography.

Negative Photographic image, usually on film, in which the tones of the original scene are reversed.

Negative formats Most popular small-format sizes are 110 (image size 13-17mm), 126 (28 × 28mm), 35mm or 135 (24 × 36mm), 120 (6 × 6cm/ $2\frac{1}{4} \times 2\frac{1}{4}$in). Variants on the last roll film size are 4.5 × 6cm, 6 × 7cm and 6 × 9cm. Larger-format cameras mainly use $3\frac{1}{4} \times 4\frac{1}{4}$in ($\frac{1}{4}$-plate), 5 × 4in and $6\frac{1}{2} \times 8\frac{1}{2}$in (whole-plate), and 10 × 8in

Neutral density filters Filters that block a degree of light without modifying its colour content. Employed when light intensity is too great for the film, or to give some exposure control with telephoto mirror lenses, which do not have a diaphragm.

Newton's rings Rainbow-hued rings that appear between film and glass. Slides with treated surfaces minimize the problem.

Open flash Firing of flash when the shutter is held open, usually for night shots with negligible ambient light.

Overexposure Action of too much light on the emulsion. An overexposed negative is very dense, requires a long printing time and may show excessive graininess. An overexposed transparency is too thin.

Panchromatic Type of black and white film in general use which is sensitive to the complete visible spectrum.

Pan head Tripod attachment that aids taking of a panoramic view in sections which will match up exactly.

Panning Technique of holding and following a subject moving across the field of view, releasing the shutter during this swing.

Paper negatives Negative image on thin paper from which same-size prints can be made.

Pentaprism Prism arrangement on top of SLR cameras that renders the image in the viewfinder the right way round.

Perspective control lens (also known as a shift lens) A lens which can move both laterally and vertically in relation to the film. Used chiefly in architectural photography to include, say, the top of a building without having to tilt the camera and cause perspective distortion.

Photo-electric cell Exposure meter component that generates an electrical current when light falls on it.

Photoflood Lamp with filament used in floodlights.

Photogram Photo-images made by placing solid or translucent objects on sensitive paper and exposing to light to produce an image of their outline or skeletal structure.

Photomicrography Photography through a microscope, the camera being attached to the eyepiece to give magnifications over 10 × .

Polarized light Light that has been caused to vibrate in one plane by being reflected from a surface.

Polarizing filter Filter that cuts out polarized light to eliminate reflections from water and shiny surfaces (but not metal). It also darkens blue skies on colour film without altering other colour values.

Positive A photograph with tones having a recognizable relationship to those in the subject; that is, a print or transparency.

Positive lens Simple lens which causes light to converge to a point.

Posterization Technique whereby several negatives and positives are made from an original image, each step restricting the range of tones. When printed together in register, the result shows only a restricted range of tones.

Print contrast control Main control is by selection of appropriate paper grade. Use of soft or vigorous working developer also affords control, and techniques of burning-in and dodging give localized control.

Process film Slow film used for copying work.

Push-processing Known as pushing film, this is prolonging development to permit rating of films at faster speeds than recommended. Most successful with fast films on low-contrast subjects, and particularly useful in photo-journalism and sports photography.

Rangefinder camera Type of camera with focusing aid which relies on the exact aligning of two images of part of the subject.

Reciprocity law Principle which shows that if the product of exposure (light intensity × time) is constant, then exposure effect will be the same. Thus $\frac{1}{25}$ sec at f 11 produces the same density as $\frac{1}{100}$ sec at f 5.6.

Reducer Chemical applied to reduce density of a negative. Best known type is Farmer's reducer.

Reflector Surface for directing and concentrating light. Flashlight sources and other artificial light sources utilize bright metal surfaces, often dome-shaped. White cards or sheets may be used outdoors to direct light to shadow areas.

Reflex camera One in which the image seen by the lens (or a second lens) is directed by mirrors to form the viewfinder image on a screen. Main types: single-lens reflex (SLR) and twin-lens reflex (TLR).

Refractive index Numerical value of the light-bending power of transparent materials, particularly glass.

Resin-coated paper Bromide paper with a plasticized surface that fixes, washes and dries very quickly compared with conventional bromide paper.

Resolving power The degree of ability of a lens to provide a sharp detailed image. Scale in general use indicates line pairs per millimetre resolved. Also relates to the ability of a film to reproduce fine detail.

Reversal material Film that is processed direct to a positive image, such as a colour transparency.

Reversing ring Ring for attaching a lens to a camera body (or extension bellow) back to front. This avoids loss of definition at close-focus distances.

Ring flash Unit that has a ring-shaped flash tube. When positioned round the lens it gives flat, shadowless lighting. Useful for some close-up work.

Safelight Light allowing illumination in the darkroom without damage to sensitized materials (e.g. green for bromide paper).

Scheimpflug effect Principle that notes that if projections of the planes of subject, lens and negative or film meet, then all the subject plane will be in focus. It is applied to maintain sharpness all over a subject of some depth when using a technical camera with a range of movements, or to maintain sharpness all over an enlarger baseboard tilted to correct verticals, if negative plane can also be inclined.

Selenium cell Exposure meter cell type which does not need an external battery for operation. Its spectral response is close to that of panchromatic film. As it has a relatively wide measuring angle, it is most suited for use in hand-held light meters.

Shutter Means of controlling the time that light is allowed to pass to the film. Calibrated in fractions of a second, commonly in equal steps from $\frac{1}{1000}$ sec to 1 sec. Two main types, focal plane and between-lens shutters.

Silhouette Technique of photographing a subject in outline only, achieved by shooting dark object against light background.

Silicon photodiode cell Exposure meter cell (resistance type) of high sensitivity. Needs a battery to supply power. Very sensitive with faster response and recovery than CdS cells. Incorporated in some recent camera metering systems.

Silver halides Light-sensitive salts for silver bromide, chloride and iodide in a photographic emulsion.

SLR Abbreviation for single-lens reflex. popular camera in which the image that appears on film is also, by means of a mirror and viewing screen, that seen in the viewfinder.

Soft focus Diminishing of normal definition of a lens to give a soft, romantic appearance to a photograph. Achieved by special filters on the camera lens or by a diffusing material such as muslin in front of the enlarger lens.

Solarization Correct term for the usual application is pseudo-solarization or Sabattier effect. A brief exposure to light is given to a print after normal enlarger exposure and short development, then development and the subsequent processes are completed.

Spectrum Bands of colour into which white light is split on passing through a prism.

Speed Sensitivity of photographic emulsions to light (incident radiation). Films have ASA and DIN numbers denoting speed.

Spherical aberration Lack of sharpness in a lens caused by light passed through the lens edges coming to a different point of focus to that passing through the centre.

Spot metering Camera TTL metering in which exposure is based on a very small area in the centre of the frame. Reading should be on a mid-grey tone. Separate spot meters are highly sensitive meters taking a reading from a very small angle of measurement, around 1°.

Standard lens That with a focal length approximately equal to the diagonal of the format it covers. It is the lens generally supplied with a camera; for 35mm models it is around 50mm focal length.

Stop Alternative name for aperture.

Stop bath Process following development, usually a dilute solution of acetic acid to neutralize the developer.

Stopping down Decreasing the size of the aperture.

Subminiature camera Small-format camera, generally using 16mm film stock.

Supplementary lenses Close-up lenses for attachment to the normal camera lens.

Synchronization Ensuring coincidence of the flash firing with the shutter's maximum opening.

Telephoto lens Lens of longer than standard focal length, but with shorter physical length than a true long-focus lens. This is achieved by a telephoto's optical construction.

Test strip Progressive proportionate exposing of a strip of printing paper to assess correct print exposure.

TLR Abbreviation for twin-lens reflex, a camera type with a viewing lens mounted immediately above a taking lens.

Tonal range Difference in the density between the brightest and least bright part of an image, or in the reflective power of a subject.

Toning Altering the natural colour of a print by a chemical toning bath. Best known application is sepia toning by sulphide and selenium toners. Gold, red, green, yellow and other tones can also be attained by using the appropriate formulas.

Transparency Positive image in a transparent base, called a slide.

Tripod Sturdy three-legged camera support, essential for long exposures.

T setting "Time" setting. Shutter opens at first pressure, remaining open until depressed.

TTL metering Abbreviation for "through the lens". Common feature of SLR cameras, the camera's internal exposure metering being actuated by light passing through the lens to a cell in front of the film plane.

Tungsten-halogen lamp Improved smaller version of the tungsten lamp, with whiter and brighter light.

Ultraviolet Invisible radiation having a wavelength shorter than that of the blue-violet part of the spectrum. Though not seen by the eye it will cause blue cast in colour film. Prevalent at high altitudes, near sea and in misty conditions.

Ultraviolet filter Absorbs excessive ultraviolet radiation and particularly necessary at high altitudes. Needs no exposure adjustment.

Underexposure Condition where insufficient light has fallen on the emulsion to form a sufficiently strong image. An underexposed negative is too thin, a transparency too dense, a print too dark.

View camera Large-format plate camera where image is seen on a ground-glass screen. Used mainly in the studio or for architecture, where its movements give great control of depth and perspective.

Viewfinder Apparatus for viewing and sometimes focusing, either direct vision, optical, reflex or ground glass.

Viewpoint Position of the camera in relation to the subject or scene.

Vignette Printing technique in which the image fades into the edges and corners.

Washing Immersion of a fixed emulsion in running water to rinse out the fixer salts.

Weston speeds An obsolescent speed rating system, similar to ASA but $\frac{1}{3}$ stop "slow". Modern Weston meters use the ASA system.

Wetting agent Solution in which a film is immersed after washing. It reduces surface tension, enabling the film to dry quicker.

Wide-angle lens Lenses with a wider angle of view than that of standard for the format.

Working solution A processing solution at the correct dilution for use.

X-ray Electromagnetic radiations that can produce a visual representation of the internal structure of an object.

Zoom lens A lens of variable focal length. Various types available cover a focal length range from moderate wide-angle to medium telephoto, from about standard to moderate telephoto, or from moderate to long telephoto. There are two methods of changing the focal length: helical, the barrel being turned, or rectilinear, when it is pushed back or forward. Similar to zooms are "variable-focus" lenses, but they require refocusing after altering the focal length.

INDEX

Page numbers in *italic* refer to illustrations and captions

ACKNOWLEDGEMENTS
The Publishers gratefully acknowledge the
assistance of the following in providing
photographs

Konica 8, 9, 10, 11, 14, 17
Nikon 15, 16, 17, 28, 29, 30, 31, 32, 33
Olympus 8, 10, 11, 13, 15, 16, 17, 25, 33
Pentax 8, 9, 14, 16, 21, 26, 27